EXPOSÉ 6 ™

Finest digital art in the known universe

Edited by

Daniel Wade & Paul Hellard

Publishers

Mark Snoswell & Daniel Wade

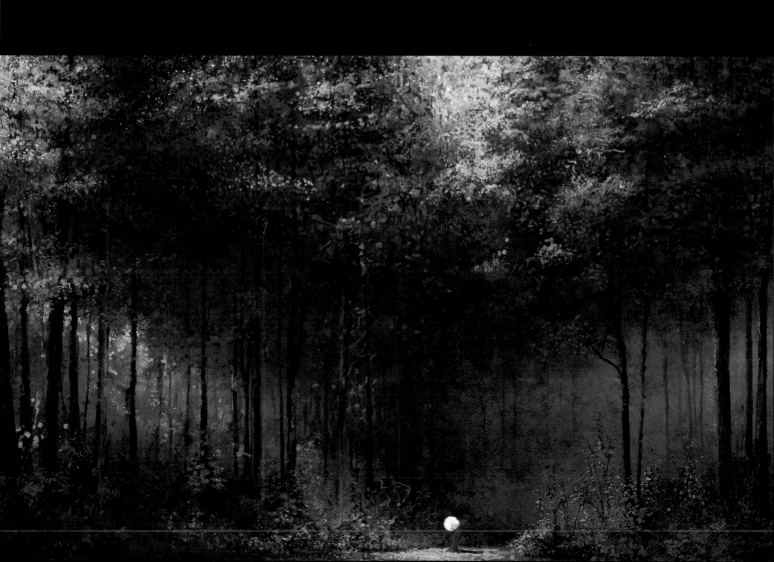

EXPOSÉ 6 ™

Published
by

Ballistic Publishing

Publishers of digital works for the digital world

134 Gilbert St
Adelaide, SA 5000
Australia

www.BallisticPublishing.com

Correspondence:
info@BallisticPublishing.com

First Edition published in Australia 2008 by Ballistic Publishing

Softcover Edition ISBN 978-1-921002-50-2
Hardcover Edition ISBN 978-1-921002-49-6
Limited Collector's Edition ISBN 978-1-921002-51-9

Managing Editor/Co-Publisher
Daniel Wade

Assistant Editor
Paul Hellard

Art Director
Mark Snoswell

Design & Image Processing
Lauren Stevens, Daniel Cox

Advisory board
Brom, Ryan Church, Max Dennison, Lorne Lanning, Stephan Martiniere, Jeff Mottle, Chris Sloan, Phil Straub, David Wright

Printing and binding
Everbest Printing, China (www.everbest.com)

Partners
The CGSociety (Computer Graphics Society) www.CGSociety.org

Also available from Ballistic Publishing
EXPOSÉ 5 Softcover ISBN 978-1-921002-39-7
d'artiste Character Modeling 2 ISBN 978-1-921002-35-9
Creative ESSENCE: The Face ISBN 978-1-921002-36-6
EXOTIQUE 3 Softcover ISBN 978-1-921002-45-8

Visit www.BallisticPublishing.com
for our complete range of titles.

Cover image credits

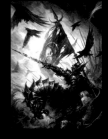

Red Robin
Photoshop
Linda Bergkvist, SWEDEN
[Front cover: EXPOSÉ 6
Softcover & Hardcover editions]

Books of the South
Photoshop
Client: Tor Books
Art Director: Irene Gallo
Raymond Swanland, USA
[Back cover: EXPOSÉ 6
Softcover & Hardcover editions],123

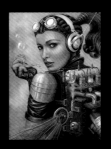

Golden Bee
Photoshop
Jeffrey M. de Guzman,
PHILIPPINES
[Cover: EXPOSÉ 6
Limited Edition], 15

/ BALLISTIC /

Daniel Wade | Managing Editor &
Co-Publisher of Ballistic Publishing

Paul Hellard | Assistant Editor
of Ballistic Publishing

/ B A L L I S T I C /

WWW.BALLISTICPUBLISHING.COM

Every other month at Ballistic Publishing and CGSociety we celebrate major milestones whether it's a bigger, better edition of a book in our EXPOSÉ, d'artiste, EXOTIQUE, or ELEMENTAL series, a record-breaking number of entries for a book, or the 100,000th image posted to our online CGPortfolio. The preparation of EXPOSÉ is a milestone in itself as it always signals an impending flood of great artwork that needs to be squeezed into a book.

As with all of our EXPOSÉ books, we started with the Advisory Board. We welcomed Ryan Church (leading concept artist and Grand Master), Stephan Martiniere (renowned concept artist and Grand Master), Lorne Lanning (Oddworld Inhabitants), Chris Sloane (Art Director of National Geographic), Jeff Mottle (founder of CGArchitect.com), Brom (renowned fantasy artist), and Phil Straub (art director and concept artist) as returning judges. To round out the advisory board we were very fortunate to secure the help of Max Dennison (leading matte painter and founder of Matte Painting UK) and David Wright (Creative Director of NVIDIA).

The call for entries was a flood this year with 5,130 entries arriving in our entry system in the last few weeks before the deadline. To cater for the surge of entries in character and narrative entries we added a number of new categories. The new categories were: Warriors; Fantasy Femmes; Conflict; and Storytelling. The returning categories for EXPOSÉ 6 were: Portrait (Painted); Portrait (Rendered); Architecture (Exterior); Architecture (Interior); Fantasy; Creatures; Concept Art; Matte Painting; Science Fiction; Environment; Futurescapes; Abstract & Design; Product Design & Still Life; Humorous; Whimsical; and Transport. The categorizing and shortlisting process took just under one week to complete before the Advisory Board began judging their top twenty entries per category.

The judging results were then tallied to determine the award winners. The top images were awarded Master Awards and depending on merits 1-3 images received Excellence Awards in each category. With the high standard of entries for EXPOSÉ 6, almost all of the featured artists can consider themselves award winners with the Master and Excellence award winners leading a hugely talented group. With the judging complete, the real work then began with Lauren Stevens, our designer extraordinaire, working through the layouts of entries and hand-tweaking every image to achieve the best results for print. We were extremely fortunate to have Linda Bergkvist create a piece of art especially for the EXPOSÉ 6 cover, and I'm sure you'll agree that it is an exquisite example of Linda's wonderful work. We look forward to many more of her creations.

Of the 5,130 images entered, 334 were featured in EXPOSÉ 6. These featured images came from 257 artists in 43 countries (just over half of these artists were featured for the first time). As with EXPOSÉ 5 one in 15 entries was successful in EXPOSÉ 6 (compared to one in sixteen for EXPOSÉ 4, one in 25 for EXPOSÉ 3, one in 15 for EXPOSÉ 2, and one in four for EXPOSÉ 1). All featured artists in EXPOSÉ 6 receive a free hardcover copy of the book and six month's free membership to the CGSociety.

Promoting artists through Ballistic Publishing and CGSociety, and offering services like CGPortfolio, CGJobs, CGWorkshops keeps us at the forefront of a fantastic creative community whose work continues to amaze and drive us to raise the bar higher in everything we do. Congratulations to all the artists who have submitted work for the EXPOSÉ series and our other titles. We hope you enjoy EXPOSÉ 6 as much as we enjoyed producing it.

EXPOSÉ 6 CATEGORIES

CHOOSING CATEGORIES

Each year we look at every image entered for EXPOSÉ and then choose the categories that best represent the balance of those entries. Several categories will regularly receive most of entries like Portrait (Painted), Fantasy, Science Fiction, and Architecture. In contrast to the smaller number of new categories added to EXPOSÉ 5, four new categories were added to EXPOSÉ 6—Fantasy Femmes, Warriors, Conflict, and Storytelling. The other category changes were a shift from Cityscapes to Futurescapes, the removal of Horror/Surreal, and the addition of Design to the Abstract & Design category. As with each previous EXPOSÉ, the quality of entries increased to the point where few votes separated the top ten in each category. EXPOSÉ 6 also returned to a record number of entries with just over 5,200 entries.

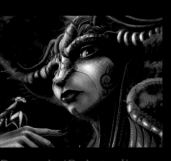 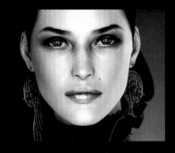 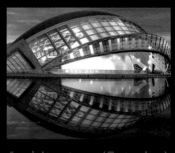 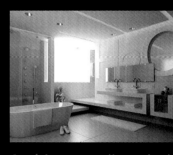

Portrait (Painted)

This category was created to recognize the greatest talent in bringing a character to life, independent of style, or nature of the character. The defining criterion was the ability that the artist demonstrated in breathing life into the subject. This encompassed technical skill, believability, composition, and importantly, emotion.

Portrait (Rendered)

This category recognized the greatest talent in bringing a 3D character to life. The defining criterion for the category was the ability that the artist demonstrated in bringing the subject to life, particularly with texturing and lighting. Successful entries encompassed technical skill, believability, composition, and, most of all, emotion.

Architecture (Exterior)

This category awarded the best exterior architectural visualization, independent of style, or setting. The category tested the artist's ability to create a commercial or residential space that was not just believable (lighting, scale and perspective), but inspirational and evoked a desire to visit the location/building/space.

Architecture (Interior)

This category awarded the best interior architectural visualization of a commercial, or residential space, independent of style, or setting. The judging criterion for the category was the artist's ability to create an interior setting that was not just functional, but also believable (lighting, scale and perspective).

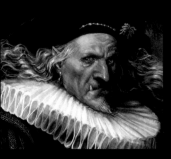 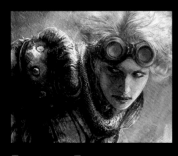 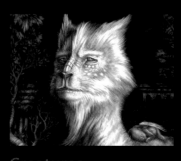 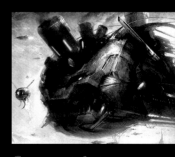

Fantasy

The Fantasy category honored the highest achievement in the mythic fantasy style from traditional fantasy creatures to heroic characters and dragons. Here, the artist's talent in evoking an emotional response or attachment with the image was paramount. The artist's ability to place their characters in an unfolding story was also crucial.

Fantasy Femmes

The Fantasy Femmes category recognized the most outstanding examples of character creation in the fantasy style from elves and nymphs to heroic femmes. Here, the artist's ability to breathe life into fantastic characters was paramount. Technical skill, composition, and emotional resonance all played a major role in successful entries.

Creatures

This category recognized the greatest talent in bringing a creature (real or mythical) to life. This was independent of style or of the organic nature of the creature. The defining criterion was the artist's ability to create a living creature. This encompassed technical skill, believability, and composition.

Concept Art

This category recognized the highest achievement in bringing a concept into being, whether for a movie, TV, or game environment. The defining criterion for this category was to convey a sense of place or personality. Technical skill, composition, color palette, and mood all contributed to an entry's success.

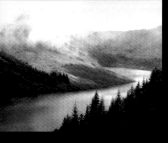

Matte Painting

This category honored the artist's ability to create a compelling stage upon which an epic story could be told. The judging criterion was to create a landscape or space where depth, scale, and atmosphere were all well-executed. Technical skill, composition, and mood were also crucial elements.

Environment

This category honored the best landscape or location (indoors, outdoors, underwater, or in space). The artist's ability to evoke a sense of wonder and a wish to see more was paramount. The category demanded a combination of artistic interpretation, detail, and lighting to create a believable and evocative environment.

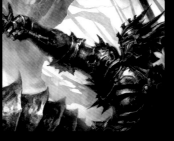

Warriors

The Warriors category recognized the most outstanding examples of character creation in the heroic style from armour-clad knights to vikings, demons, elves, and vixens. The judging criterion for the category was the artist's ability create heroic characters. Technical skill, composition, and menace were all crucial to success.

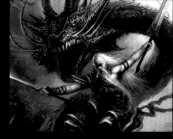

Conflict

The Conflict category recognized the greatest talent in creating a scene of conflict. The defining criterion for the category was the artist's ability to capture a moment of danger just passed or about to happen. Successful entries encompassed technical skill, composition, mood, and narrative.

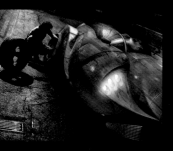

Science Fiction

This category awarded the greatest talent in creating a believable environment or character with hints of its origins in the not-too-distant past. The defining criterion was the artist's ability to create an environment or character which though familiar, appeared otherworldly, and technologically advanced.

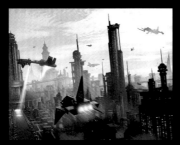

Futurescapes

This category recognized the greatest talent in realizing a cityscape or civilization. The defining criterion was the artist's ability to create a city which enticed the viewer. It demanded a combination of artistic interpretation, detail, and lighting. Technical skill, believability, composition, and mood were also crucial factors.

Product Design & Still Life

This category awarded the best examples of still life and product designs that demonstrated excellence in technical design and execution. The judging criterion for this category was a combination of the intricacy of the design and the technical excellence of the modeling, texturing, and lighting.

Abstract & Design

This category recognized the most outstanding image that was abstract or predominantly abstract (fractal-generated, 3D or 2D). Here, the artist's design and artistic expression were paramount in creating a piece of artwork that defied categorization and excelled in its pure design and visual appeal.

Storytelling

This new category recognized the best examples of visual narrative regardless of genre. The judging criterion was the artist's ability to entice the viewer into an unfolding story. Successful entries encompassed technical skill, mood, composition, and, most of all, a strong narrative.

Humorous

This category recognized the most amusing image, whether 2D or 3D, cartoon, humorous, satirical, or just plain ridiculous. The judging criterion was all about making the viewer smile or even laugh out loud. In addition to humor, it was also crucial that the artist demonstrated technical mastery of character or creature design.

Whimsical

This category awarded the best examples of artwork with a lighthearted feel or in a style that conveys childlike themes. The criterion for the category was very similar to Humorous with technical mastery of character or creature design a must. Most Whimsical entries would be ideally suited as illustrations for children's books.

Transport

This category recognized the best vehicle for moving about in. Whether exotic vehicle, vintage aircraft, or futuristic ocean-going vessel, this category sought out the best examples of transportation. The defining quality was the artist's ability to capture and evoke the desire to travel to a place, or by a mode of transport.

Each year we appoint an advisory board to assist in nominating and judging images for the EXPOSÉ awards. All of these people are either leading artists in their own right or are experienced and respected editors and reviewers of digital content and artists.

Stephan Martiniere is an internationally-renowned science fiction and fantasy artist and EXPOSÉ 4 Grand Master. An accomplished concept artist, he has worked on movies such as 'I Robot', 'Star Wars' (Episode II & III), 'Virus', and 'Red Planet'. He is currently Creative Visual Director for Midway Games.

Ryan Church worked as a concept artist at ILM on 'Star Wars' (Episode II & III). The EXPOSÉ 2 Grand Master's clients include ILM, Lucas Animation, Paramount Studios, Mattel, Bay Films, Lightstorm Entertainment, and Electronic Arts. Ryan is currently working on James Cameron's Avatar (2009).

Lorne Lanning is Co-Founder, President, and Creative Director of Oddworld Inhabitants. He serves on the advisory boards of organizations such as Academy of Interactive Arts and Sciences and the CGSociety. Lorne is now in active development on two major projects—his first CG feature film and a CG television series.

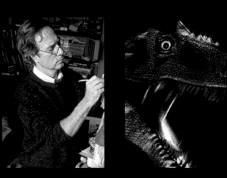

Phil Straub is an Art Director and Concept Artist for a wide range of clients including, Electronics Arts, NCSoft, Mattel, Vivendi Universal, and Disney. In addition to overseeing three major Concept/Visual development groups in the games industry, he is also co-author of d'artiste: Digital Painting.

Jeff Mottle is the President and Founder of CGarchitect.com, and is the Creative Director—North America for Smoothe, an award-winning design firm based in London, Manchester, and Calgary. Jeff has also worked for SMED International, one of the world's largest construction industry leaders.

Christopher Sloan is the Art Director for the National Geographic Magazine. Sloan is also the magazine's specialist in paleontology and paleoanthropology, writing articles for National Geographic including 'Feathers for T. rex' as well as several award-winning children's books.

 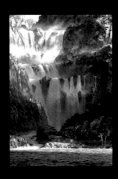

Max Dennison is the founder of Matte Painting UK Ltd. His work includes: 'The Da Vinci Code', 'Harry Potter and the Goblet of Fire', 'XMen III', 'Superman Returns', 'The Lord of the Rings' trilogy, 'Star Wars: Episode III', 'Black Adder Back and Forth', 'Lost (Series 3)', and 'Hitchhikers Guide to the Galaxy'.

Brom is a painter of anything that is nasty and bites. For 20 years his work has featured in books, games, and film. His paintings are collected in two art books 'Darkwerks' and 'Offerings'. Recently, he turned his hand to writing a series of illustrated novels. His first novel 'The Plucker' received a Chesley Award.

David Wright is Creative Director of NVIDIA. David started as a 3D artist with the Commodore Amiga and primitive ray tracing software. He co-founded Artmaze, still a leading provider of integrated 3D animated visuals and multimedia services for real estate developers.

Mark Snoswell | President of the CGSociety & Creative Director, Ballistic Media

SOCIETY OF DIGITAL ARTISTS

CGSociety.org

Congratulations to all of the artists that submitted work for EXPOSÉ 6. You are all winners and it's our continuing privilege to be able to showcase the amazing work you submit. The demand for and supply of quality digital art has steadily risen over the past year. As our community expands, we continue to see a relentless rise in work submitted from members all over the world. In these times of rising global environmental issues and a weakening western economy, the wellspring of creative output takes on more than just economic significance. It's an indication of an irrepressible creativity in human nature. The growth of work coming from Asian and eastern European regions is particularly notable. There is a vibrancy to the explosion of development in these regions. This energy shines through in the work we are seeing from artists. We are also seeing a continual pushing of the boundaries of artistic expression with interesting new software and images st les arising.

We have seen so ie significant developments in the CGSociety this past year. The CGPortfolios continue to be outstandingly popular. There are over 30,000 portfolios on line now and we have just celebrated the 100,000th image ·pload to the CGPortfolios. Both the Portfolios and book submissions get a boost each year from the CGSociety's regular CGChallenges. These are the world's largest competitions for digital artists with regular prize pools that now exceeded $100,000 for each competition. In the past year Challenges have been themed on 'Strange Behaviour' and 'Eon: Worlds within Worlds'. As I write this the next challenge 'Uplift Universe: Alien Relations' is about to launch. The CGChallenges run twice a year and are one of the other ways (besides books) that the CGSociety gives artists the opportunity to showcase their work to the world.

As we enter our 7th year, the prospects for digital art are better than ever. I feel privileged to be able to help artists at every level—from speaking in schools to press conferences in art museums. The important thing is the art and the artists themselves. More and more, digital art is being accepted as more than just a passing fad. It's being accepted as the expression of today's culture. It's relevant, it's emotive, it's critical, it's fun and it expresses a growing global consciousness. If you haven't ever visited our web site please do. It doesn't matter if you're not an artist yourself. Take a look at all of the great work that is being done around the world—all of the work that we can't possibly fit into books. If you are an artist or an aspiring artist then please join the community and show the world your work, or just join in for the sheer fun and for the learning opportunities. Whatever you do—participate, express yourself, enjoy life more and make a difference.

Ballistic Media divisions

Ballistic Publishing
www.BallisticPublishing.com

View All Entries
www.BallisticPublishing.com/bsw/

The CGSociety (The Society of Digital Artists)
www.CGSociety.org

Artist Portfolios
http://portfolio.CGSociety.org

CGSociety Events
http://events.cgsociety.org

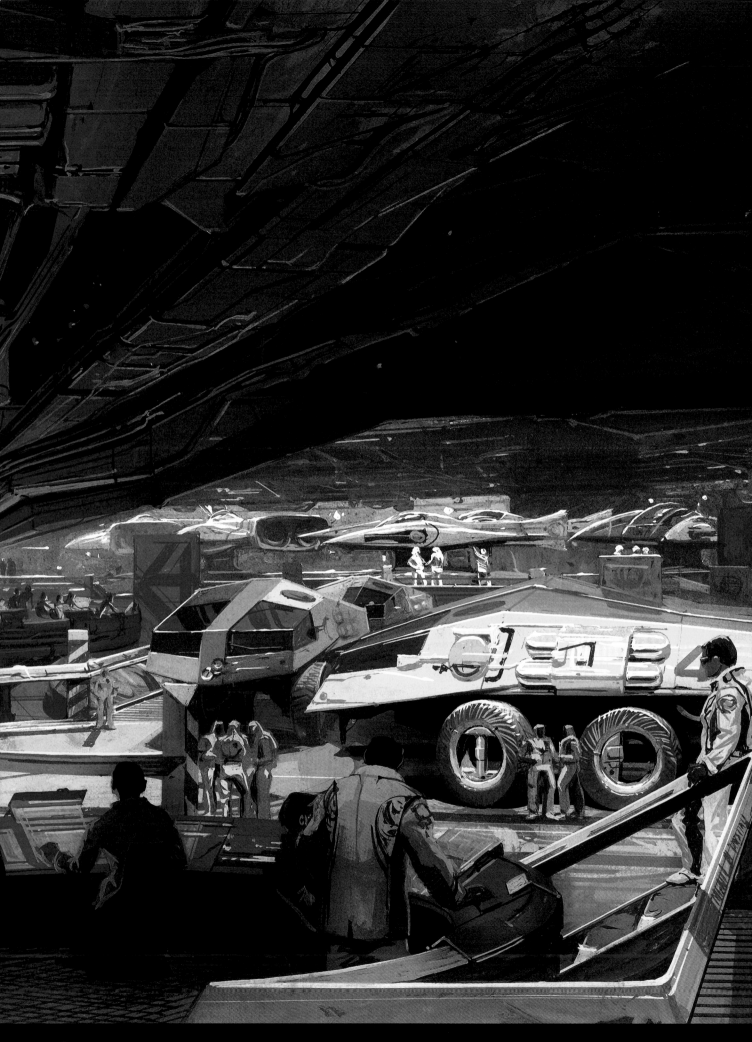

Grand Master
Syd Mead

Control: The control area for a lunar installation. We see the moon holographic image floating above operation consoles, EVA vehicles at right available for terrain exploration. In the background are defense fighters in their hanger space

The EXPOSE 6 Grand Master Award winner is Syd Mead. Syd's extensive career reads like an artist's wildest dream being launched into prominence in the early 60s for his futuristic vehicle designs for U.S. Steel. In the late 1970s and early 1980s Syd worked at the forefront of science-fiction film with concept work on 'Star Trek: The Motion Picture', 'Tron', 'Aliens', '2010', and his best known work on Ridley Scott's 'Bladerunner'. Syd was asked what title he'd like for the film's end credits and came up with 'Visual futurist'. Though it was an off-the-cuff suggestion, the title perfectly describes the work for which Syd Mead has become synonymous.

Syd Mead's earliest creative memory wasn't set in the future, but a little closer to his surroundings in South Dakota: "It was a stencil illustration of a guy skiing down a slope when I was in the second grade. I used brown paper, cut out the stencil, and then sprayed it with a white paint supplied by the 'arts' class teacher."

With a Baptist Minister father, the Mead family was often on the move through Syd's childhood before they settled in Colorado. Syd's first job out of high school was for Alexander Film Co. as an animation cell-inker, character originator, and background illustrator. Shortly after, he joined the U.S. Army Corps of Engineers serving two years in Okinawa Japan: "Okinawan culture is a mix of Japanese and Chinese. I became fascinated by the decorative geometry and the stylized depiction of scenario. Then, before I checked out of the Army I spent a month in Hong Kong with a buddy on 'R and R' and got more exposure to the oriental culture."

On his return to civilian life Syd presented his portfolio at Art Center in Los Angeles and was accepted for the fall semester. In the interim, he was asked to work at a new studio in Albuquerque by the former head of studio at Alexander Film Co. He instead took a position designing window displays at the Lerner Shoppe (a chain of women's wear stores). The three state manager wanted Syd to take over as the three state head of display design, but Art Center beckoned.

After graduating from Art Center with 'Great Distinction' Mead joined Ford Motor Company's Advanced Styling Center at Dearborn Michigan where he worked for just over two years. His next position was the chance of a lifetime with Hansen Co. in Chicago where Syd was commissioned to illustrate future vehicle scenarios for a variety of corporate clients. "The highlight of this time was the complete creative freedom I enjoyed doing the series of advertising books for U.S. Steel, Celanese Corporation, Allis Chalmers. The U.S. Steel books went worldwide and definitely launched my career."

At the beginning of the 1970s, Syd started his own company, Syd Mead Inc. which started a twelve-year account with Philips C.I.D.C., and also worked with Raymond Loewy in Paris and New York in addition to other contract work. Syd's first standalone book was published in partnership with Roger and Martyn Dean in 1976 titled 'Sentinel'.

In 1975 Syd headed to California while continuing his work for the automotive industry and other clients. The next chapter of his career in film began in 1979. 'Star Trek: The Motion Picture' was Syd's first movie project: "I worked with John Dykstra at Apogee in post production designing the V'ger entity—the climax of the film. I had to accommodate an existing hexagonal construct which Paramount had bought from a professor of mathematics at Boston University. The device created a hexagonal orifice when the periphery of the mechanism was rotated."

Syd's next movie with director Ridley Scott made Syd a household name for sci-fi buffs around the world: "'Bladerunner' happened through a series of links to other people in Hollywood, and the book that Roger Dean printed using U.S. Steel illustrations," he explains. Though it was Syd's second movie, it was the first he worked on from the beginning of production. In 'Bladerunner', Syd's time in Japan and Hong Kong helped him to envision the memorable future cities complete with backgrounds, interiors, and the now famous 'Spinner' flying police vehicle. "While I was doing post production matte painting preliminaries for 'Bladerunner', I started work on 'TRON' for Steven Lisberger at Disney," explains Mead. His work on 'TRON' included the design of the Sark's carrier: tanks, light cycle; the CPU; Sark's camp; various scenic sets and graphics; the title graphic; and alphanumeric 'TRON' typeface. After 'Bladerunner' was nearing completion, Mead was asked by his agent what he'd like to be called in the end credits to which he replied: "Visual futurist." Mead's body of work revolves around visions of the future, however, he goes beyond simply painting outlandish futuristic scenes: "I read lay magazines and try to keep up with the technological 'wave front' so that when I concoct some fantasy device or scenario, it has some basis in rational concept."

In 1985 Mead formed OBLAGON, an acronym for a story he had started to write years before—Orbital Biolab@ LaGrange Operational Node. OBLAGON has published several books of Mead's work including 'Oblagon', 'Kronolog,' and 'Sentury' with help from his business manager and partner Roger Servick. "The books were our sales force and catalogue, and kept our presence worldwide while normal design account work was in progress."

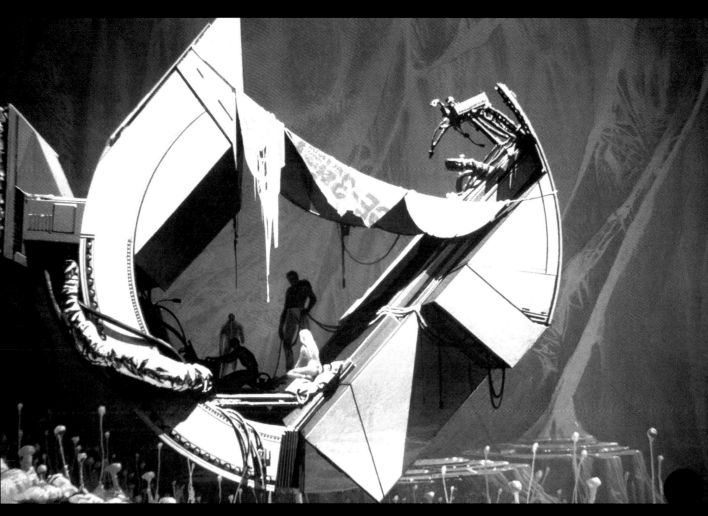

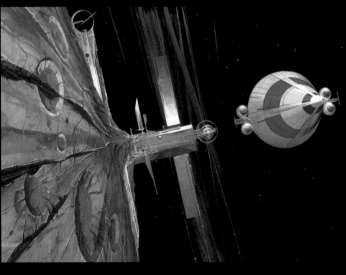

Over several decades Mead has developed a great understanding of the creative business: "First, have a grasp of context, detail, and the rationale which makes design and image-making worthwhile to yourself and commercially, to someone else. Try not to become a 'linear' professional. Learn a variety of techniques, of thinking methodology and most of all, don't become complacent. Honestly, I get scared shitless every time I start a new, big job. I read, I gather information and push the client to tell me what they want. (Sometimes they really don't know, and those jobs are usually nightmares!) Remember details, notice how people move, how

sunlight cascades over moving objects, why foliage looks the way it does (it's nature's own fractal magic) and how come velvet has about the same range of value as metallic surfaces but one is soft and the other is brittle. Finally, don't assume that technique alone will save your ass. It still is the idea that wins— every time. Remember that elaborate technique and dumb story produces a demo reel, not a narrative."

Syd Mead continues to present his work and thoughts to audiences worldwide. He is a truly talented and thoughtful artist and thoroughly deserving of the title 'Grand Master'.

A-GEE COIL
A gouache preliminary for a project that never went full size.
[top]

Asteroid Facility
A large cargo shuttle leaving a planetoid mining and processing facility.
[above left]

Eyes on the classics
Syd's first attempt to utilize a computer to create an illustration, back in the 1991 using a Macintosh IIfx.
[above]

Running of the Six DRGXX
Commissioned by the promoters of the first (and last) 'Tokyo International Sports Fair'. It depicts six huge robot 'dogs' coming around the turn on a racetrack scaled up for their 120 foot height.
[top right]

Hypervan (detail)
The first painting of Syd's Hypervan showing the vehicle parked on a brilliant red granite plaza with sculpture, foliage, and masonry accents.
[right]

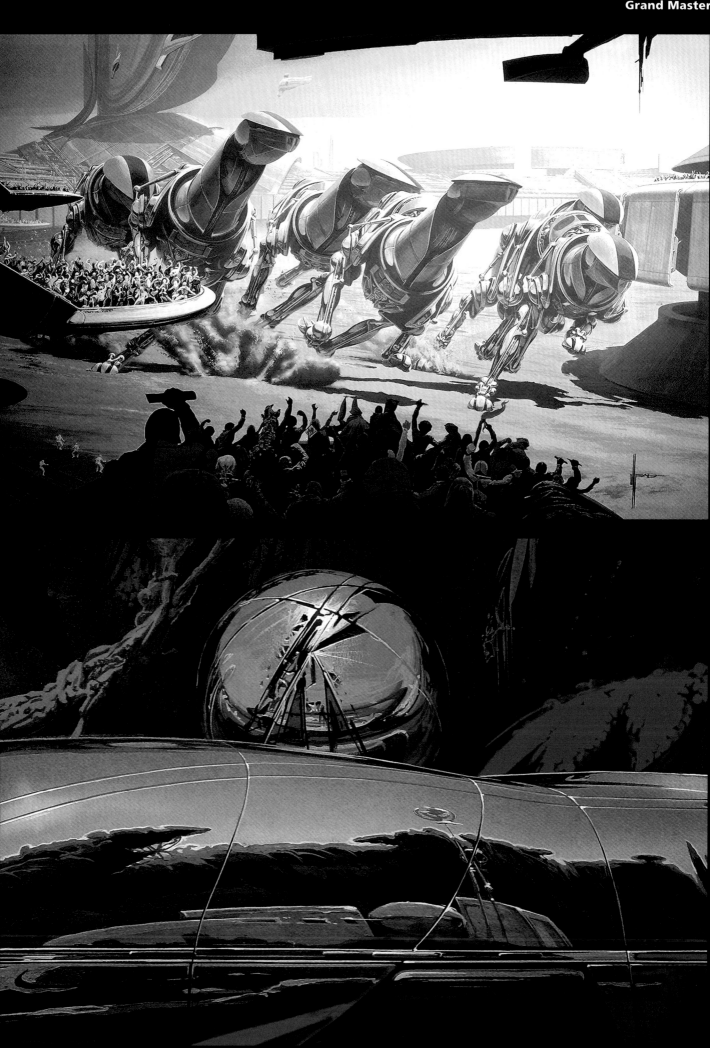

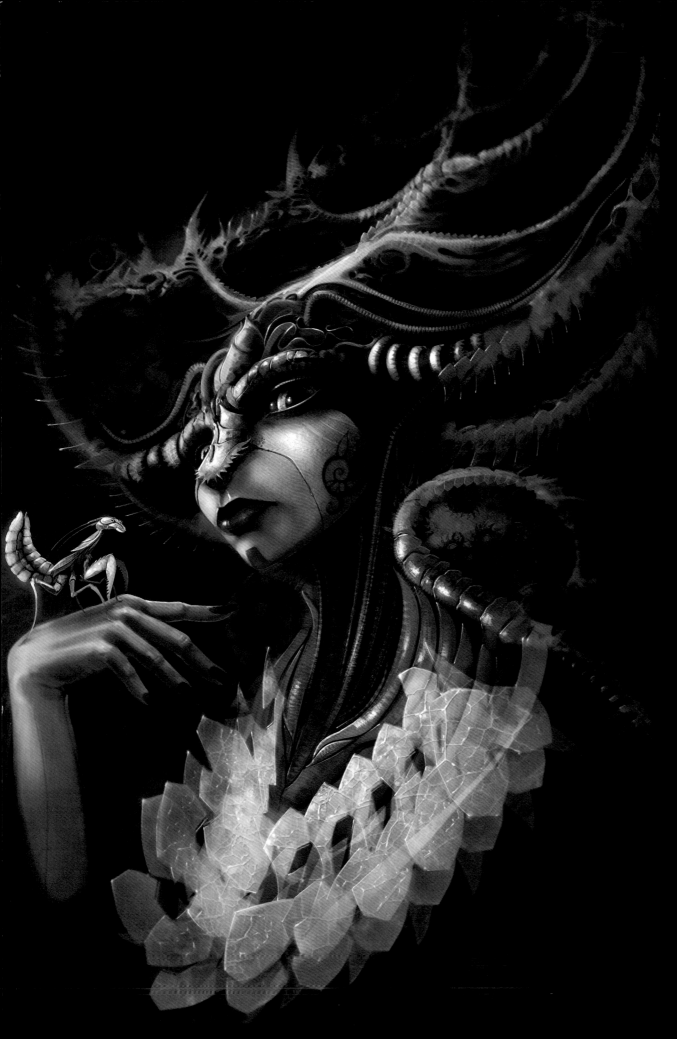

Master
Portrait (Painted)

Mantis Queen
Photoshop
Nicholas Miles, Blitz Games,
GREAT BRITAIN

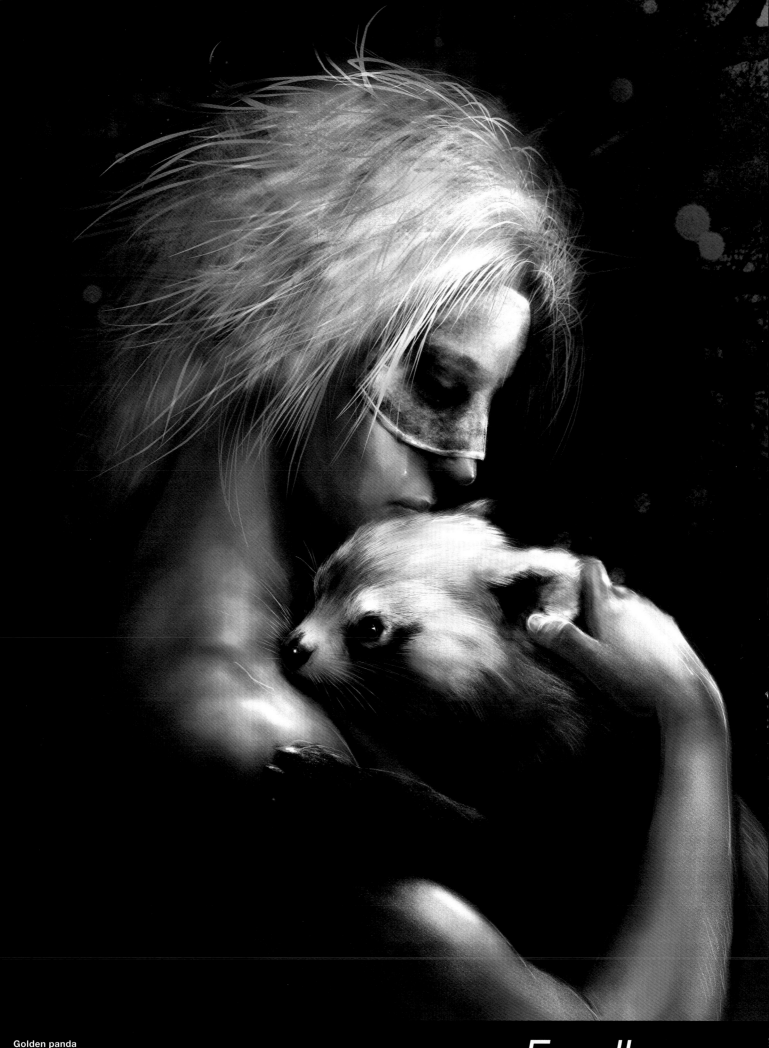

Golden panda
Painter, Photoshop
Kirsi Salonen, FINLAND

Excellence
Portrait (Painted)

Portrait (Painted)

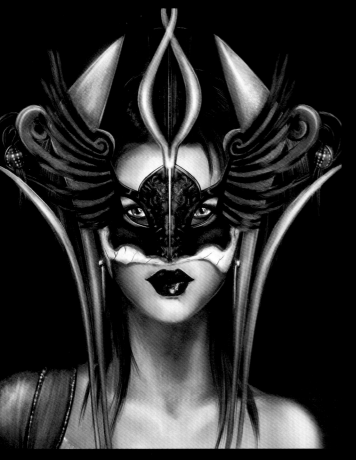

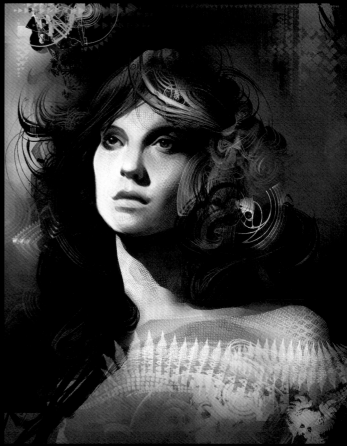

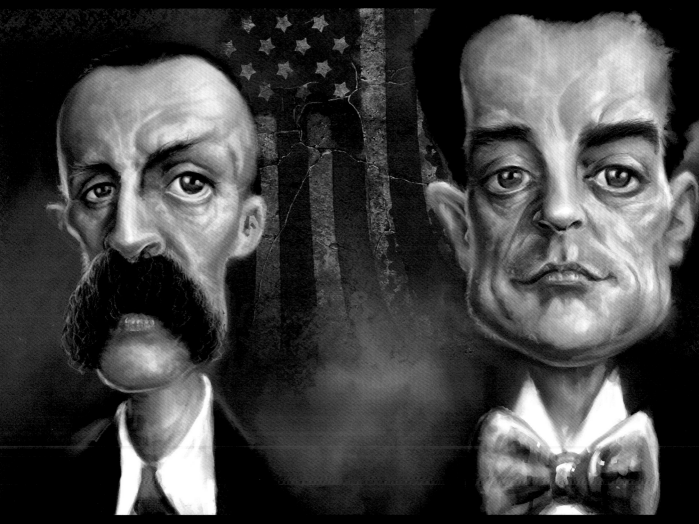

Minded
Photoshop
Samantha Combaluzier, CANADA

Ze Nicola & Ze Bartolomeo
Painter, Photoshop
Eric Scala, FRANCE

Lady Jessica Atreides
Painter, Photoshop
Andrew 'Android' Jones, USA

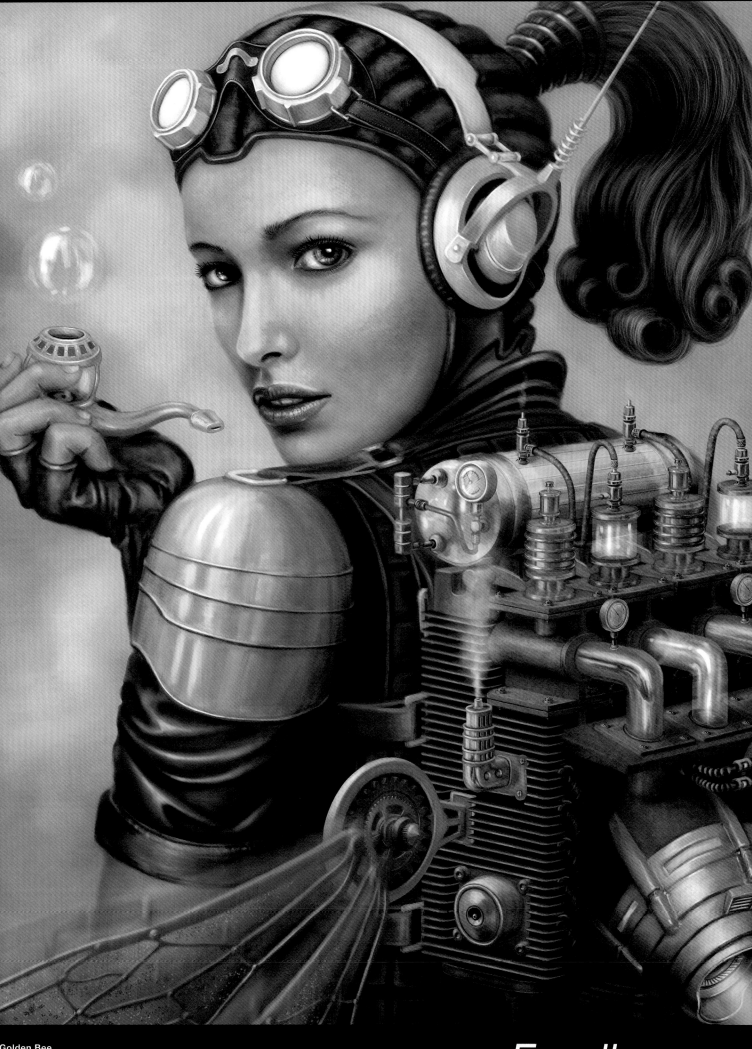

Excellence
Portrait (Painted)

Showtime
Photoshop
Client: Advanced Photoshop Magazine
Suzanne van Pelt, NETHERLANDS

Elenia
Painter, Photoshop
Katarina Sokolova,
UKRAINE

Beauty, Shanghai
Photoshop
Xiao Bing, Gameloft,
CHINA

A Lonely Heart
Photoshop
Client: Vector EA - Artes Electronicas
Alon Chou, TAIWAN

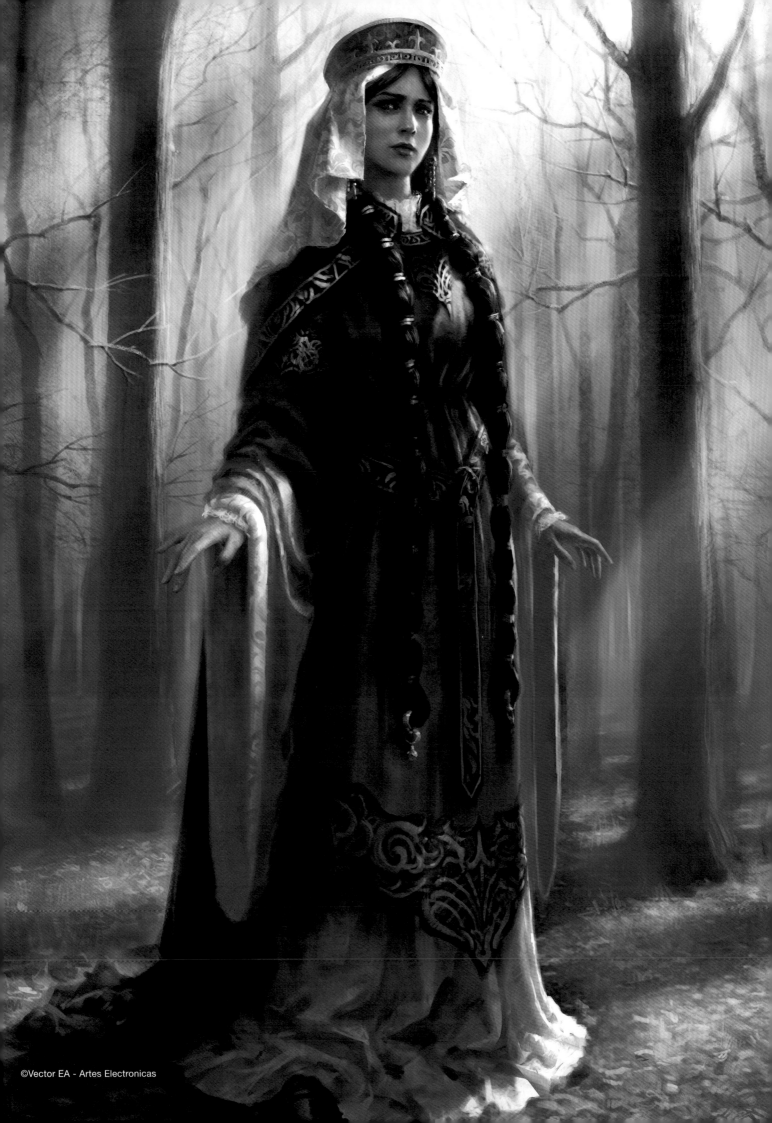

Portrait (Painted)

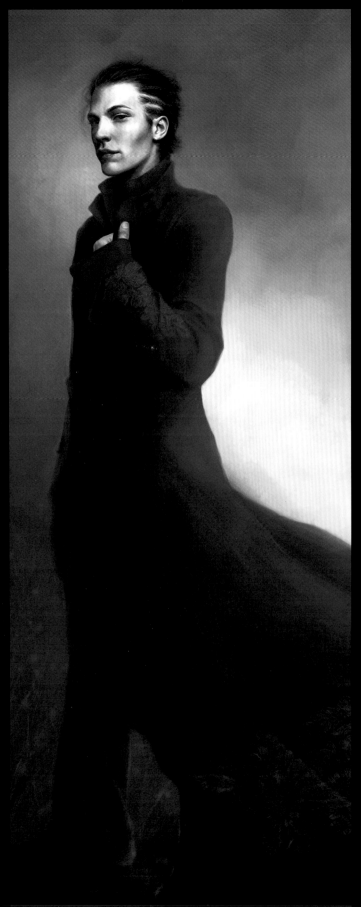

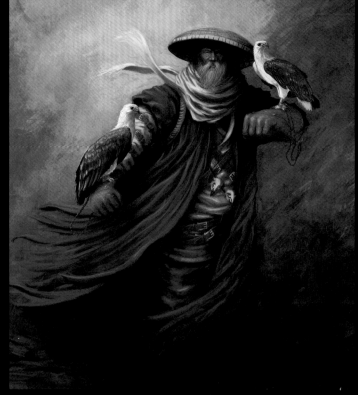

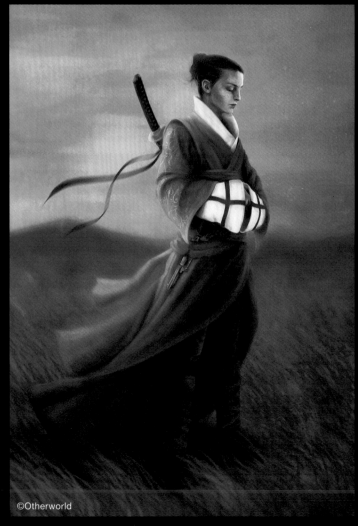

©Otherworld

Nuri
Photoshop
Model reference: JR Gallison
Inspired by: Andrew E. Maugham's 'Convivium'
Nykolai Aleksander, GREAT BRITAIN
[above]

Grandfather's Precious
Photoshop
Dennis Chan,
SWEDEN
[top]

Samurai Templar
Photoshop
Client: Jesse K. Hill
Nykolai Aleksander, GREAT BRITAIN
[above]

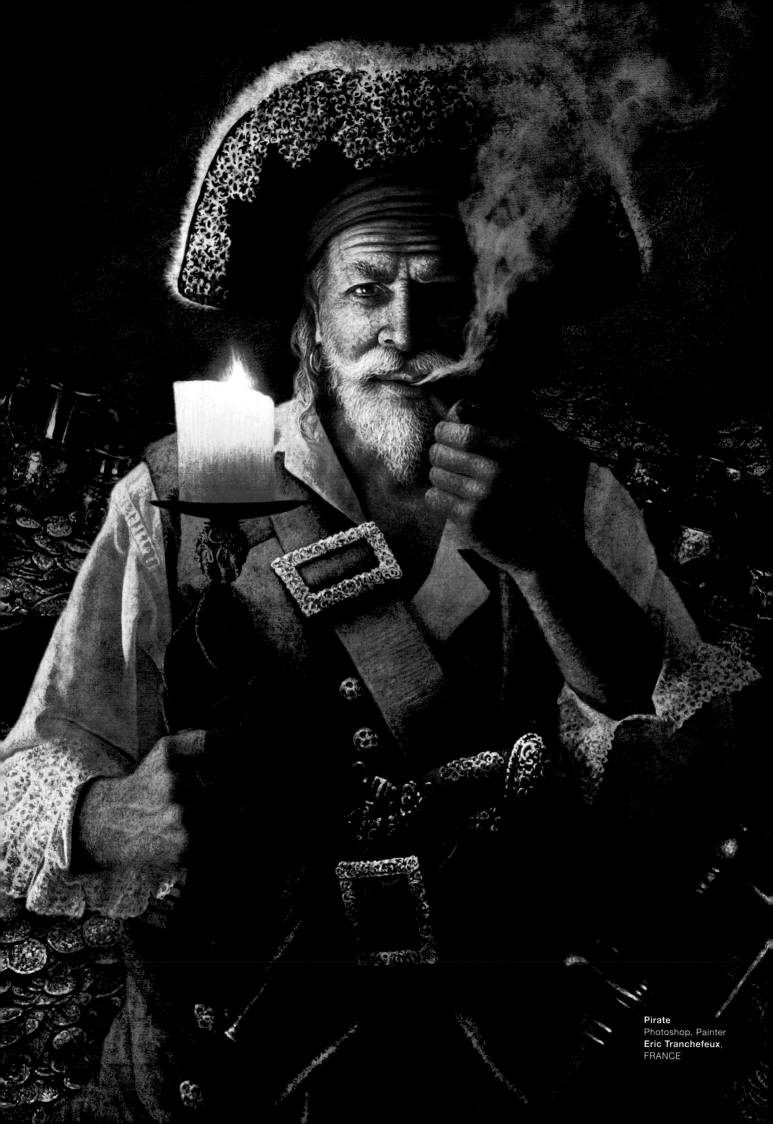

Pirate
Photoshop, Painter
Eric Tranchefeux,
FRANCE

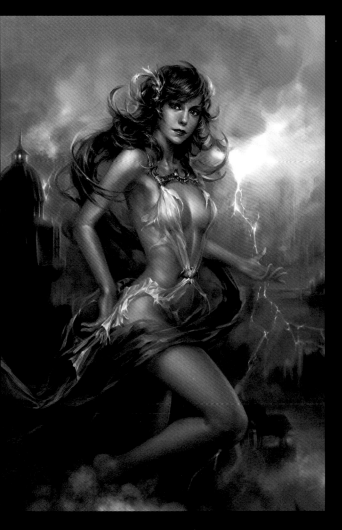

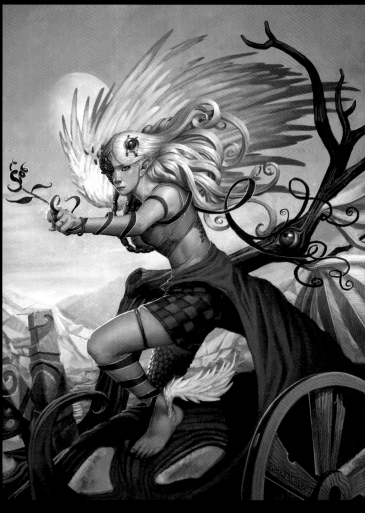

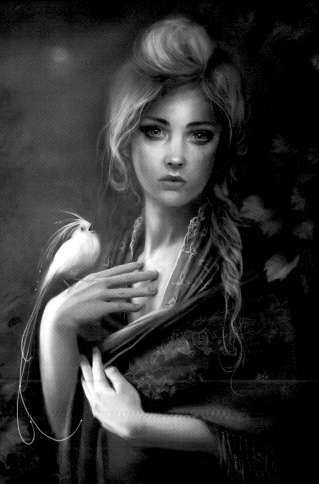

The Intrigue of Goddess
Painter, Photoshop
Na Sun, CHINA
[above left]

The Gift
Photoshop
Peter Mohrbacher, USA
[above]

Nightingale
Photoshop
Bente Schlick, GERMANY
[left]

Hanagumori
Photoshop
Diane Özdamar, FRANCE
[right]

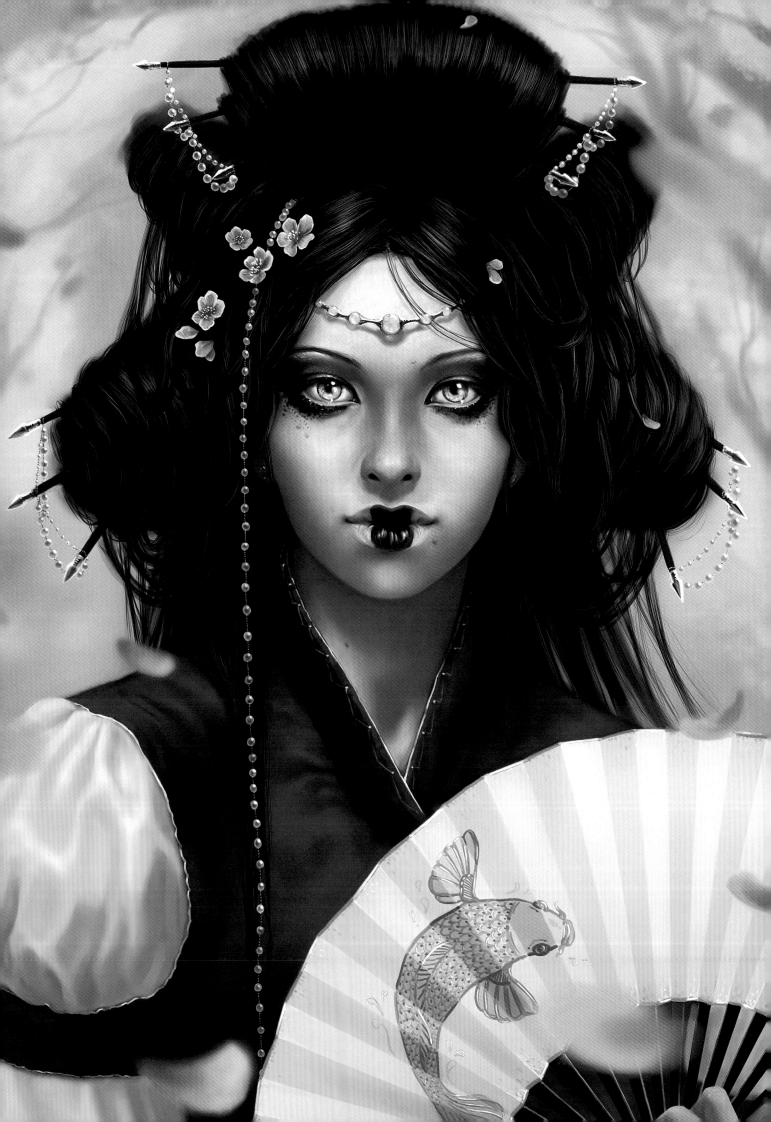

Portrait (Painted)

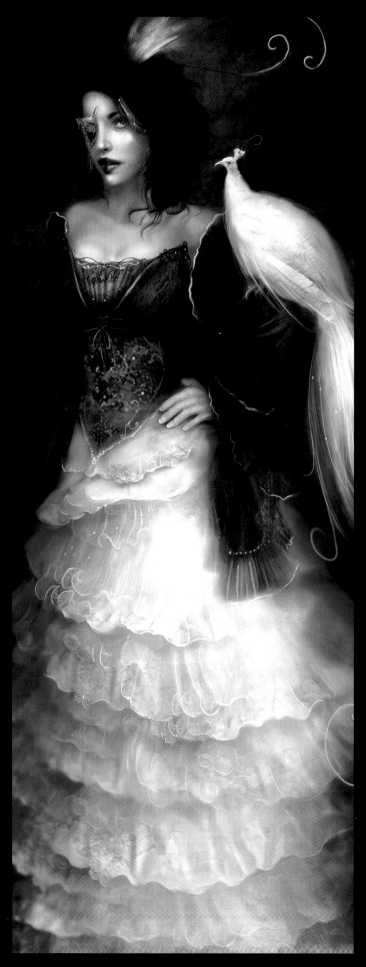

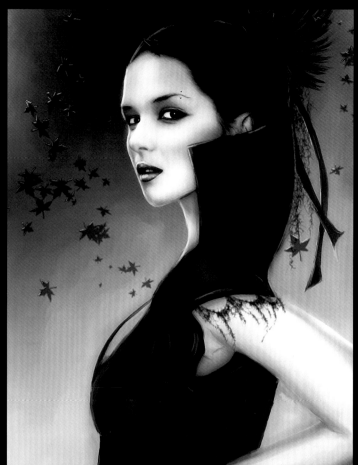

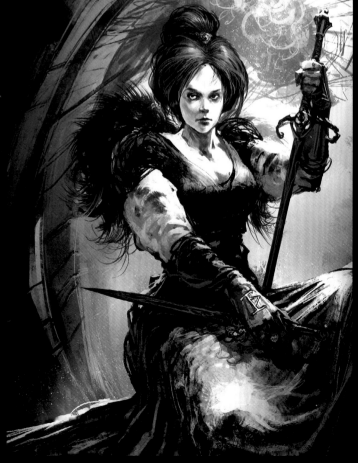

The Peacock
Photoshop
Bente Schlick,
GERMANY

Shades of Autumn
Painter, Photoshop
Anna Bird, FW Publishing,
GREAT BRITAIN

Yona
Photoshop
Tomasz Jedruszek,
POLAND

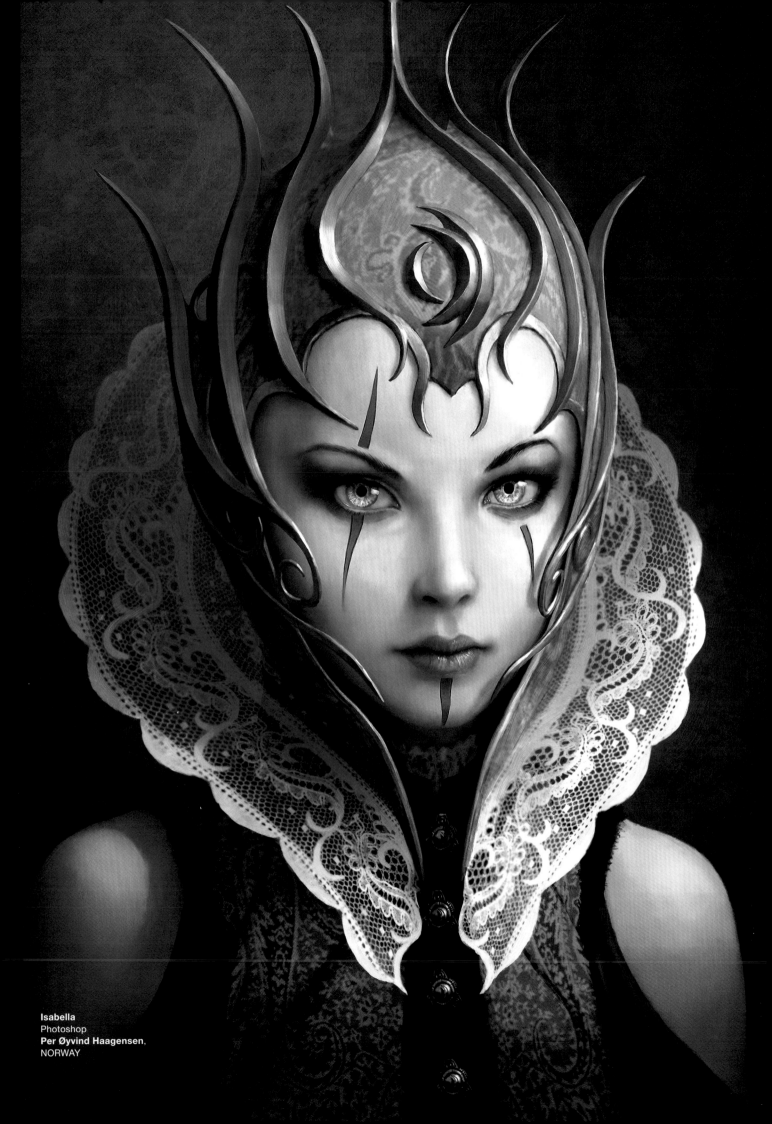

Isabella
Photoshop
Per Øyvind Haagensen,
NORWAY

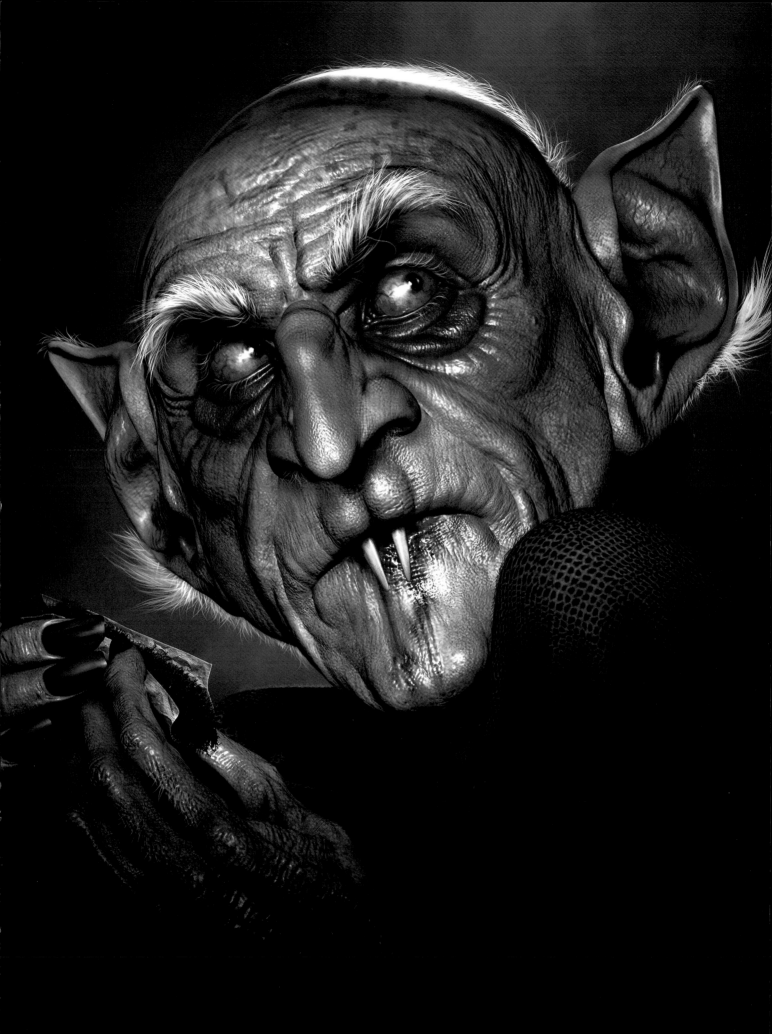

Master
Portrait (Rendered)

The Fix
3ds Max, ZBrush, Photoshop
Jef Wall, GREAT BRITAIN

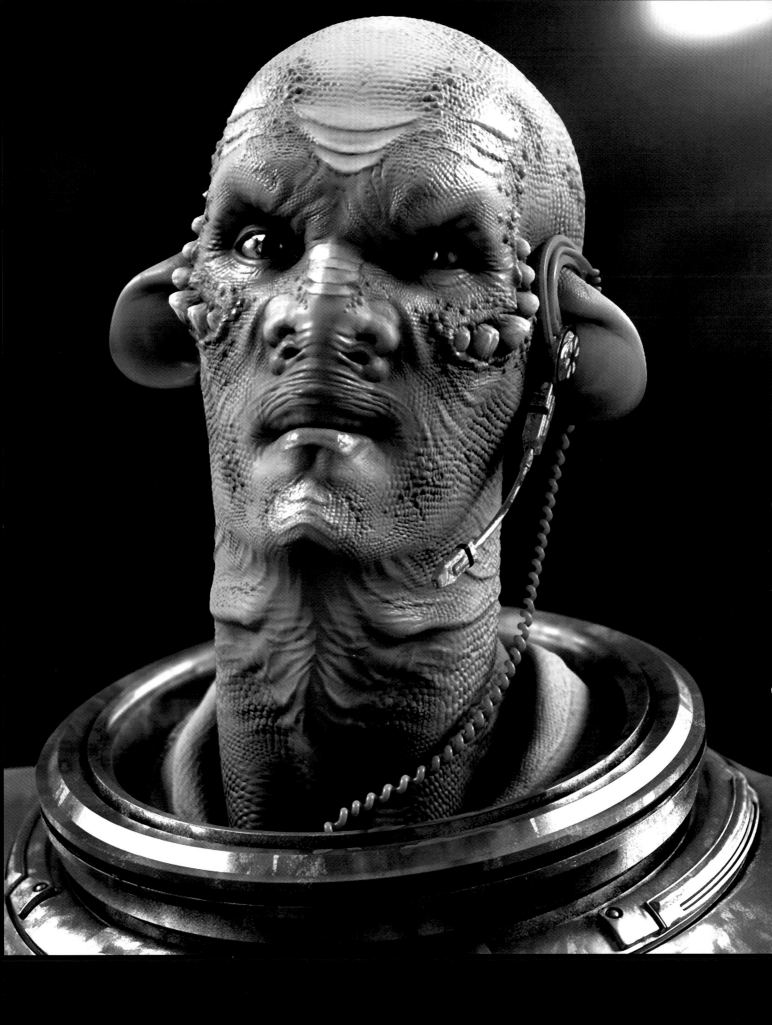

Creature Portrait
modo, Photoshop
Zoltán Korcsok, HUNGARY

Excellence

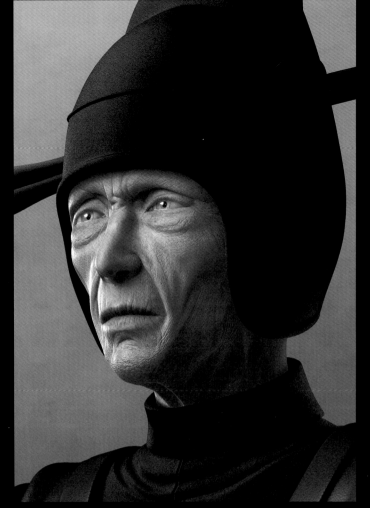

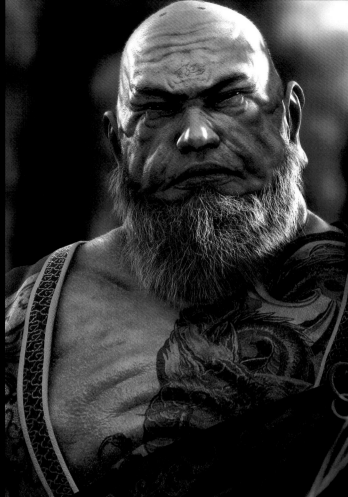

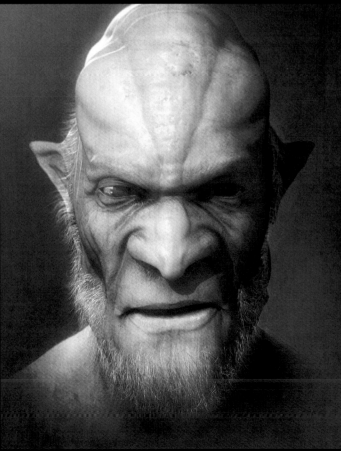

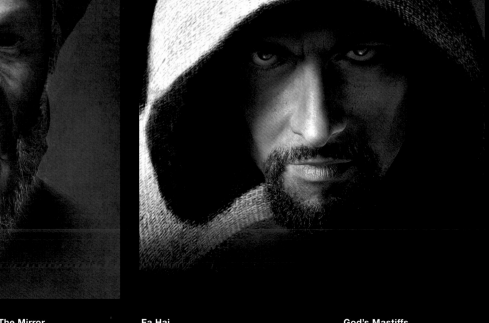

Shoju Rojin
Maya, ZBrush, Photoshop
James Xu,
USA
[top]

The Mirror
3ds Max, ZBrush, Photoshop
Sergio Santos,
SPAIN
[above]

Fa Hai
Maya, mental ray, Mudbox
Wang Xiaoyu,
CHINA
[top]

God's Mastiffs
Softimage|XSI, Poser, Photoshop
Client: Edizioni Piemme
Silvia Fusetti, ITALY
[above]

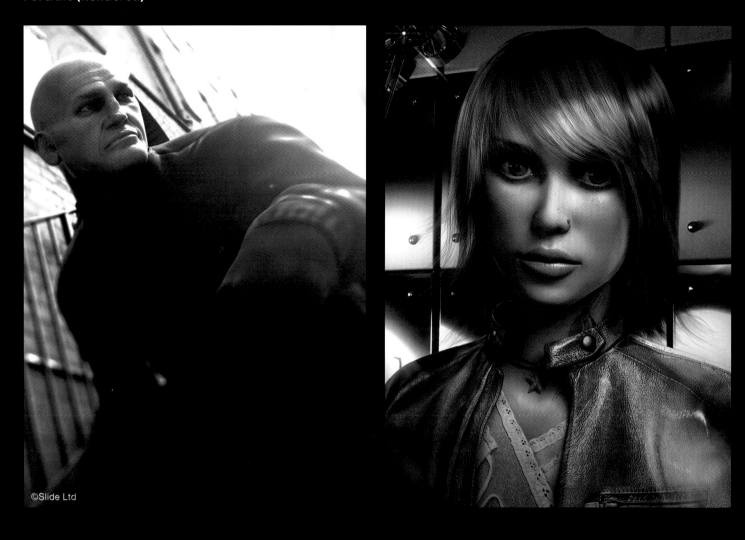

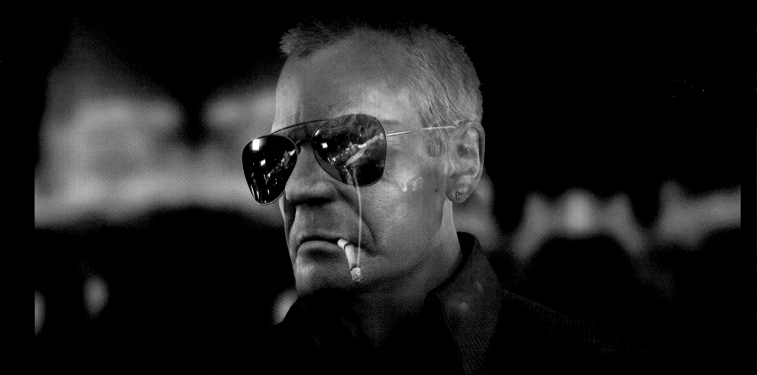

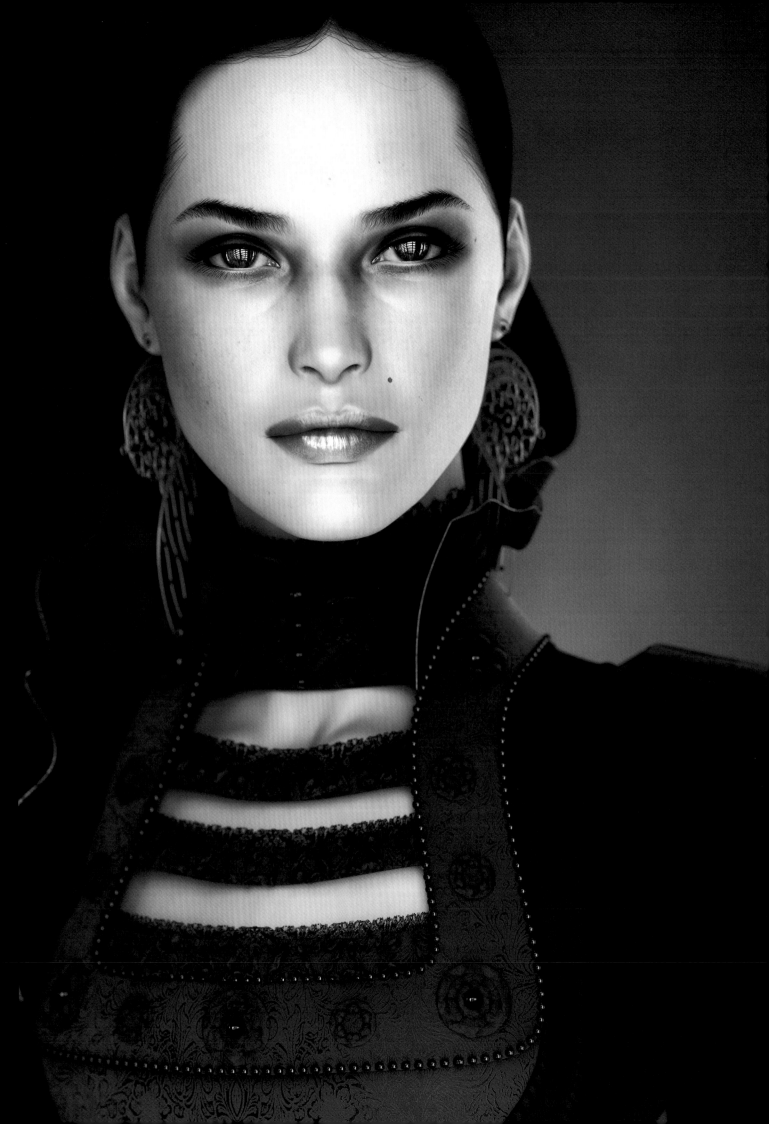

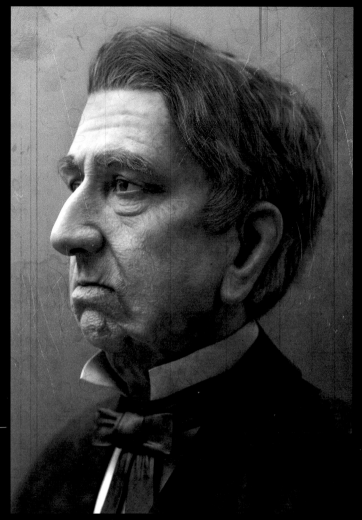

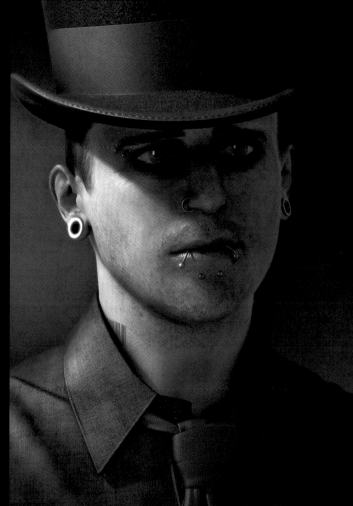

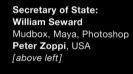

Secretary of State:
William Seward
Mudbox, Maya, Photoshop
Peter Zoppi, USA
[above left]

Cranium Accessories
Maya, Photoshop, ZBrush,
mental ray
Nathan Boyd, USA
[above]

Old Man
3ds Max, Photoshop,
Softimage|XSI, V-Ray, ZBrush
Cristian Patrasciuc, ROMANIA
[left]

Portrait of Louis Bertin
Softimage|XSI, ZBrush, Photoshop
Inspired by: Jean-Auguste-
Dominique Ingres
Shraga Weiss, USA
[right]

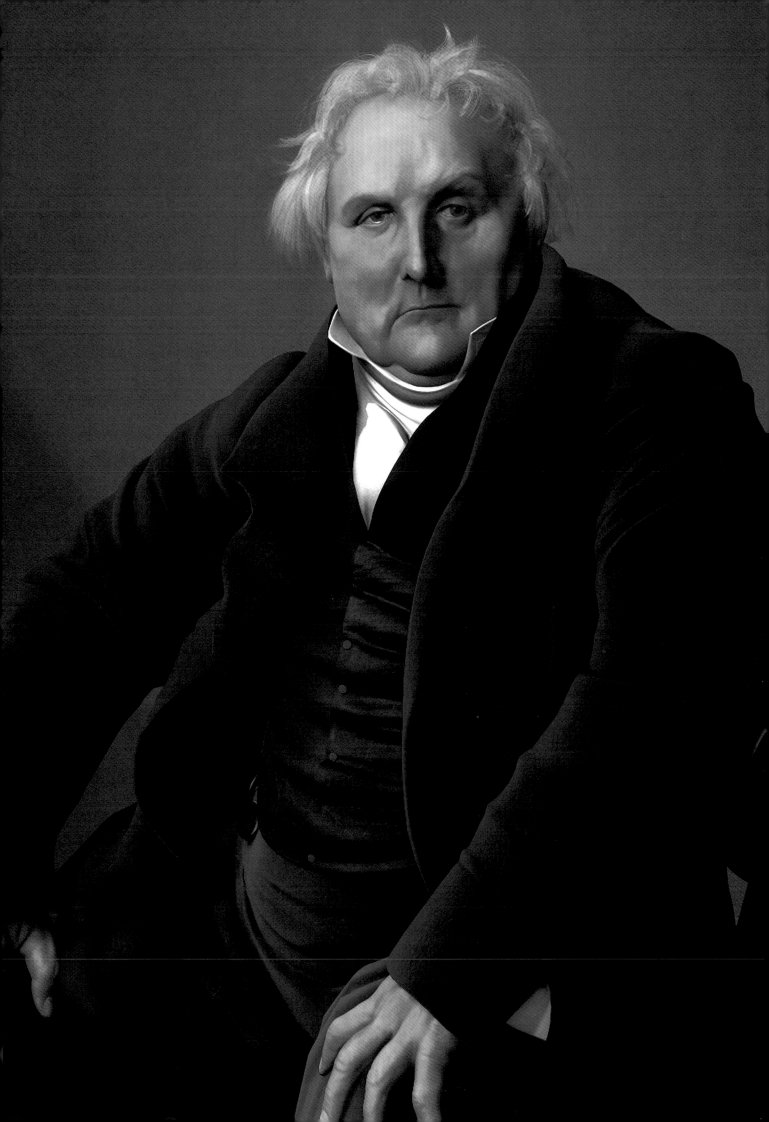

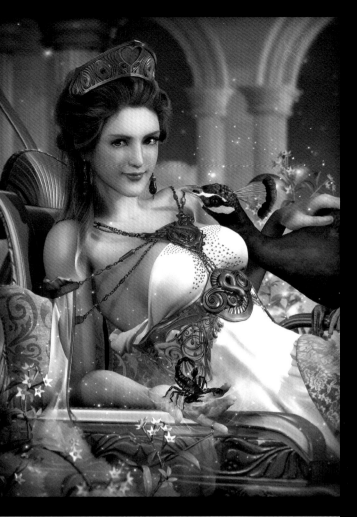

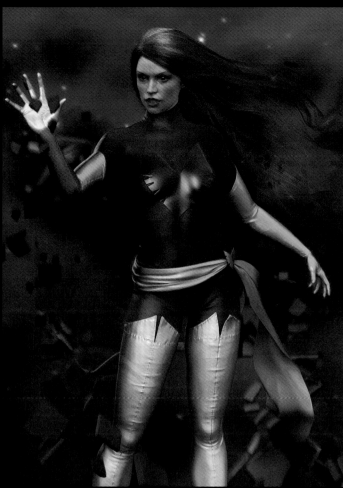

Hera
3ds Max, mental ray, ZBrush
Soa Lee, USA
[above left]

Dark Phoenix
3ds Max, Photoshop, V-Ray,
SoftimageIXSI
Rebeca Puebla, SPAIN
[above]

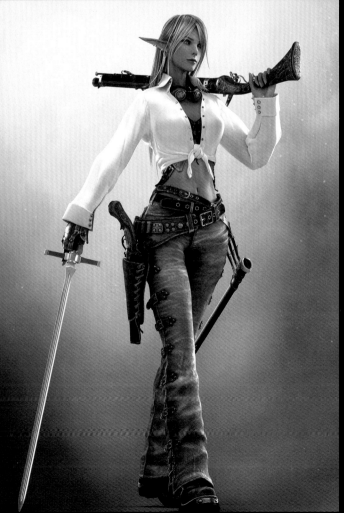

Gun and Sword
3ds Max, V-Ray, Photoshop
Choe Byung-hee, KOREA
[left]

Cherry-coloured funk
DAZ Studio, Photoshop,
POV-Ray
Matt 'Shimuzu' Smith,
GREAT BRITAIN
[right]

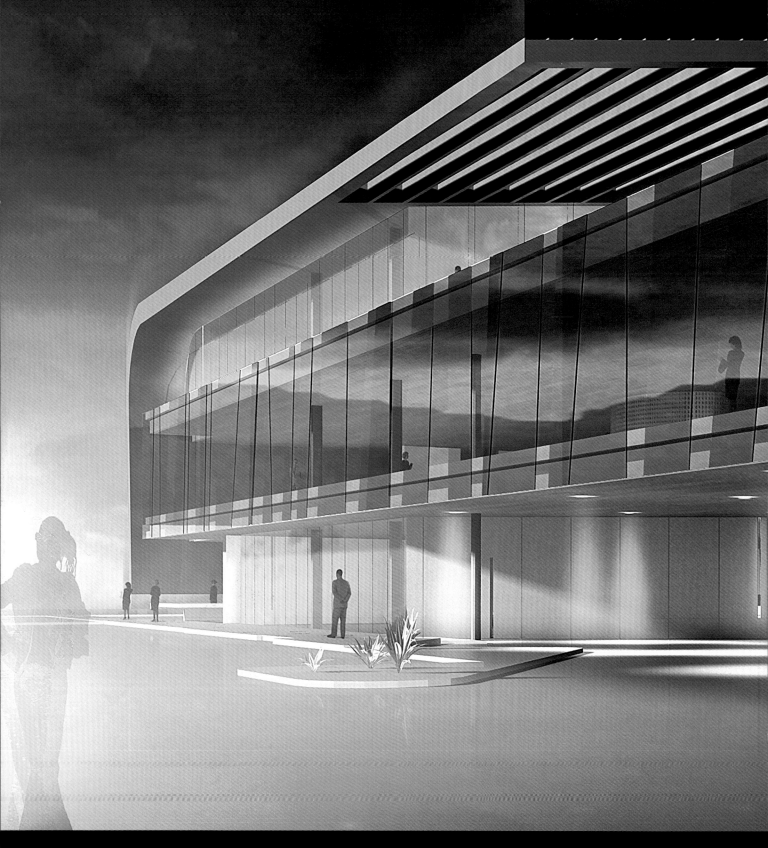

Master
Architecture (Exterior)

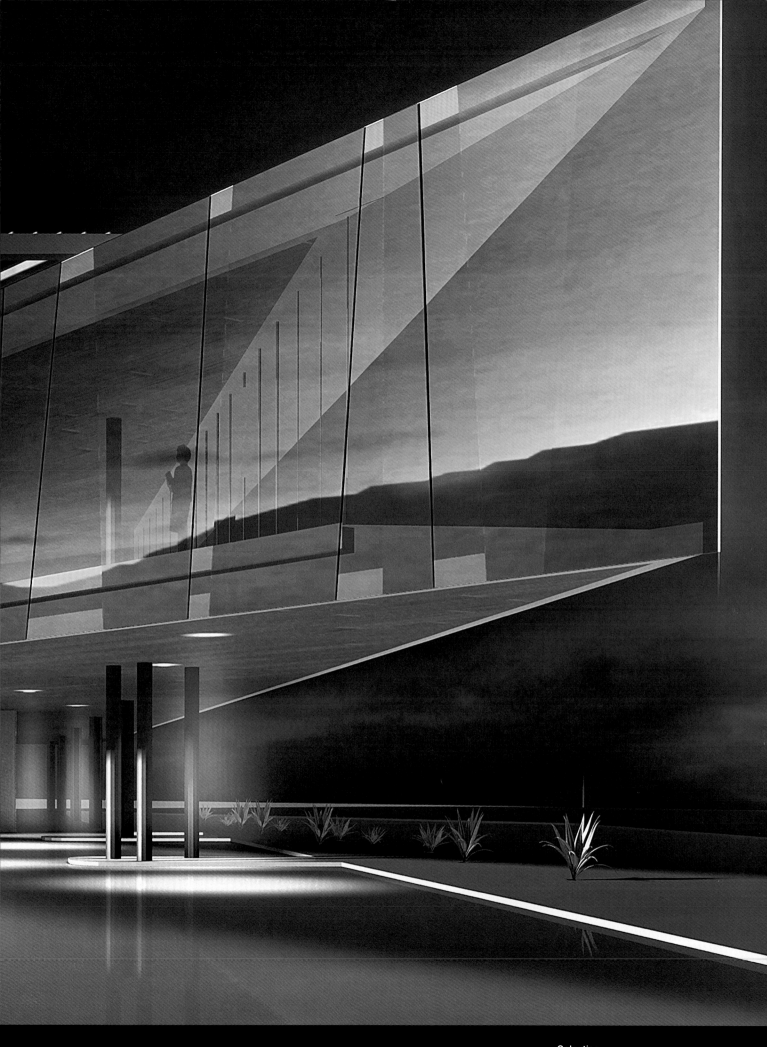

Galactica
AutoCAD, 3ds Max, V-Ray, Photoshop
Travis Smith, DAVIS, USA

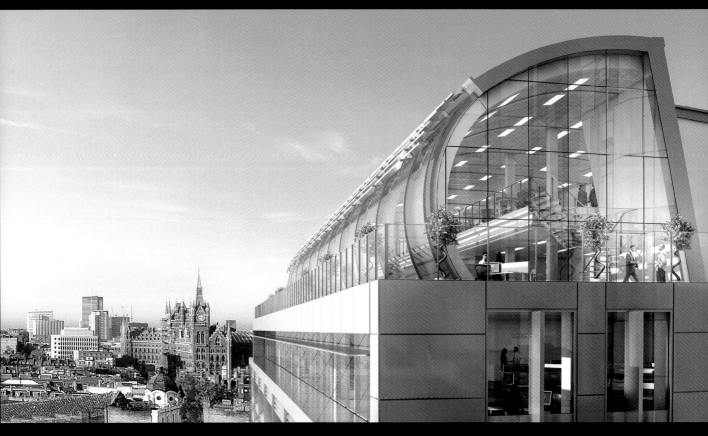

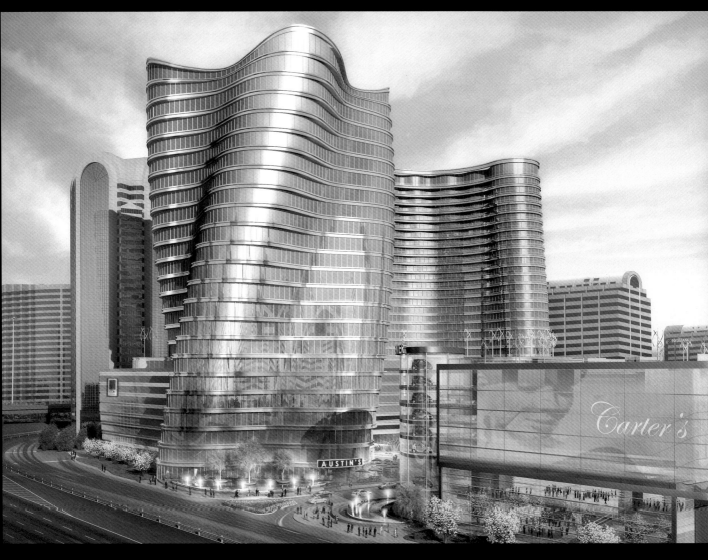

Pentonville Road
3ds Max, V-Ray, Photoshop
John Crighton, Visualisation One Ltd,
GREAT BRITAIN
[top]

Icon Center
3ds Max, V-Ray, Photoshop
Client: Icon Partners
Architect: SOM & GDA
Green Grass Studios, USA *[above]*

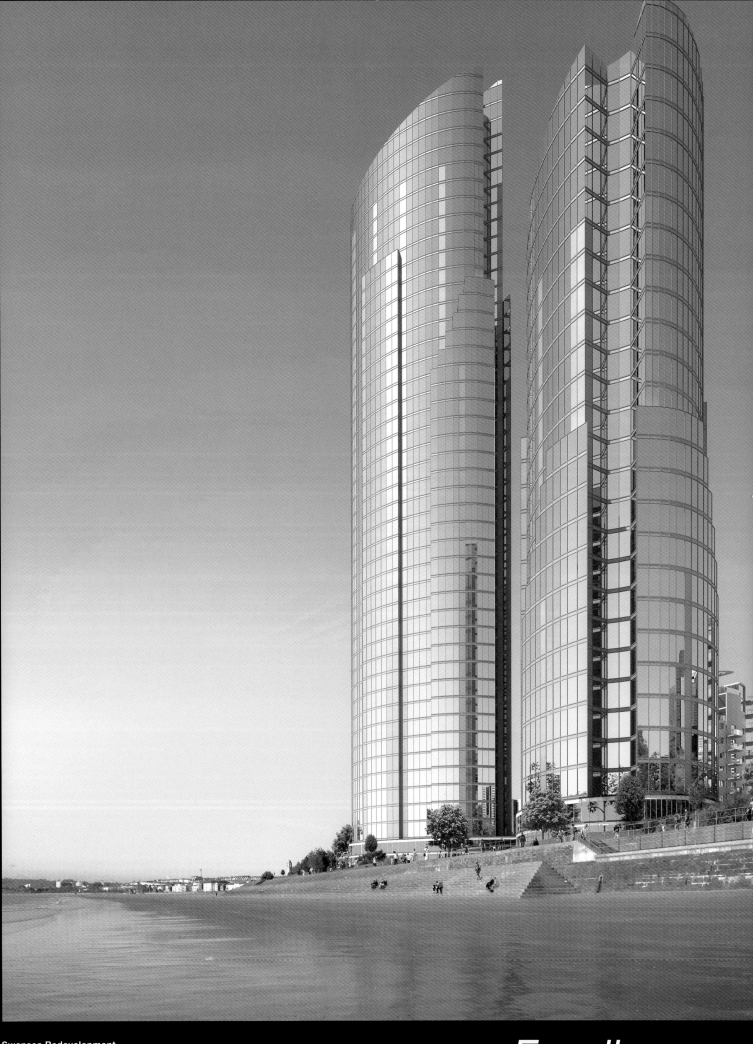

Swansea Redevelopment
3ds Max, V-Ray, Photoshop
Client: Hammerson UK Properties PLC
Troy Pearse and Gustavo Capote,
Preconstruct, GREAT BRITAIN

Excellence
Architecture (Exterior)

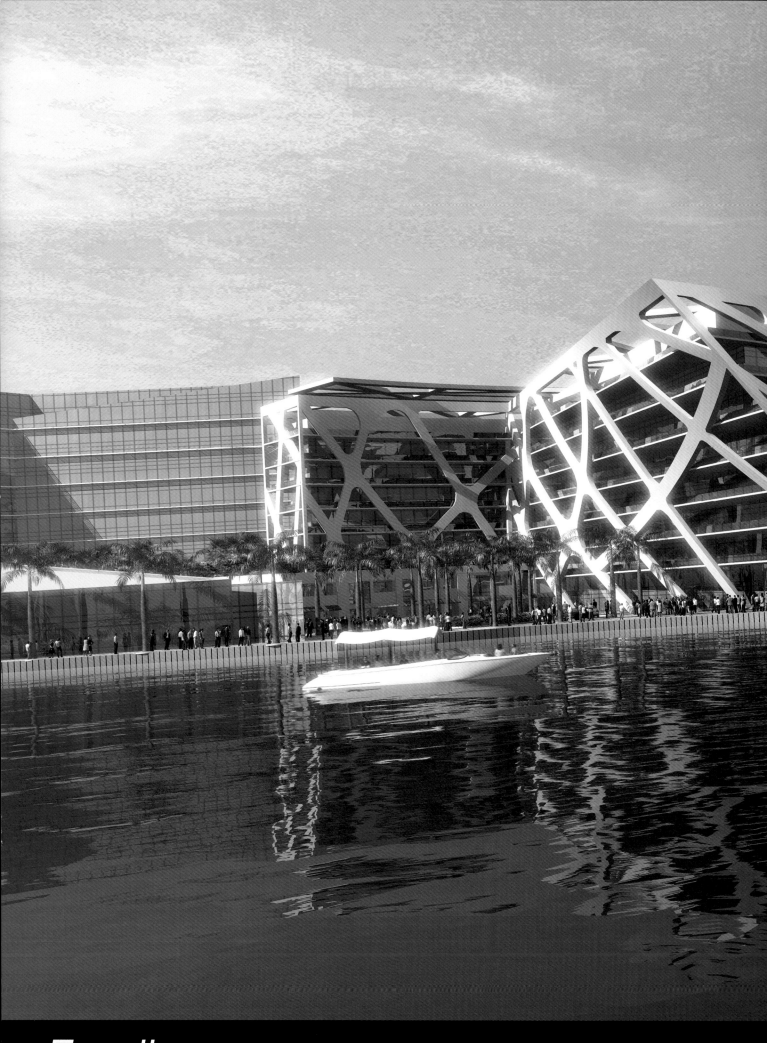

Excellence
Architecture (Exterior)

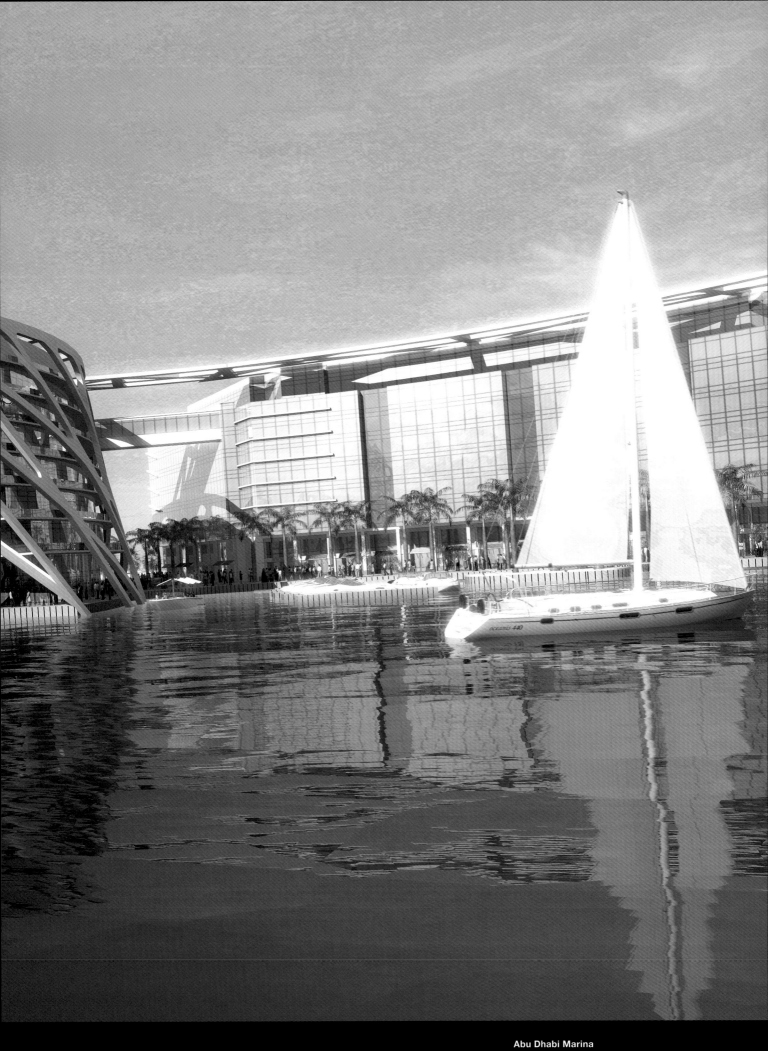

Abu Dhabi Marina
LightWave 3D, formZ, Photoshop
Client: HOK
Jeff Pulford, Jean-Marc Labal and Matt Crisalli,
Interface Multimedia, USA

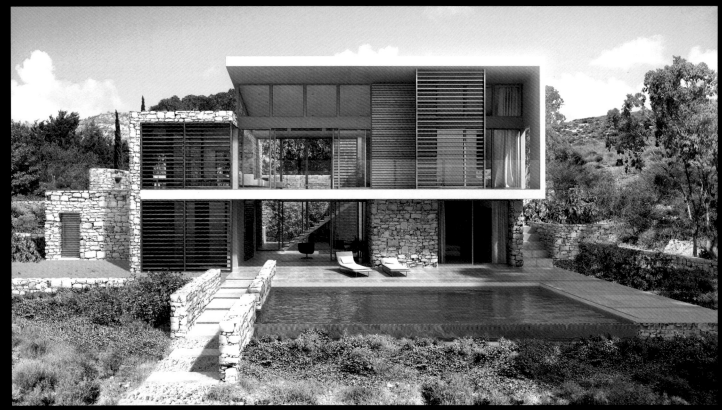

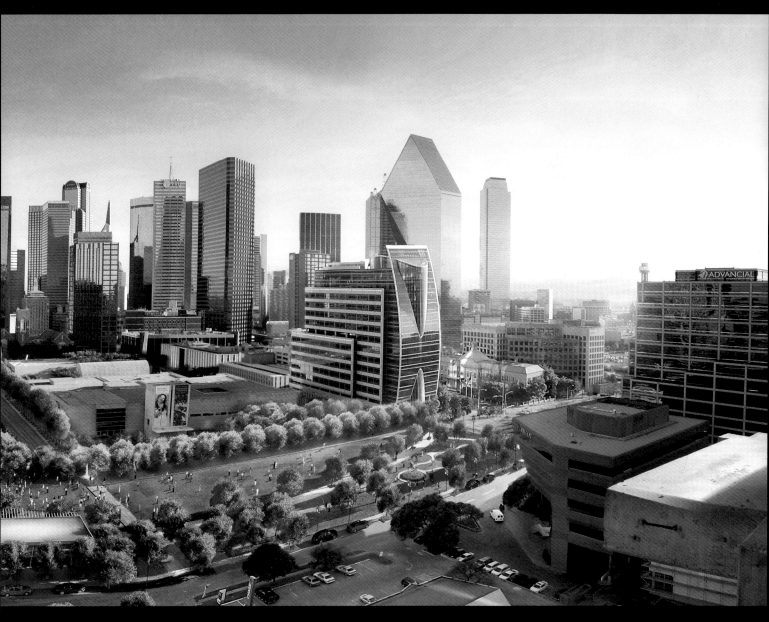

Woodall Rodgers Park
3ds Max, V-Ray, Photoshop
Client: Lincoln Property Centre
Architect: HKS
Green Grass Studios, USA
[above]

Minthis Hills
3ds Max, V-Ray, Photoshop
Gareth Thatcher, AHD-Imaging,
GREAT BRITAIN
[left]

Villa V
3ds Max, V-Ray, Photoshop
Client: Lower Mill Estate,
Architect: AR Design Studio
Martin Drake, Preconstruct,
GREAT BRITAIN
[right]

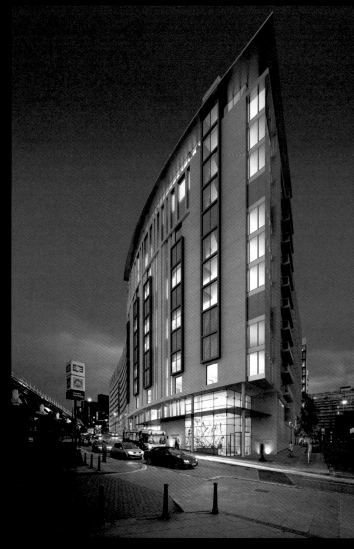

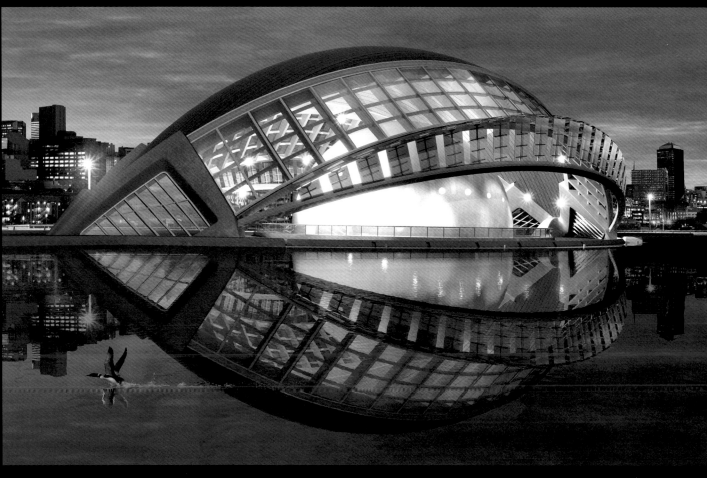

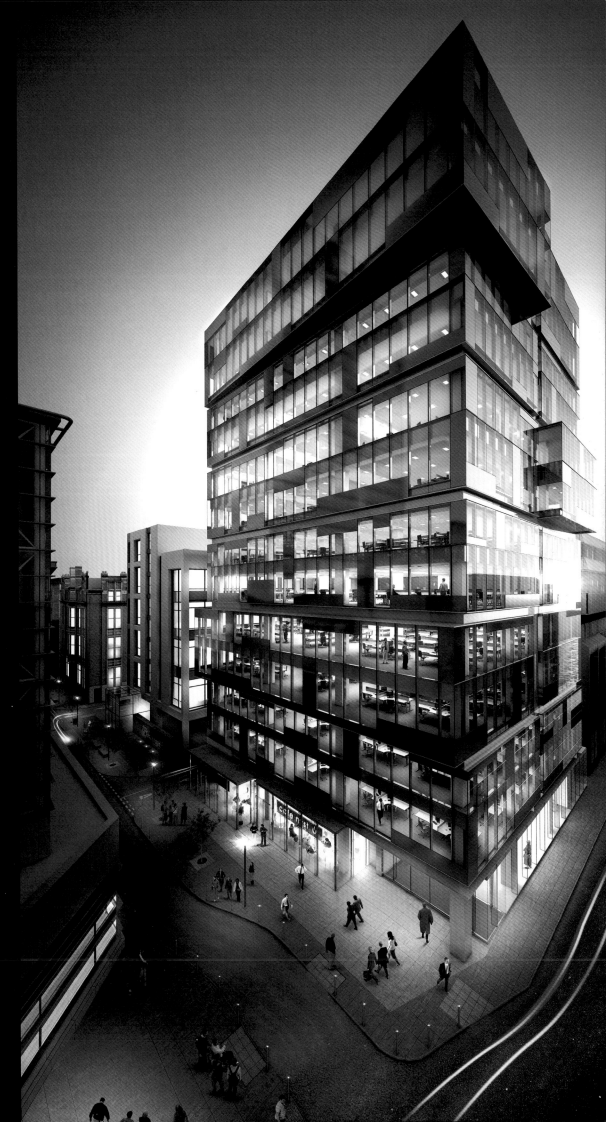

259 City Road
3ds Max, V-Ray, Photoshop
Client & Architects: Bennetts
Associates Architects
Paul Ingram, Smoothe,
GREAT BRITAIN
[far left]

Skelhorne Street
3ds Max, V-Ray, Photoshop
Chay Hawes, Visualisation
One Ltd, GREAT BRITAIN
[left]

New York Street Dusk
3ds Max, V-Ray, Photoshop
John Crighton, Visualisation
One Ltd, GREAT BRITAIN
[right]

**Valencia City of
Arts and Sciences**
3ds Max, V-Ray, Photoshop
Architect: Santiago Calatrava
Ian Brink, thebrinc,
SOUTH AFRICA
[left]

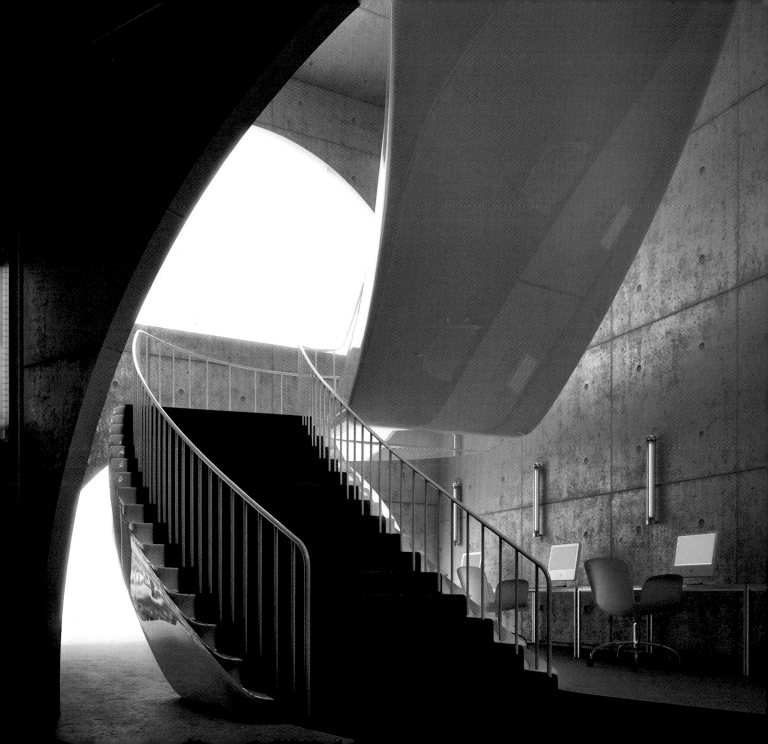

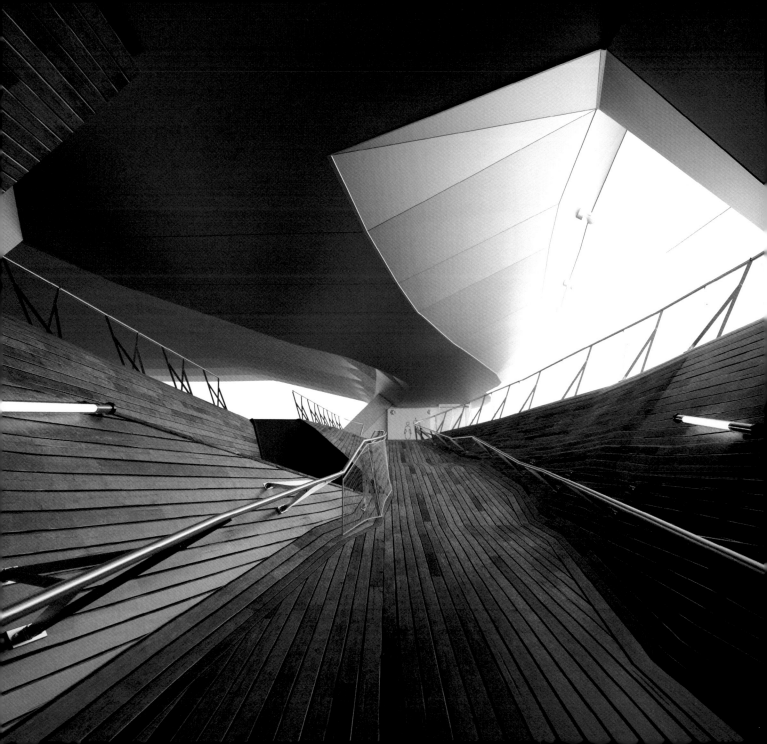

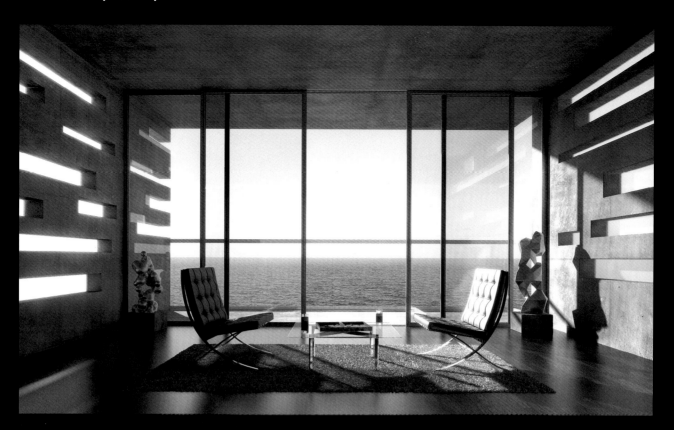

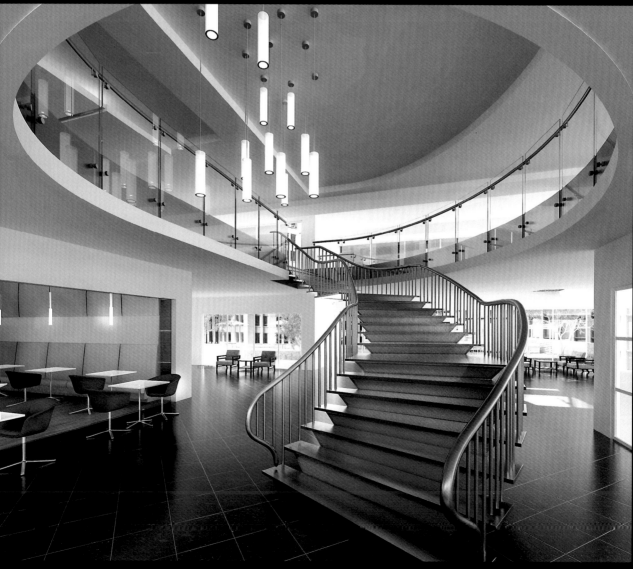

Frappe
3ds Max, V-Ray, Photoshop
Vladimir Mulhem,
GREAT BRITAIN
[top]

Boston Office Lobby
3ds Max, V-Ray, Photoshop
Nensi Karanxha,
Neoscape, Inc., USA
[above]

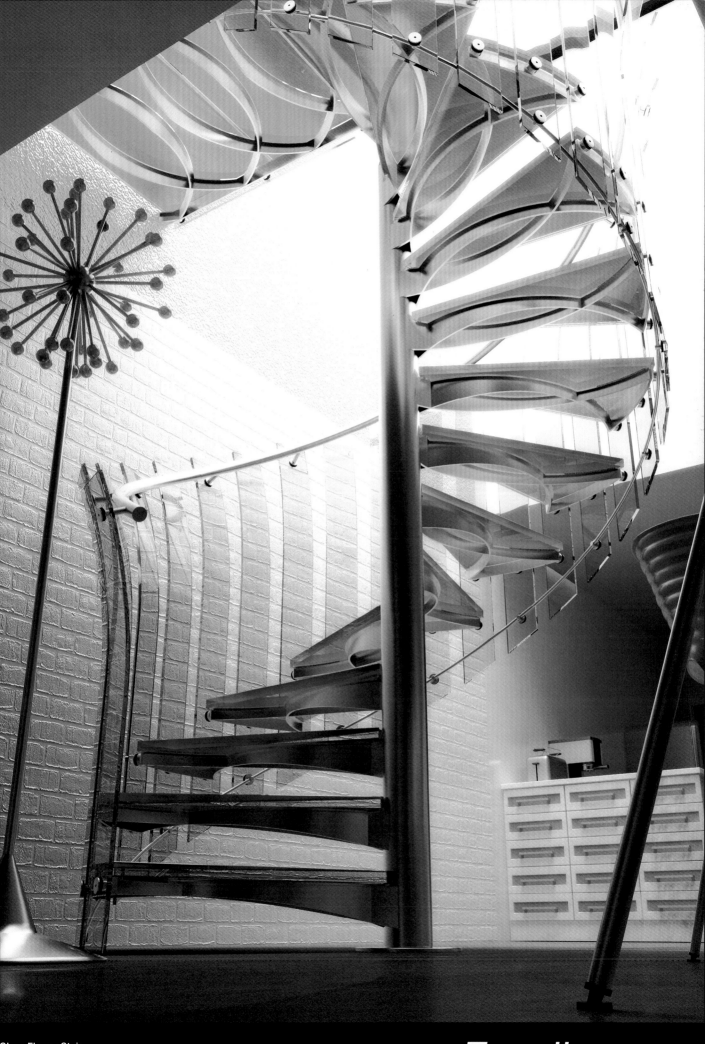

Glass Flower Stair
V-Ray, VIZ, Photoshop
Geoffrey Packer,
GREAT BRITAIN

Excellence

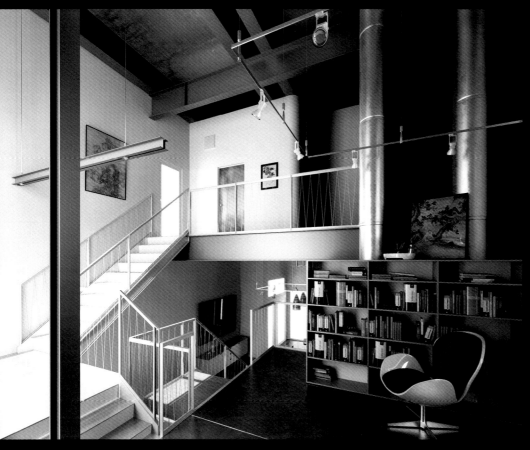

Highway home
3ds Max, V-Ray, Photoshop
Charley Cloris, FRANCE
[left]

Stairs
3ds Max, V-Ray
Bryan Jumarang,
PHILIPPINES
[right]

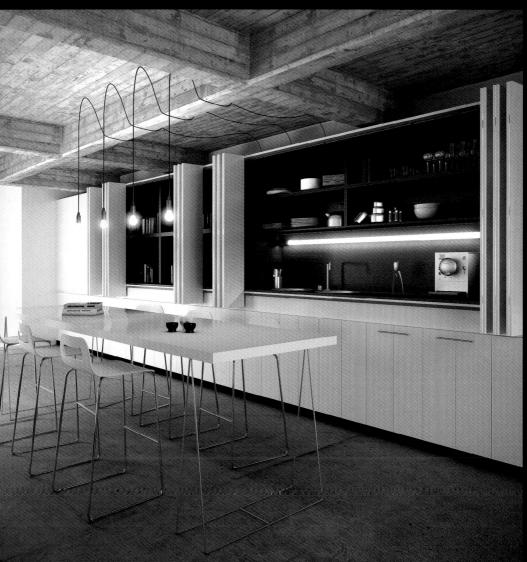

Loft in Bruxelles
3ds Max, V-Ray, Photoshop
Maximilien Louguet,
Perspicass, FRANCE
[left]

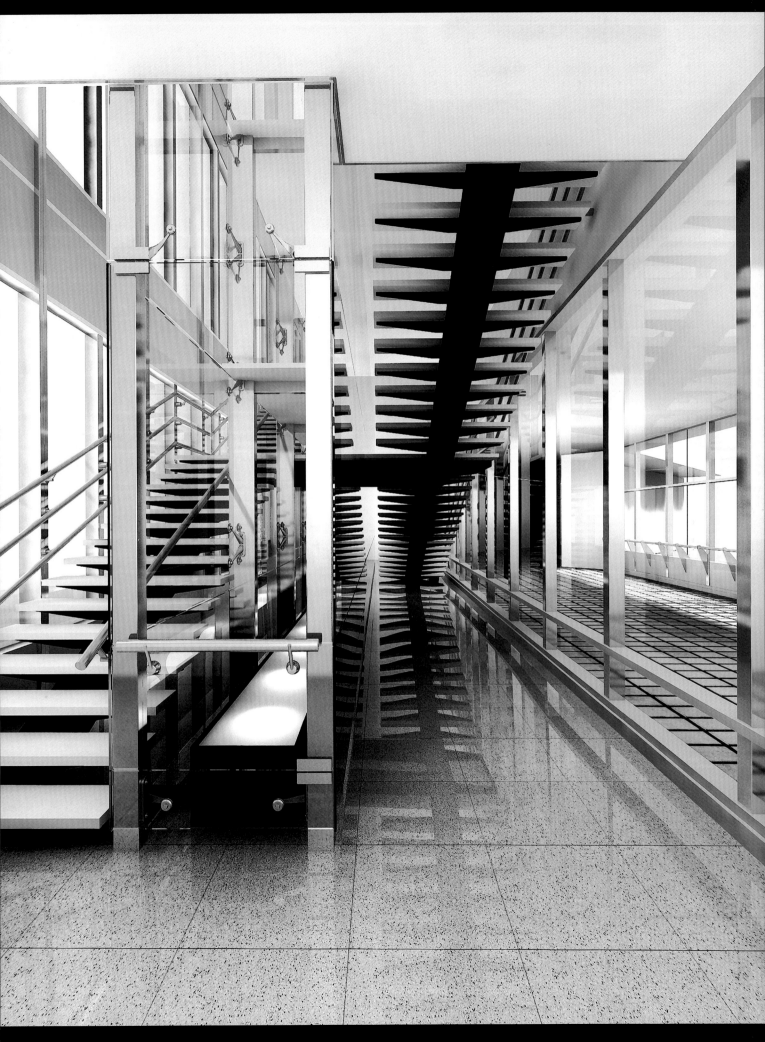

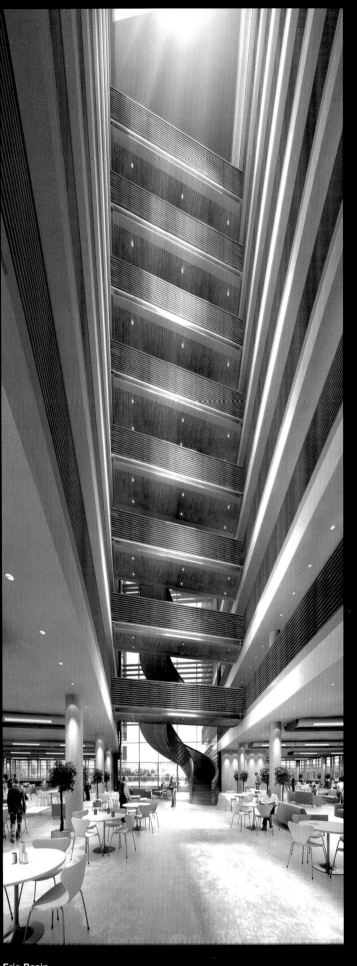

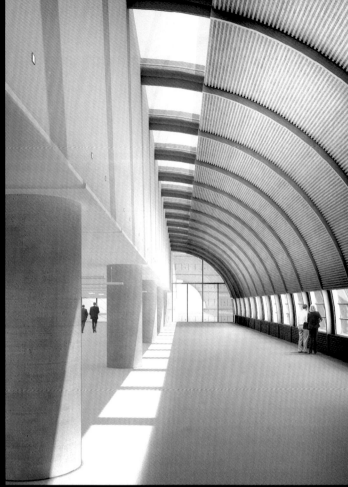

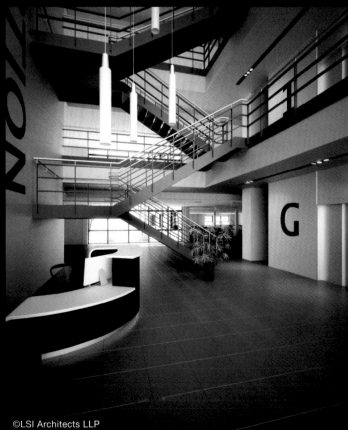

Erie Basin
3ds Max, V-Ray, Photoshop
John Crawshaw, AHD Imaging,
GREAT BRITAIN
[above]

Tooley Street
3ds Max, Photoshop, V-Ray
Matthew Turner, Smoothe,
GREAT BRITAIN
[top]

Bankside 300
formZ, Photoshop, Maxwell Render
Client: LSI Architects LLP
Derek Jackson, GREAT BRITAIN
[above]

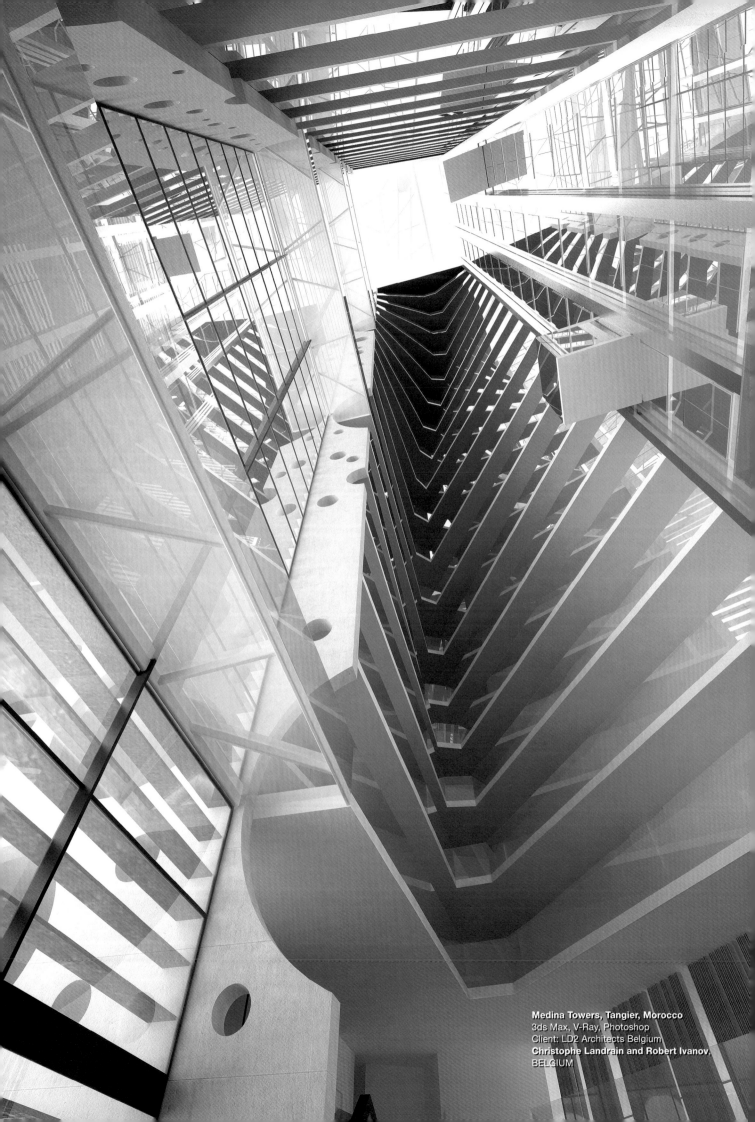

Medina Towers, Tangier, Morocco
3ds Max, V-Ray, Photoshop
Client: LD2 Architects Belgium
Christophe Landrain and Robert Ivanov,
BELGIUM

Underground Escalator
3ds Max, V-Ray, Photoshop

Home 02
3ds Max, V-Ray, Photoshop

Living room
3ds Max, V-Ray, Photoshop

Cielo Unit C

The Loft

White room
3ds Max, V-Ray, Photoshop
Client: Van der Sijpt - Willems
Gert Swolfs, G2 BVBA, BELGIUM
[top]

House
CINEMA 4D, V-Ray, LightWave 3D
Javier Senent Ruiz, infograf,
SPAIN
[above]

Red room
3ds Max, V-Ray, Photoshop
Gert Swolfs, G2 BVBA,
BELGIUM
[right]

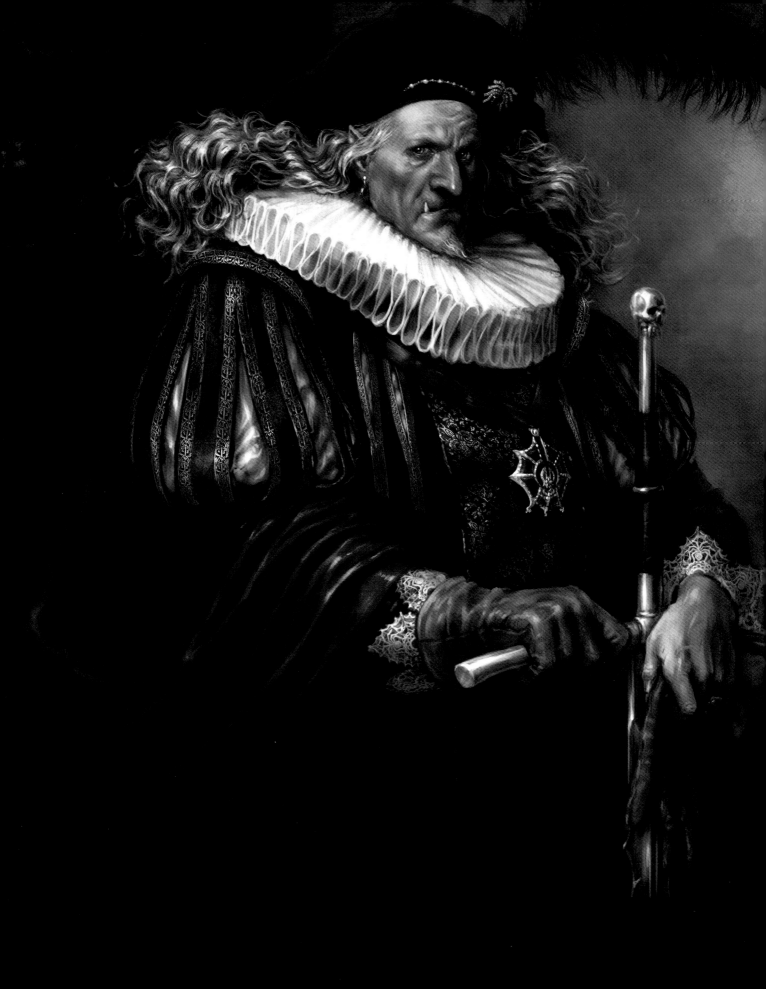

Master
Fantasy

Vampyre
Photoshop
Ruslan Svobodin,
RUSSIA

The Raven
Photoshop
Sandrine 'Senyphine' Replat,
FRANCE

Excellence
Fantasy

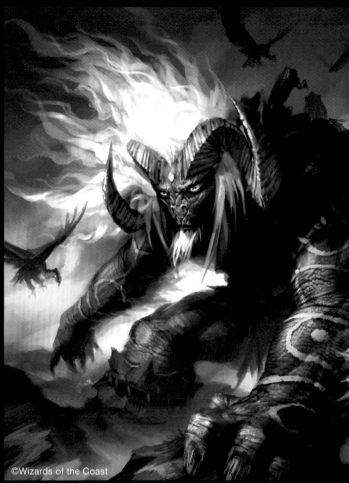

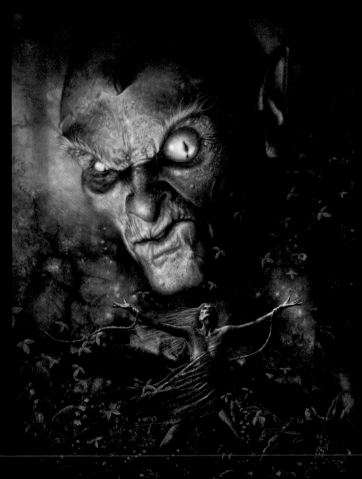

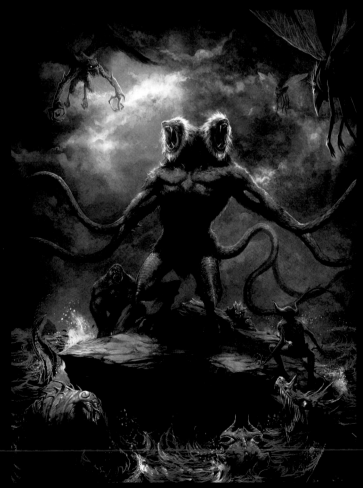

Horned God's Daughter
Photoshop
Client: Triton
Michal Ivan, SLOVAKIA
[top]

Demonic Evocation
ZBrush, Poser,
Photoshop, Painter
Uwe Jarling, GERMANY
[above]

Fomori Nomad
Photoshop
Client: Wizards of the Coast
Art Director: Jeremy Jarvis
Raymond Swanland, USA *[top]*

Demogorgon
Photoshop
Client: Paizo
Andrew Hou, CANADA
[above]

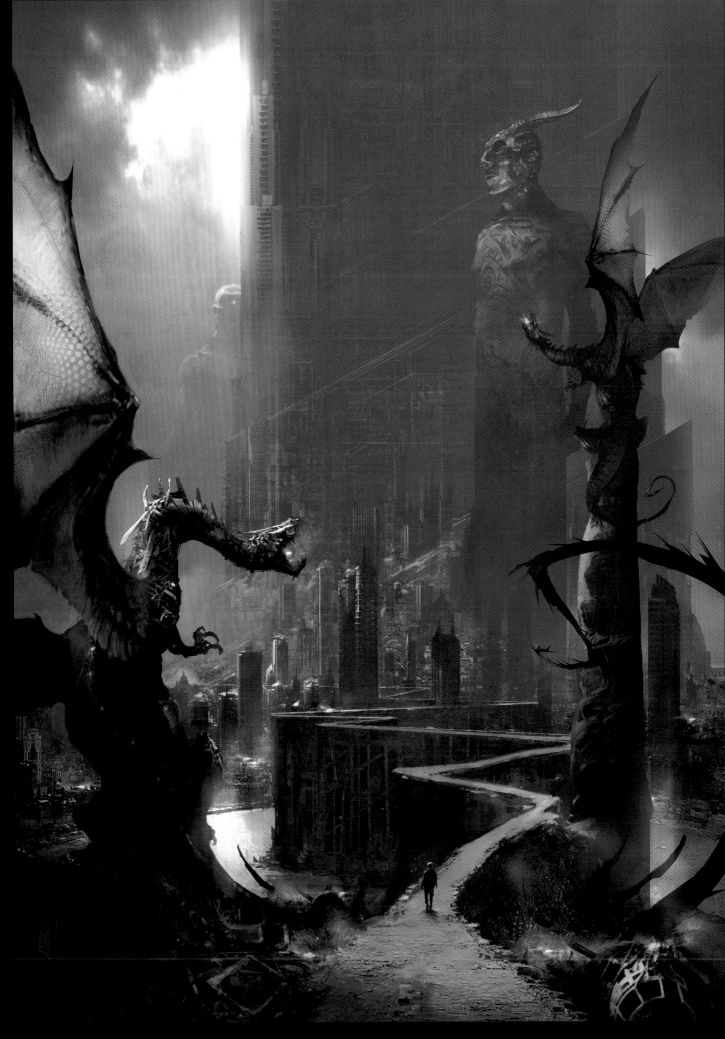

The Dragons of Babel
Photoshop
Client: Tor Books
Stephan Martiniere, USA

Excellence
Fantasy

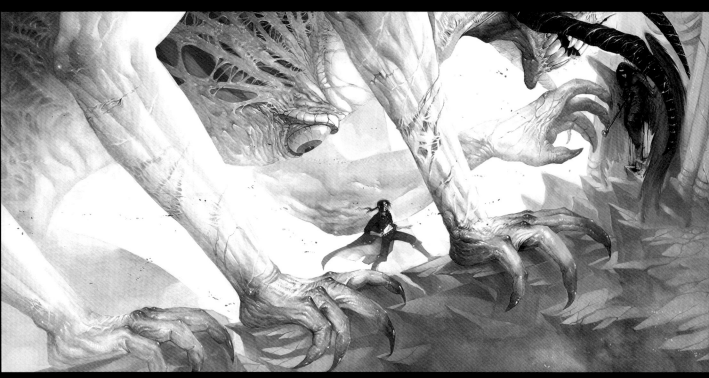

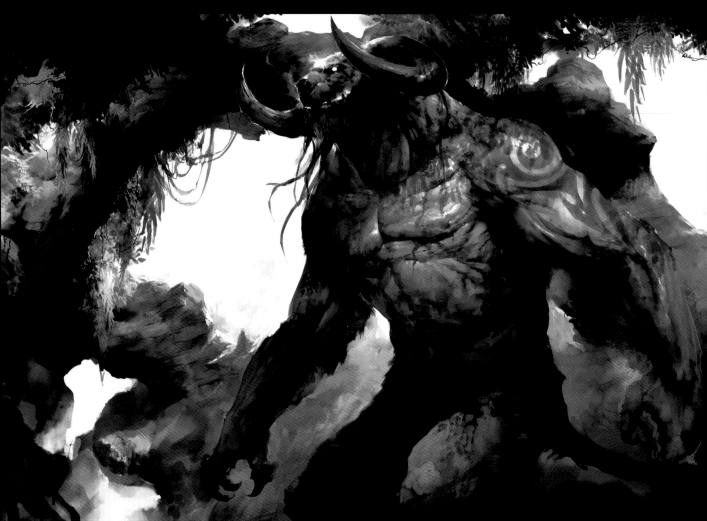

Giants and Angels II
Photoshop
Amelia Mammoliti,
USA
[top]

Forest Minotaur
Photoshop
Kekai Kotaki,
USA
[above]

Guild Wars: Tyrant
Photoshop
Client: ArenaNet
Kekai Kotaki, USA
[right]

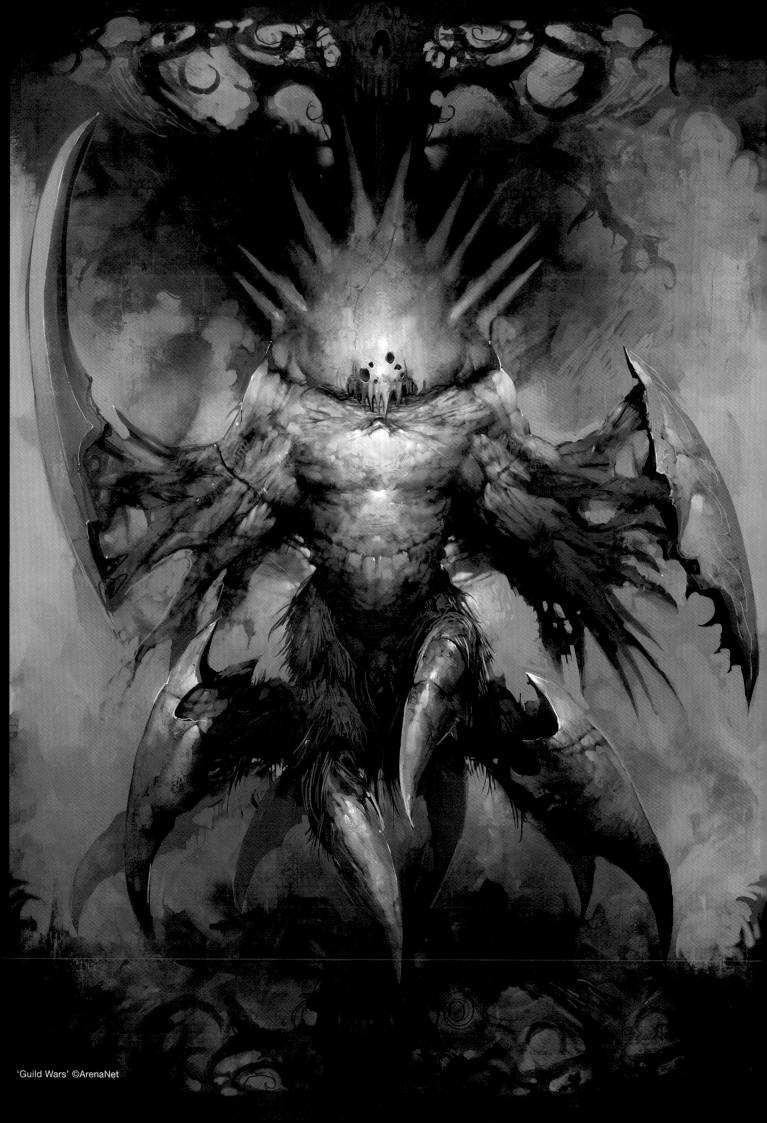

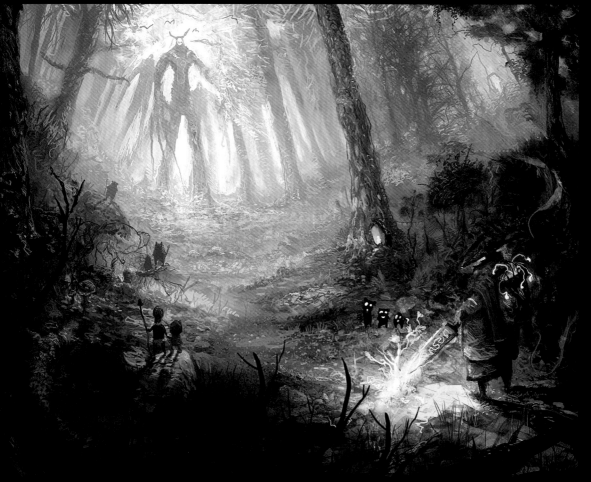

Void of spirits
Photoshop
Robin Olausson, SWEDEN
[left]

The Greenwood Deep
Photoshop, Apophysis
Phil McDarby, IRELAND
[right]

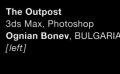

The Outpost
3ds Max, Photoshop
Ognian Bonev, BULGARIA
[left]

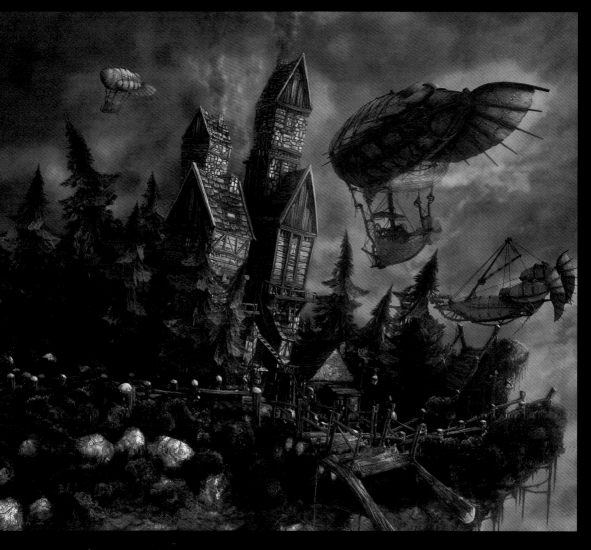

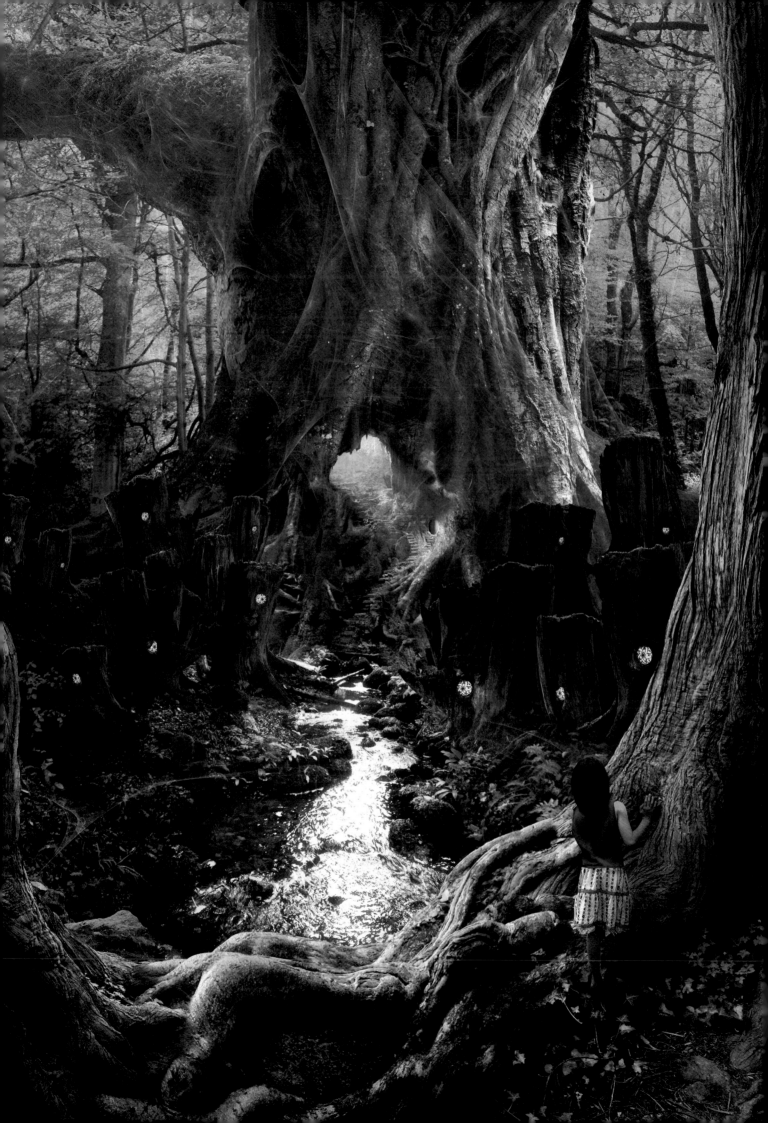

Fantasy

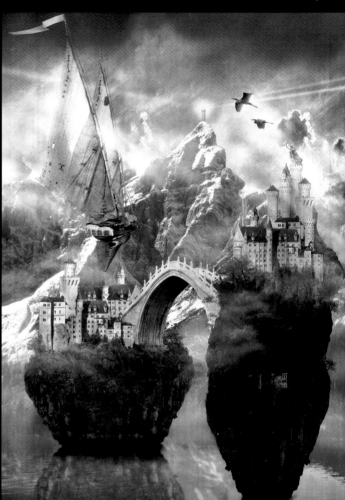

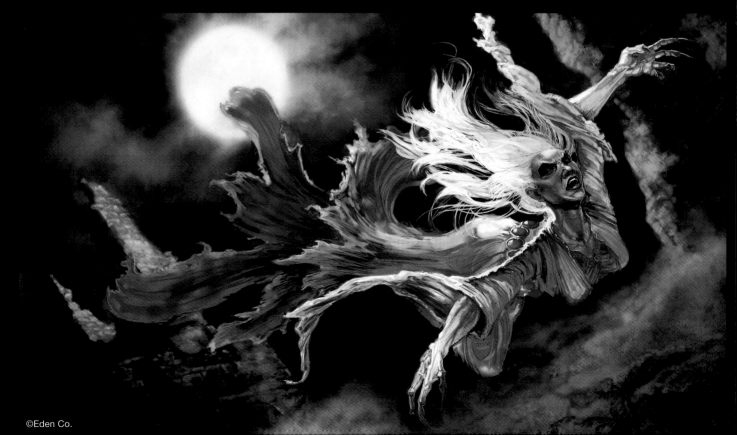

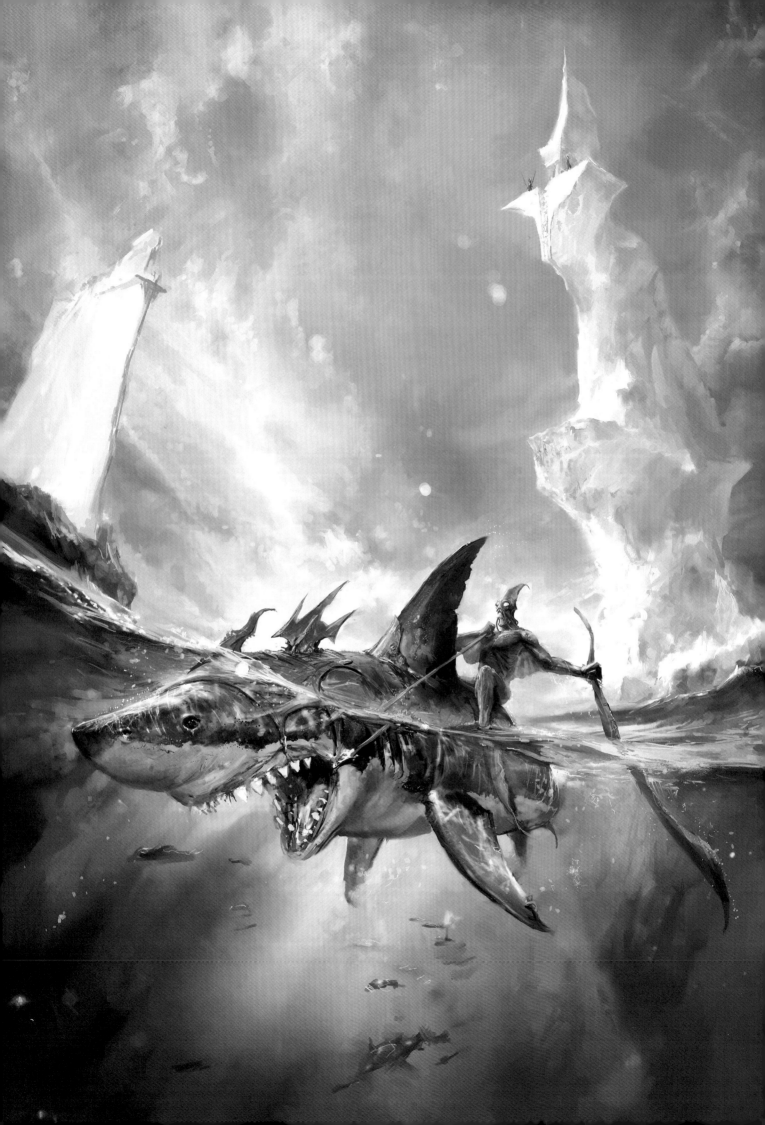

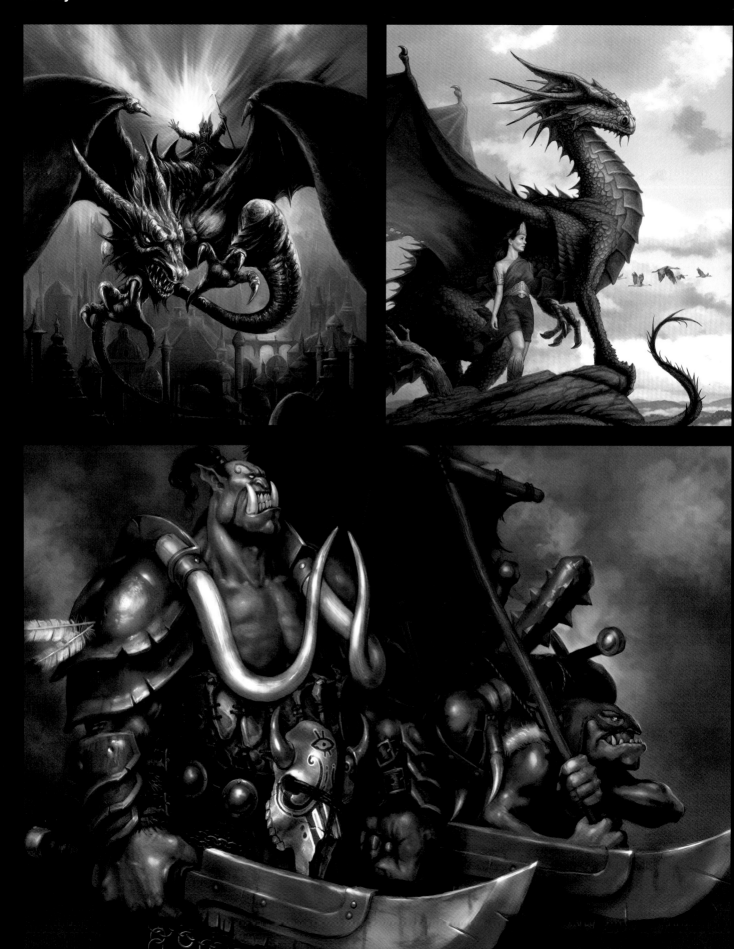

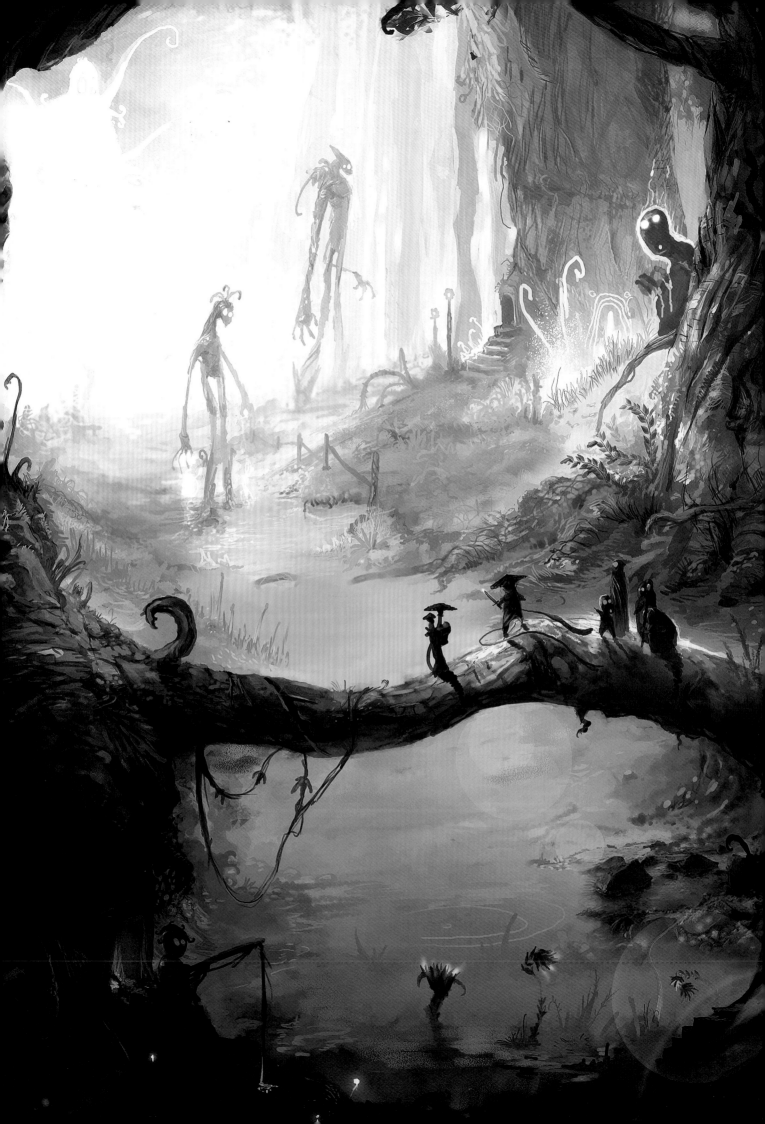

Red angel
Painter
Weiye Yin, CHINA
[above left]

Uriel
Photoshop
Peter Mohrbacher, USA
[above]

Dragonlover
Photoshop
Senol Ozdemir, TURKEY
[left]

Demon Portal
Photoshop
Sandara Tang, SINGAPORE
[right]

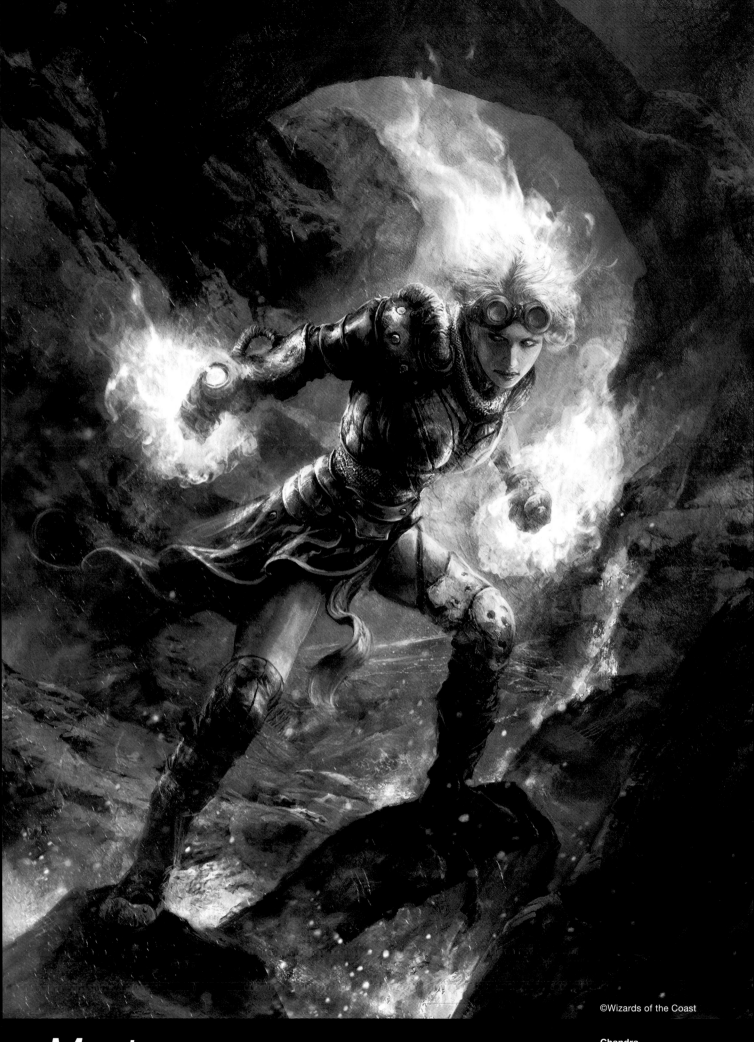

Master
Fantasy Femmes

Chandra
Photoshop
Client: Wizards of the Coast
Art Director: Jeremy Jarvis
Aleksi Briclot, FRANCE

Red Witch
Photoshop
Photo: Leslie Ann shyble-stock
Kieran Wakeman, Divine Chaos Art,
GREAT BRITAIN

Excellence
Fantasy Femmes

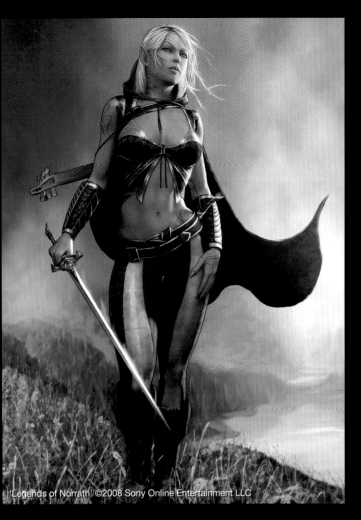

'Legends of Norrath' ©2008 Sony Online Entertainment LLC

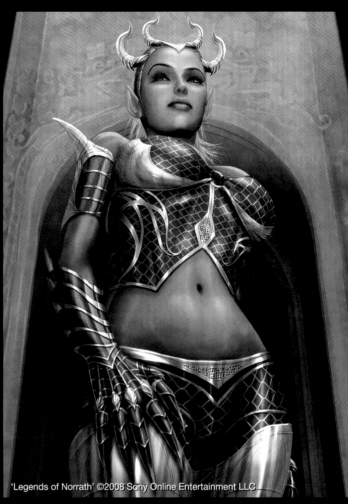

'Legends of Norrath' ©2008 Sony Online Entertainment LLC

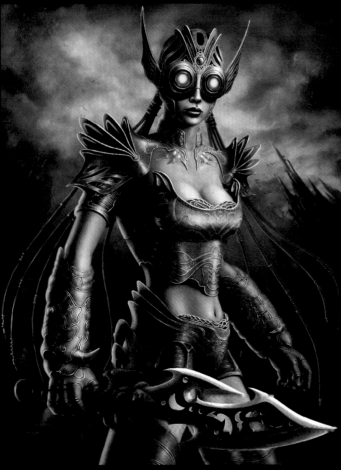

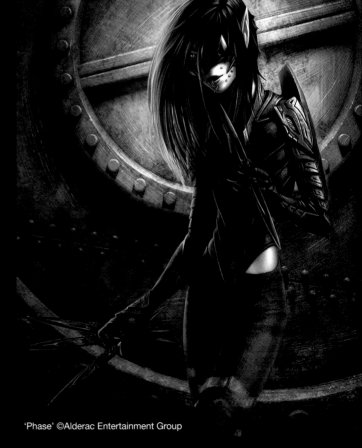

'Phase' ©Alderac Entertainment Group

Legends of Norrath: Ariseph, Mistress of Verse
Photoshop
Derek Herring, Sony Online Entertainment LLC,
USA
[top]

Esprilandrhu
Photoshop
Jeffrey M. de Guzman,
PHILIPPINES
[above]

Legends of Norrath: Queen Cristanos Thex
Photoshop
Derek Herring,
Sony Online Entertainment LLC, USA
[top]

Phase: Bloodwhisper
Photoshop
Client: Alderac Entertainment Group
Steve Argyle, USA
[above]

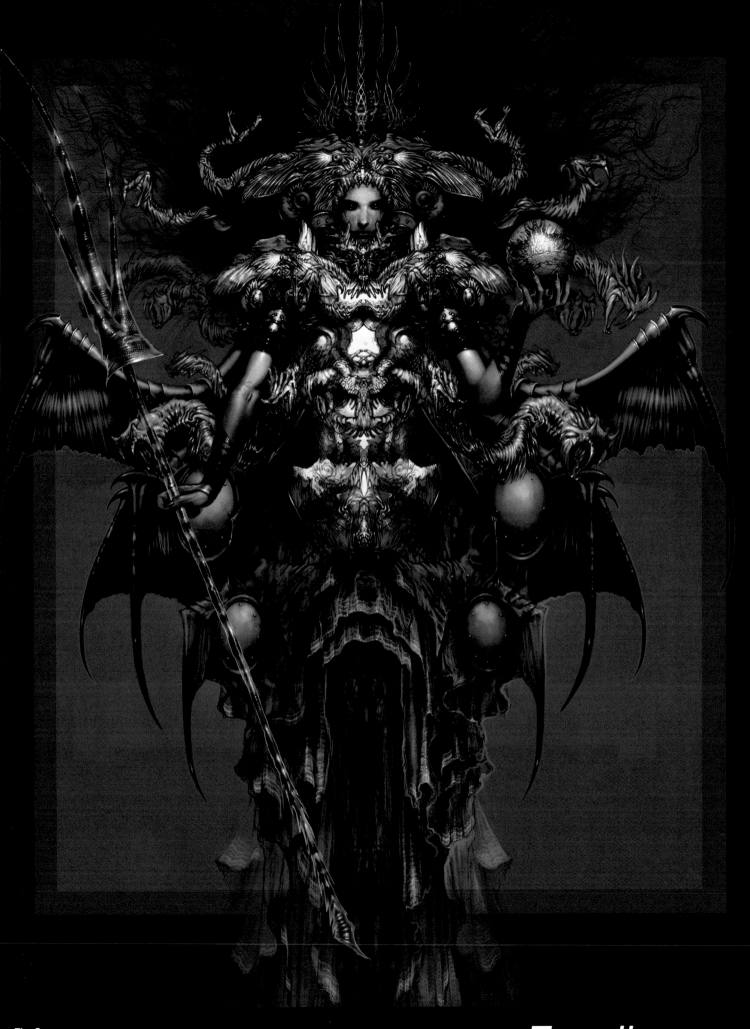

The Queen
Photoshop, Painter,
SketchBook Pro
Lawrence Williams,
L.A.Williams Art, Inc., USA

Excellence
Fantasy Femmes

Fantasy Femmes

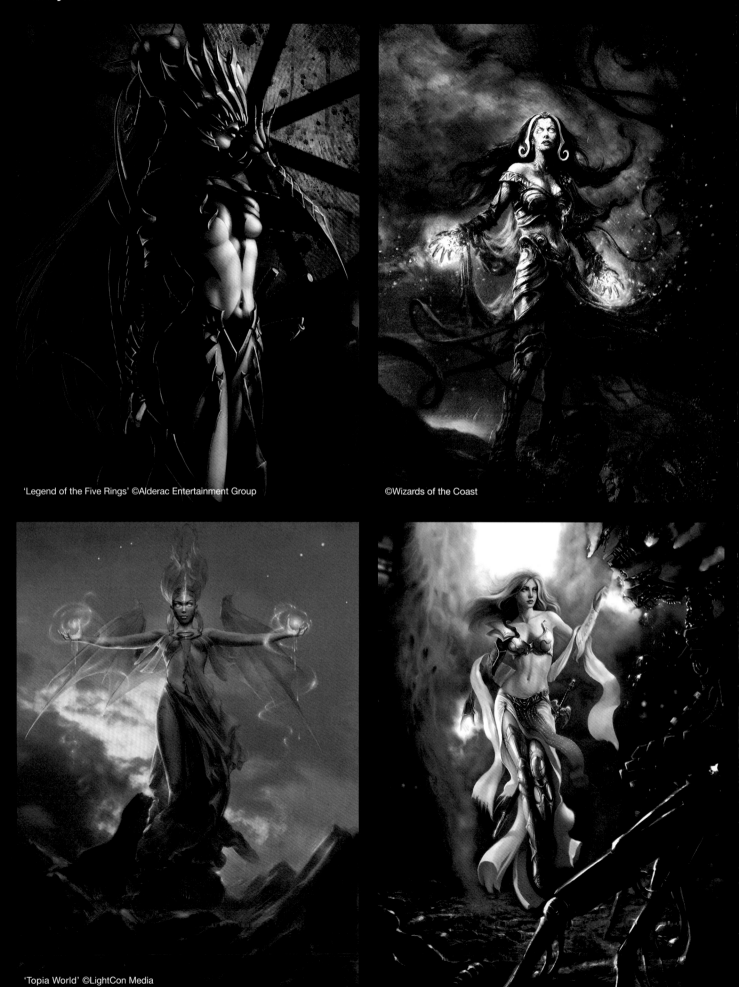

'Legend of the Five Rings' ©Alderac Entertainment Group

©Wizards of the Coast

'Topia World' ©LightCon Media

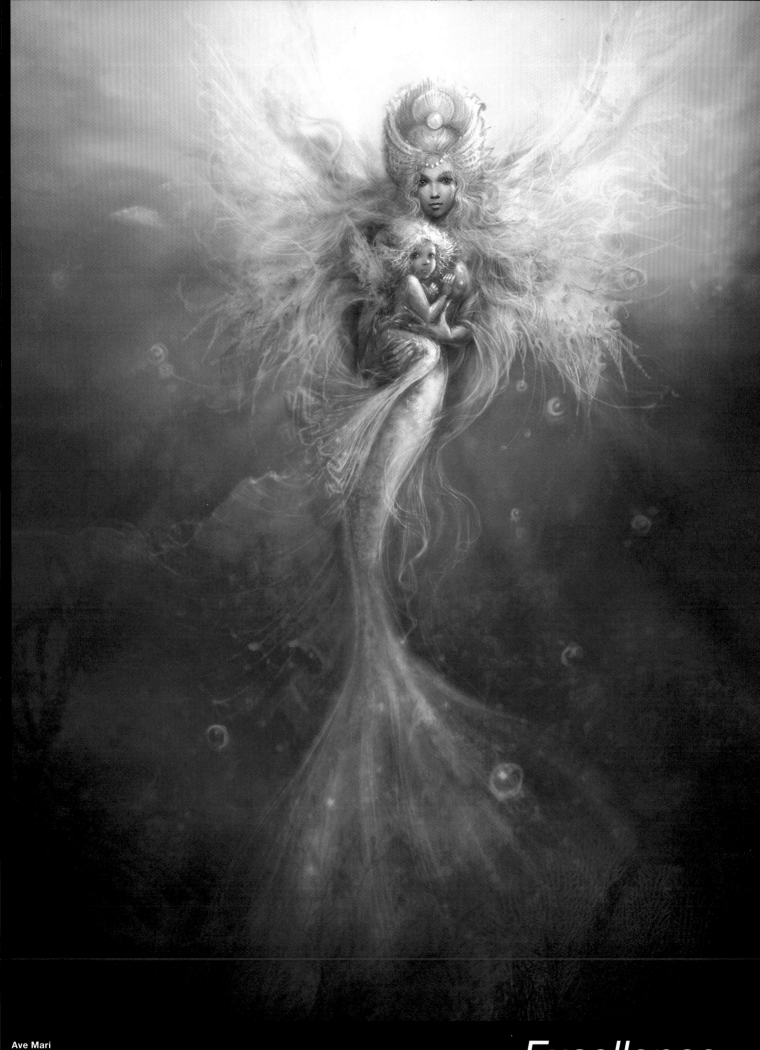

Ave Mari
Photoshop
Elena Klementyeva,
RUSSIA

Excellence
Fantasy Femmes

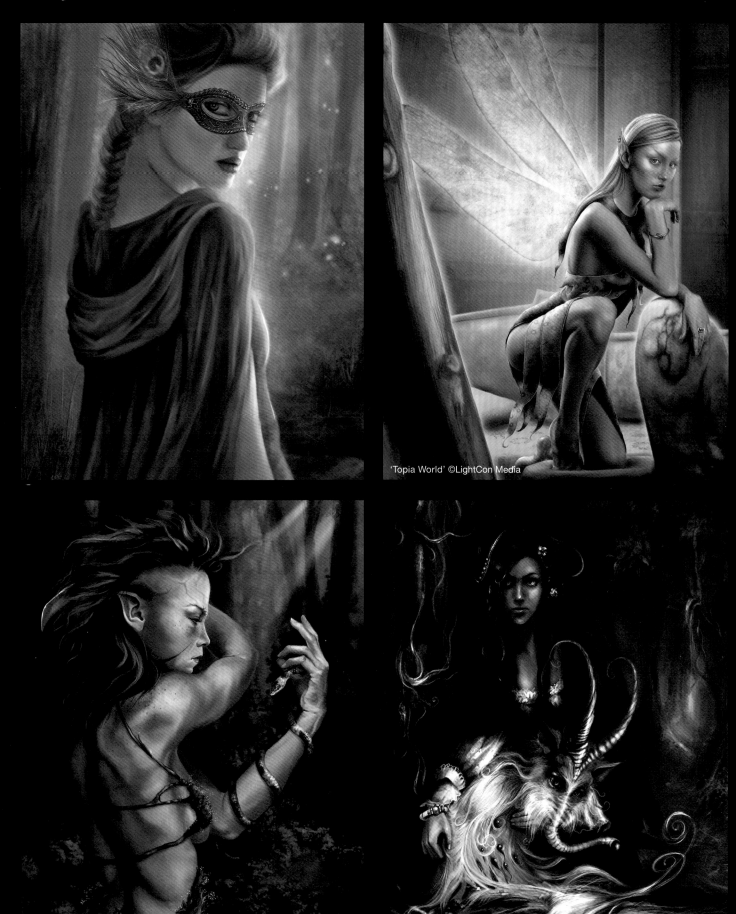

'Topia World' ©LightCon Media

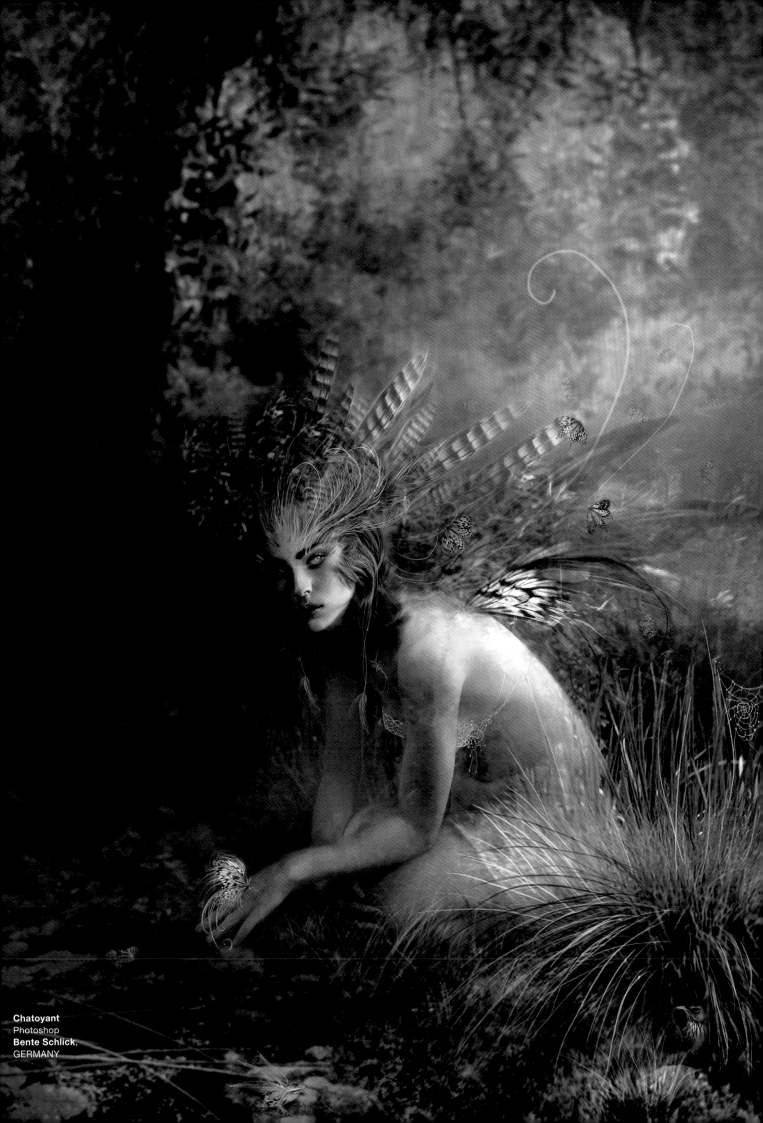

Chatoyant
Photoshop
Bente Schlick,
GERMANY

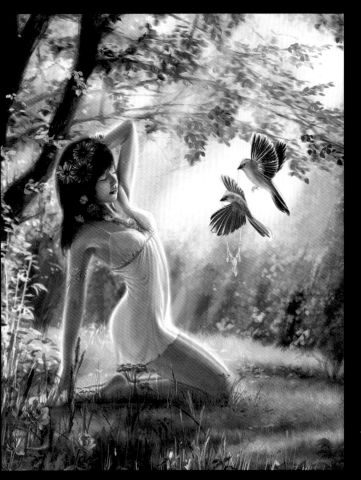

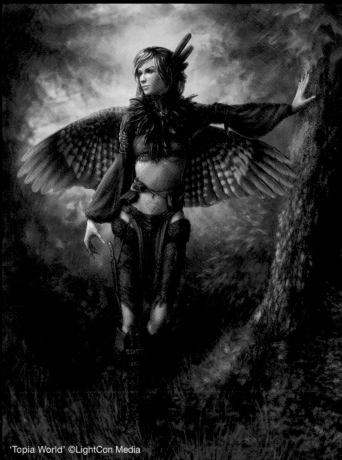

'Topia World' ©LightCon Media

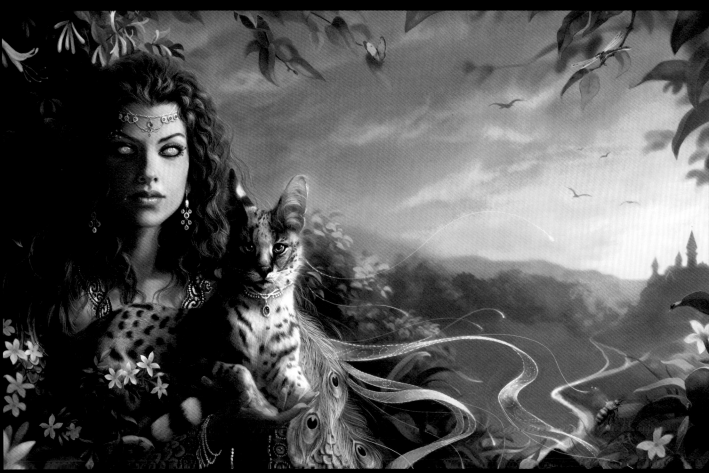

Awakening of the forest princess
Photoshop
Yanina Kucheeva,
GREAT BRITAIN
[top]

Her Eyes
Photoshop
Diane Özdamar,
FRANCE
[above]

Topia World: Glory Winddancer
Painter
Client: LightCon Media
Liiga Smilshkalne, LATVIA
[top]

Red forest's fairy tales
Painter, Photoshop
Katarina Sokolova,
UKRAINE
[right]

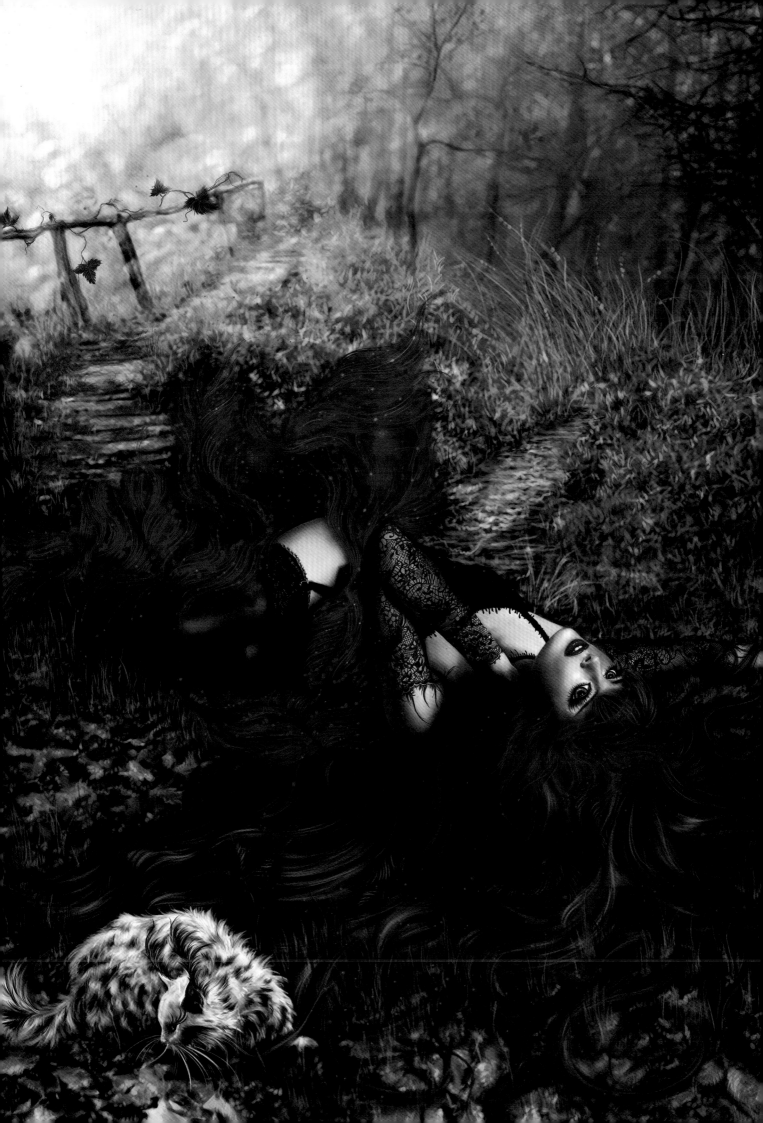

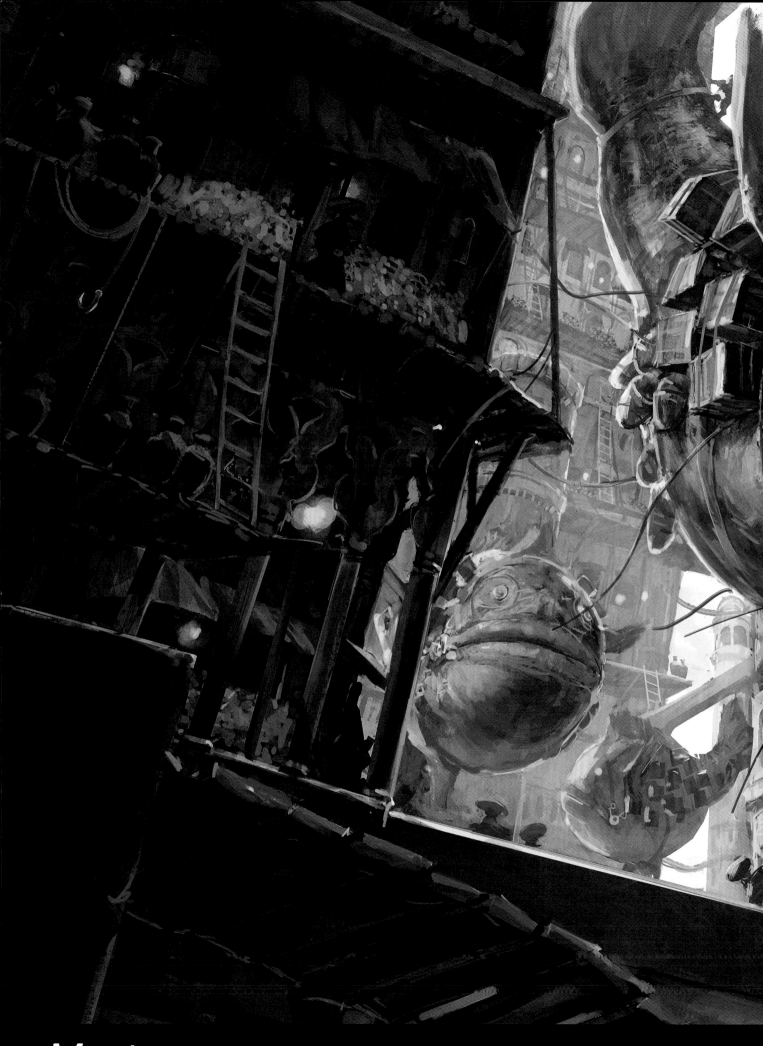

Master
Creatures

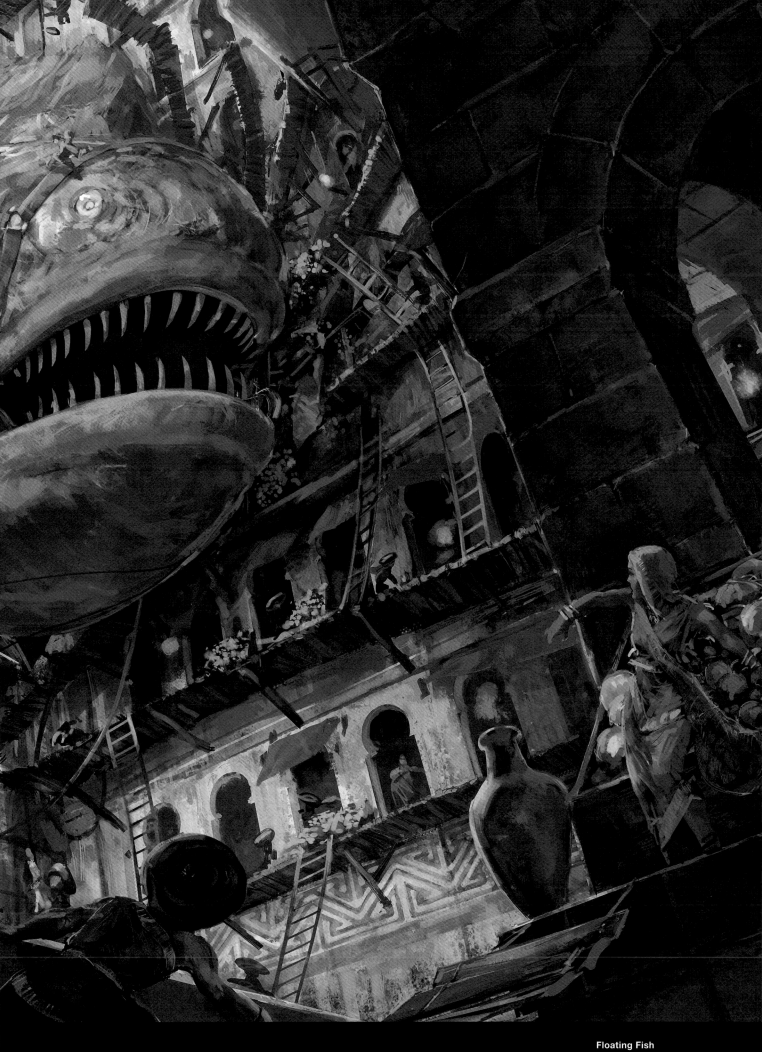

Floating Fish
Photoshop
Mats Minnhagen, SWEDEN

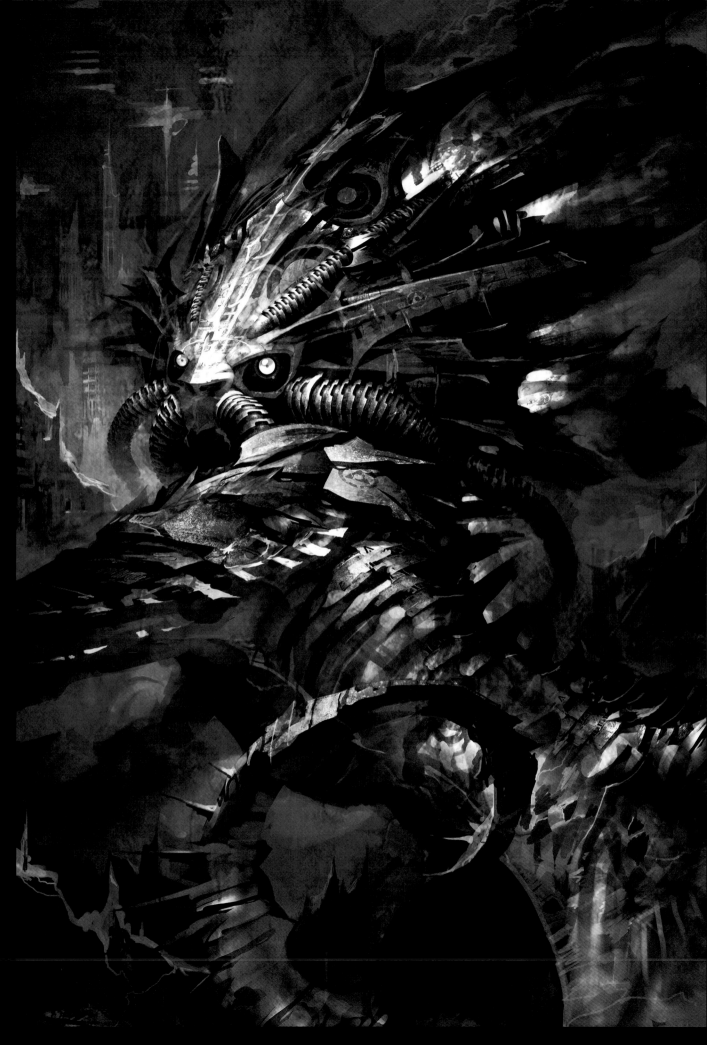

Of What's to Come
Photoshop
Raymond Swanland, USA

Excellence
Creatures

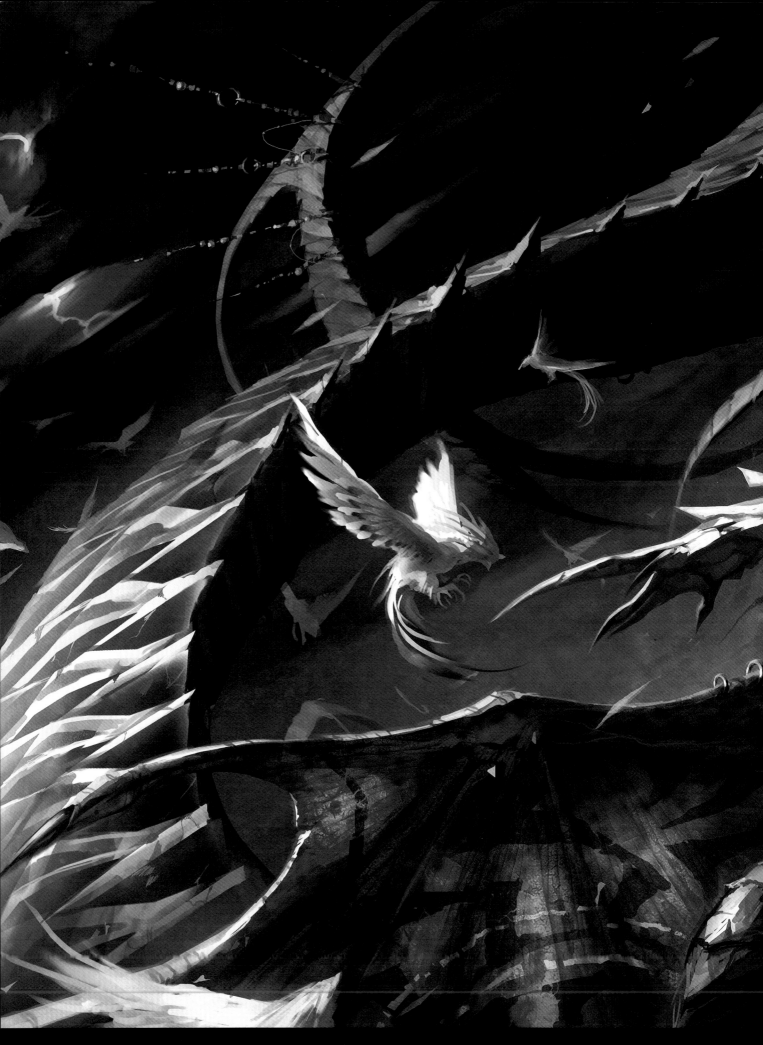

Excellence
Creatures

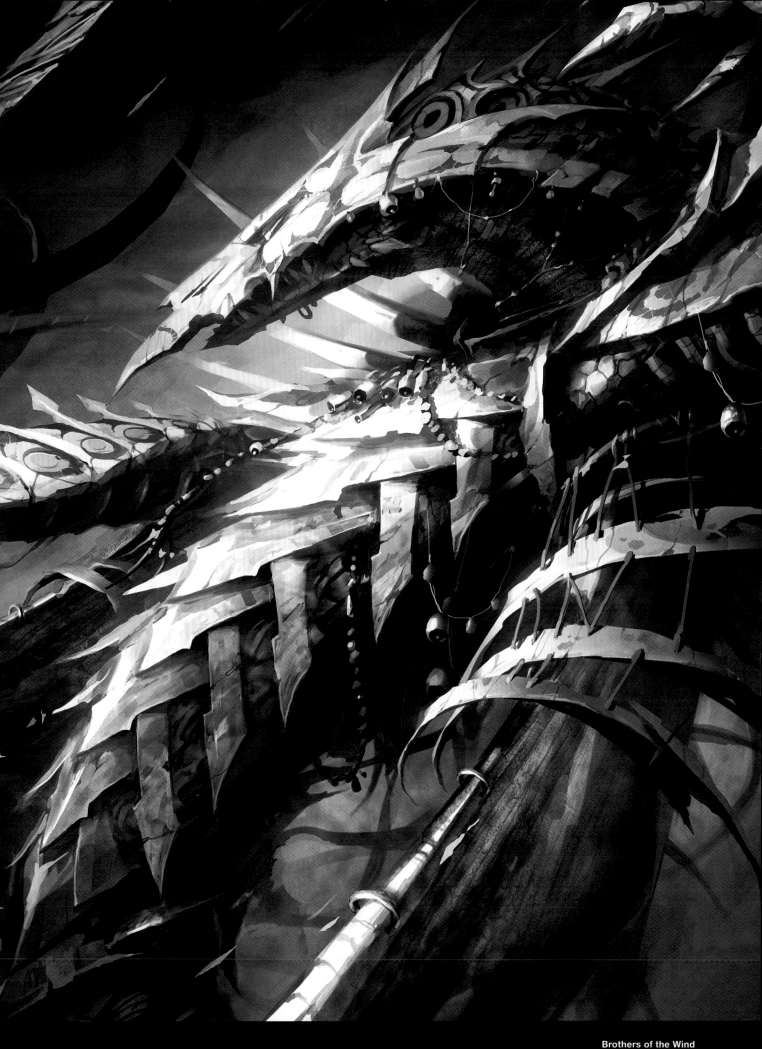

Brothers of the Wind
Photoshop
Raymond Swanland, USA

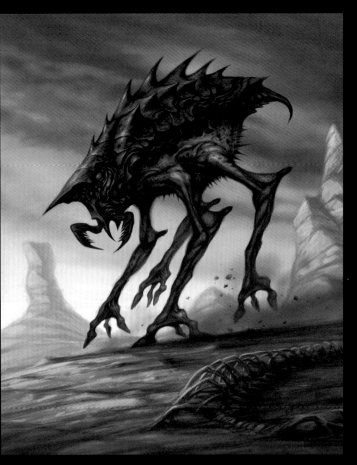

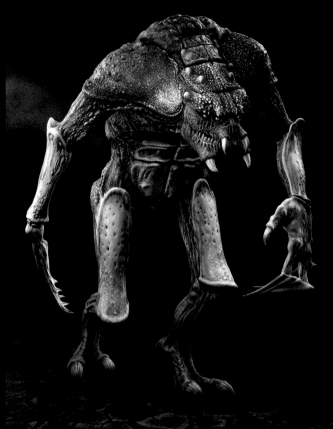

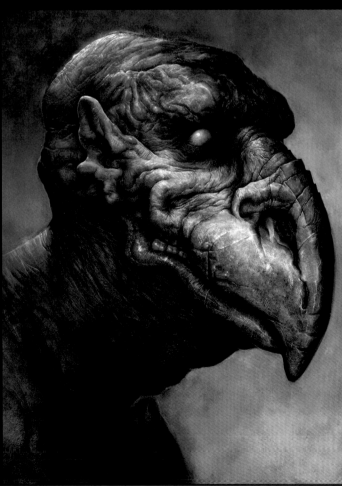

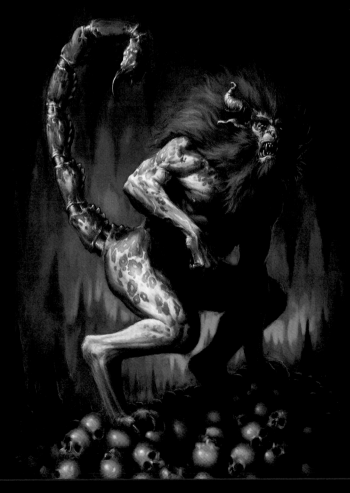

Sand Hopper
Photoshop
Mark Covell,
USA
[top]

Bird People
Photoshop, Painter
Halil Ural,
TURKEY
[above]

Monster from Hell
CINEMA 4D, ZBrush,
modo, Photoshop
Beatrix Papp, HUNGARY
[top]

Manticore
Photoshop
Markus Neidel,
GERMANY
[above]

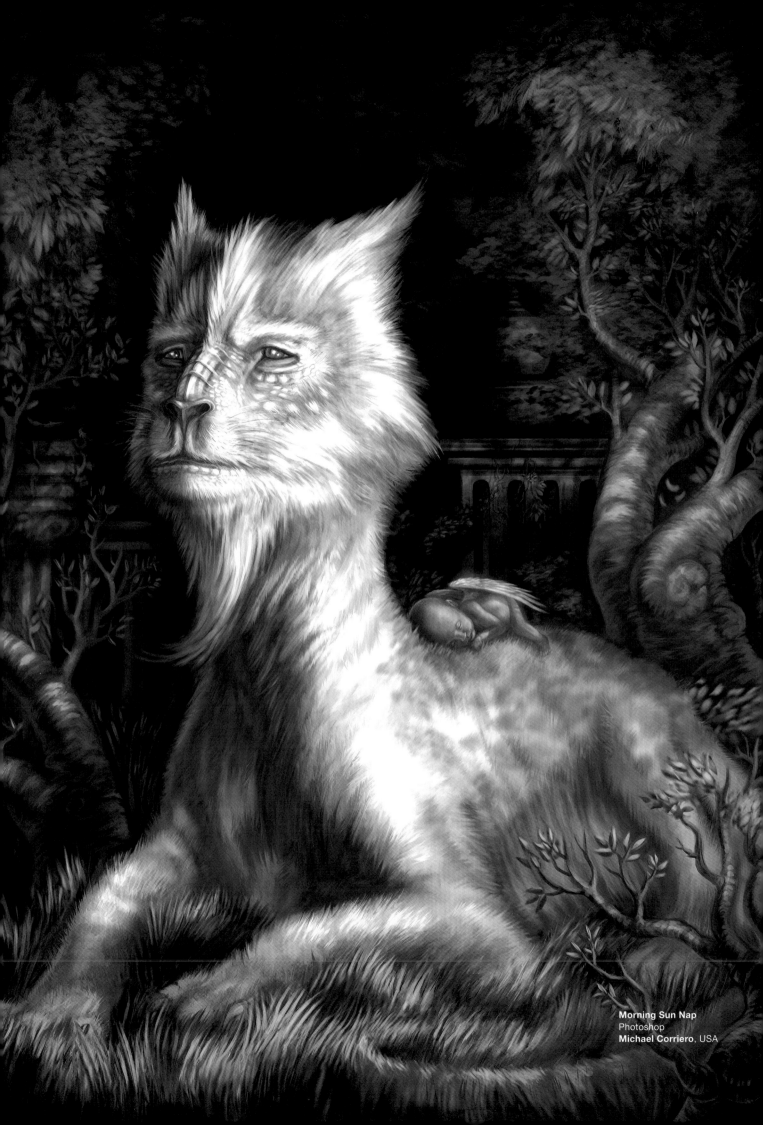

Morning Sun Nap
Photoshop
Michael Corriero, USA

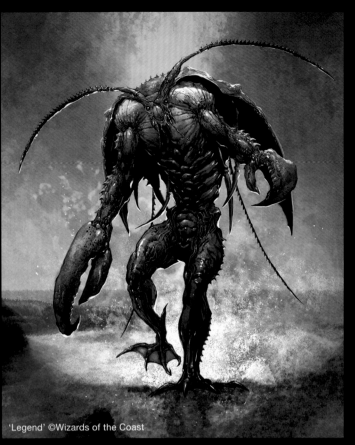

'Legend' ©Wizards of the Coast

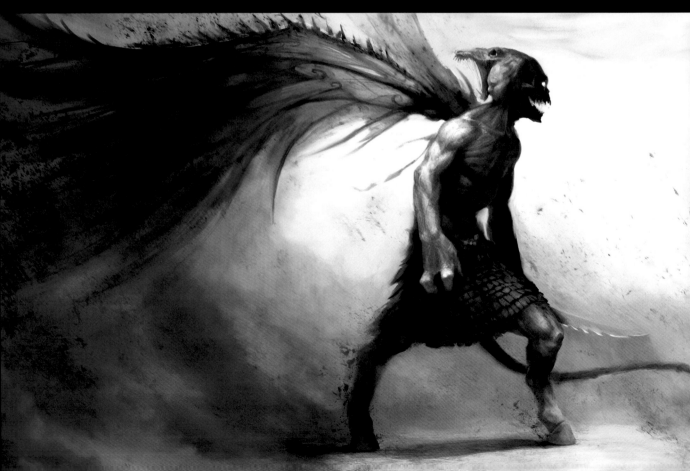

Legend: Ripper
Photoshop
Client: Wizards of the Coast
Francis Tsai, USA

Quietus
Photoshop, Painter
Branko Bistrovic,
CANADA

Nausicaa
3ds Max, V-Ray, After Effects
Inspired by: Hayao Miyazaki's 'Nausicaa'
Sergey Aleynikov, n3 design, RUSSIA

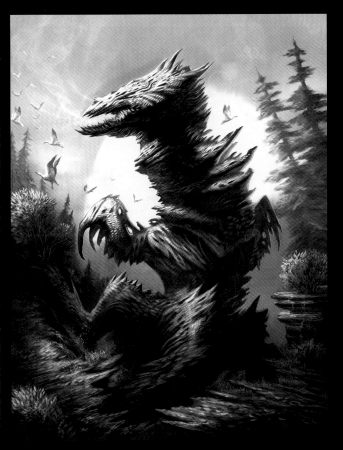

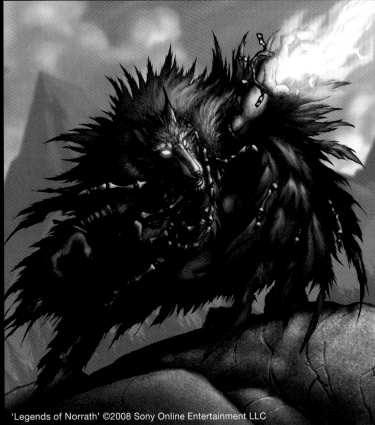

'Legends of Norrath' ©2008 Sony Online Entertainment LLC

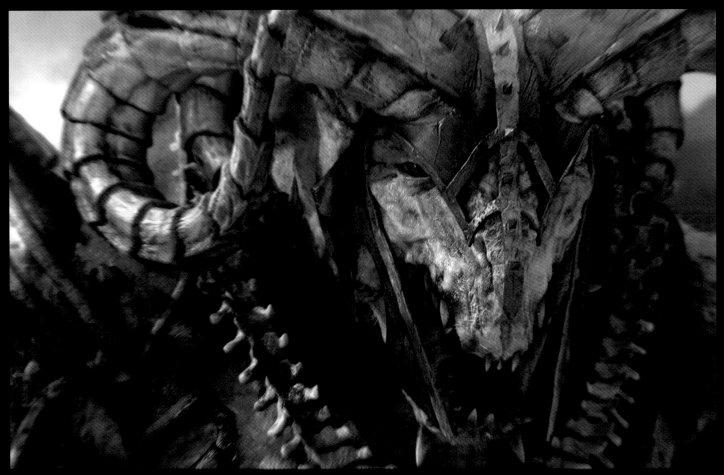

Samarium Dragon Elemental
Photoshop, Painter
Michael Corriero,
USA
[top]

Darkness Monster
SoftimageIXSI, ZBrush, Photoshop
Steve Jubinville and Yanick Gaudreau,
Hybride Technologie, CANADA
[above]

Legends of Norrath: Gnoll high shaman
Photoshop
Art Directors: Derek Herring, Joe Shoopack,
Sony Online Entertainment LLC
Patrick Ho, USA
[top]

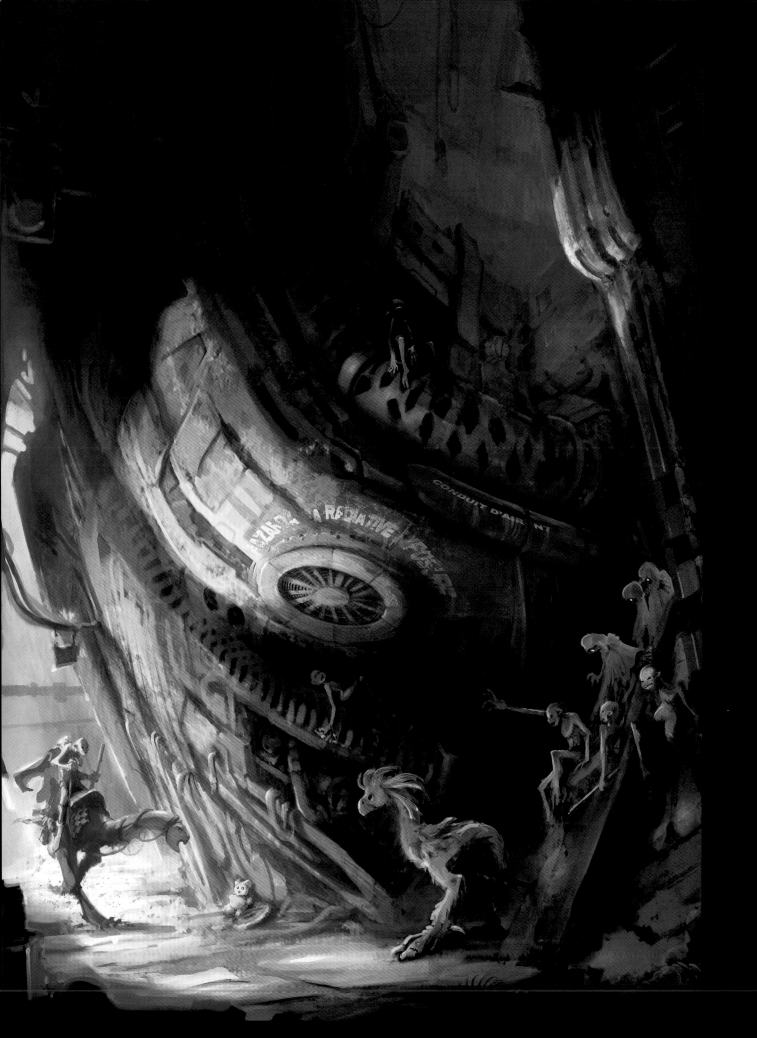

Master
Concept Art

The Dump
Photoshop
Maxime Desmettre,
CANADA

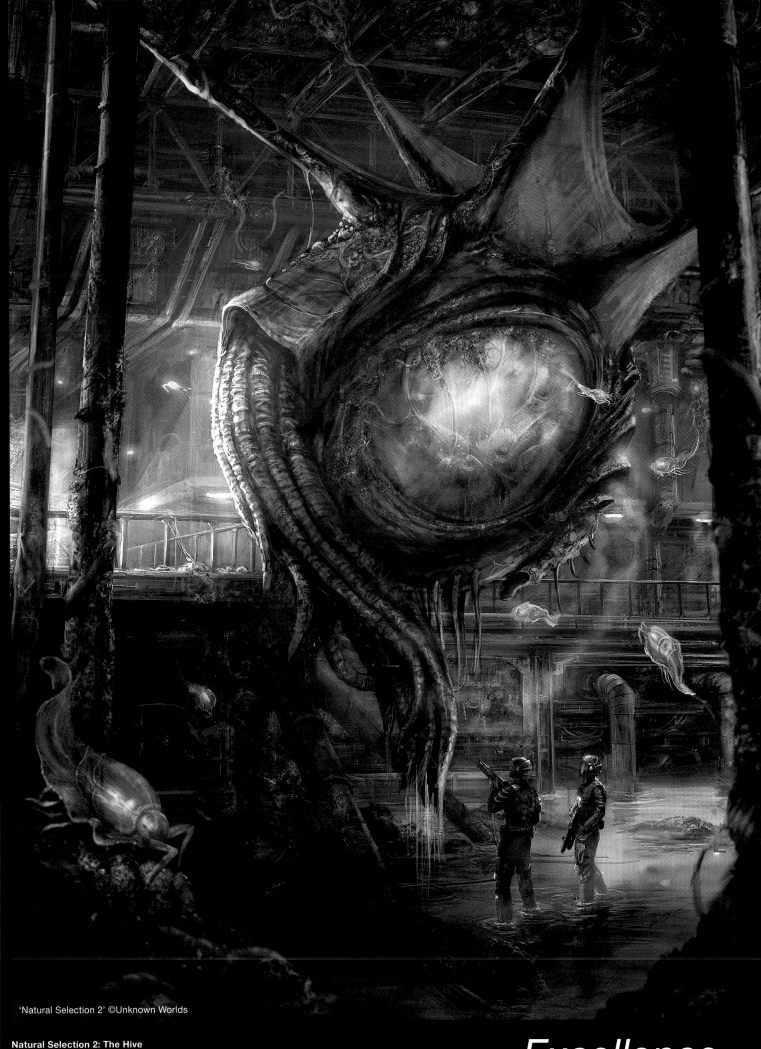

'Natural Selection 2' ©Unknown Worlds

Natural Selection 2: The Hive
Photoshop
Client: Unknown Worlds
Cory Strader, USA

Excellence
Concept Art

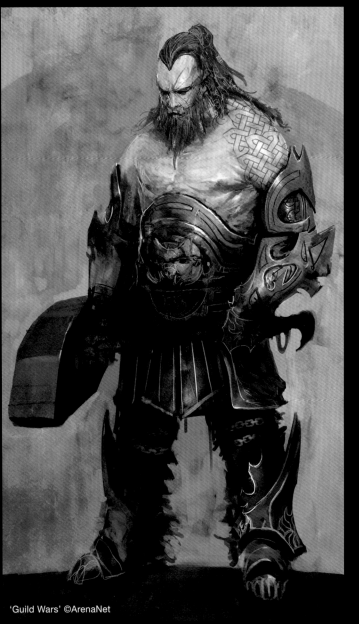

'Guild Wars' ©ArenaNet

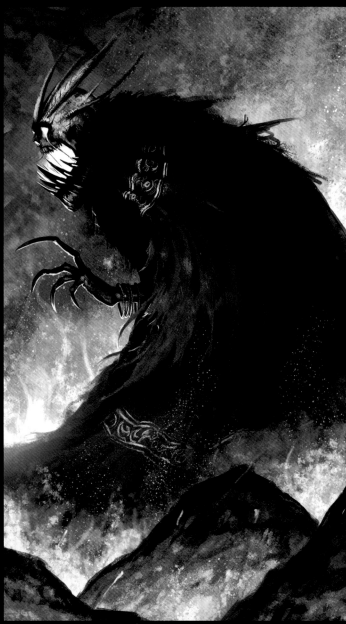

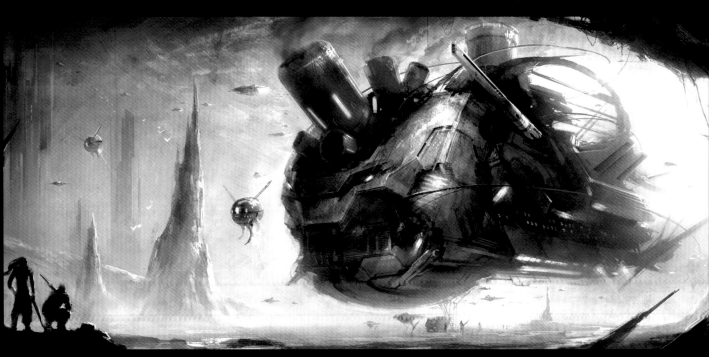

Guild Wars: Norn Warrior
Photoshop
Client: ArenaNet
Kekai Kotaki, USA
[top]

External ship
Photoshop
Jong-Won Park,
KOREA
[above]

Dark Lord
Photoshop
Xavier Collette,
BELGIUM
[top]

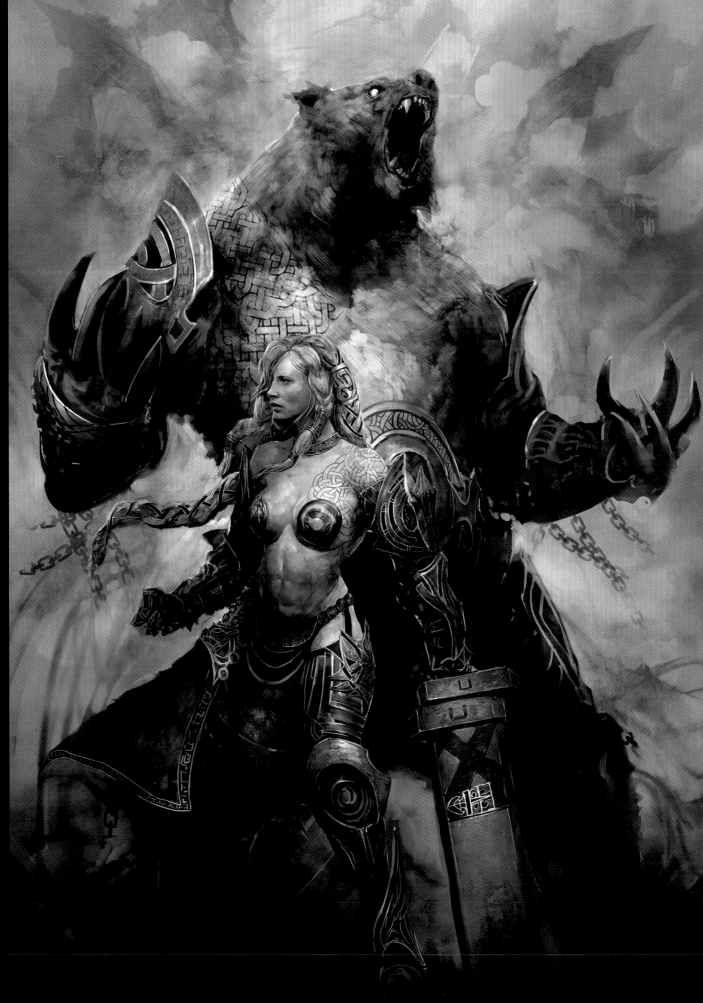

'Guild Wars' ©ArenaNet

Guild Wars: Jora
Photoshop
Client: ArenaNet
Kekai Kotaki, USA

Excellence
Concept Art

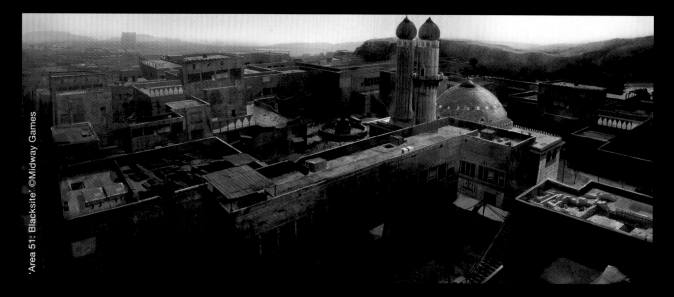

'Area 51: Blacksite' ©Midway Games

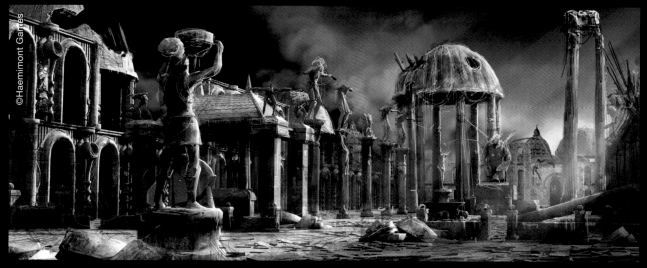

©Haemimont Games

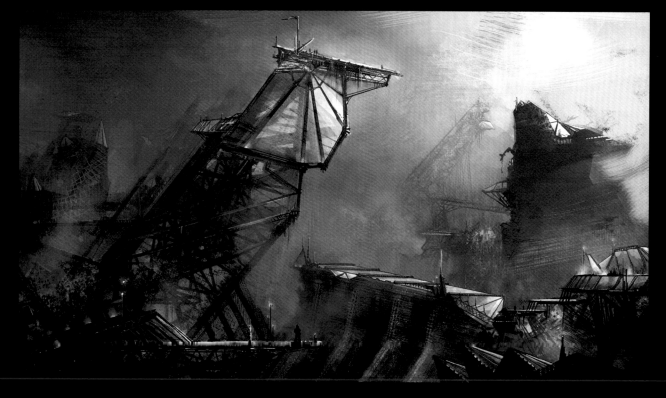

Area 51: Blacksite (Iraq Overview)
3ds Max, Photoshop
Bruno Werneck, Midway Games,
USA
[top]

Afterwar
3ds Max, Photoshop
Client: Haemimont Games
Dimitar Tzvetanov, BULGARIA
[center]

Future City Concept
Photoshop
Björn Wirtz,
GERMANY
[above]

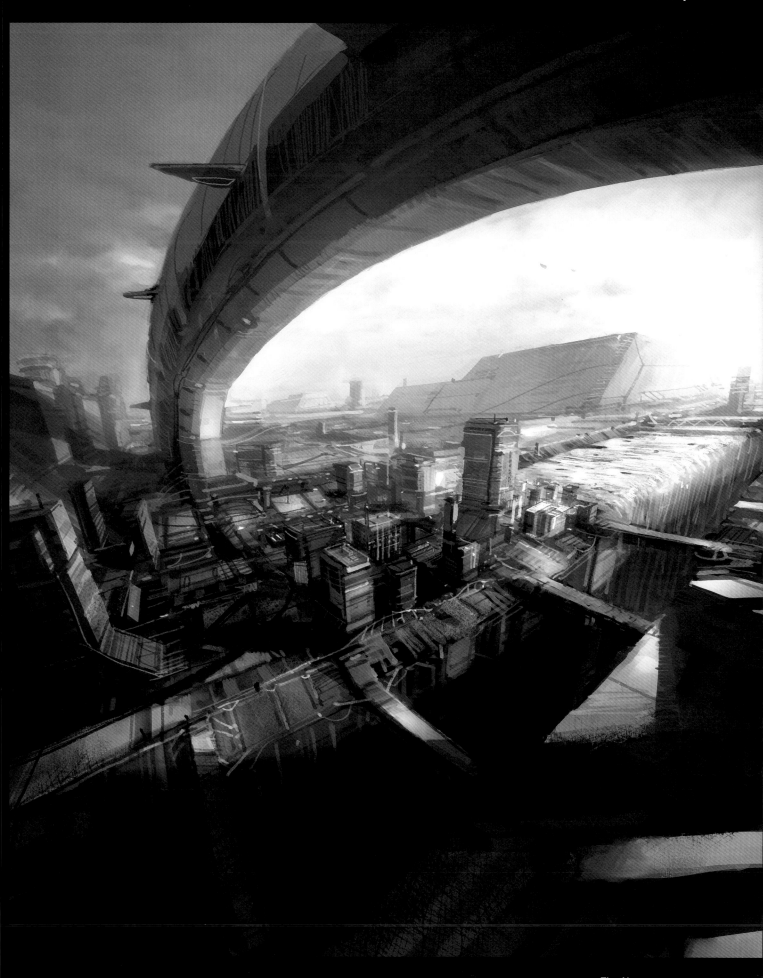

The Abyss
Photoshop
Lorenz Hideyoshi Ruwwe,
GERMANY

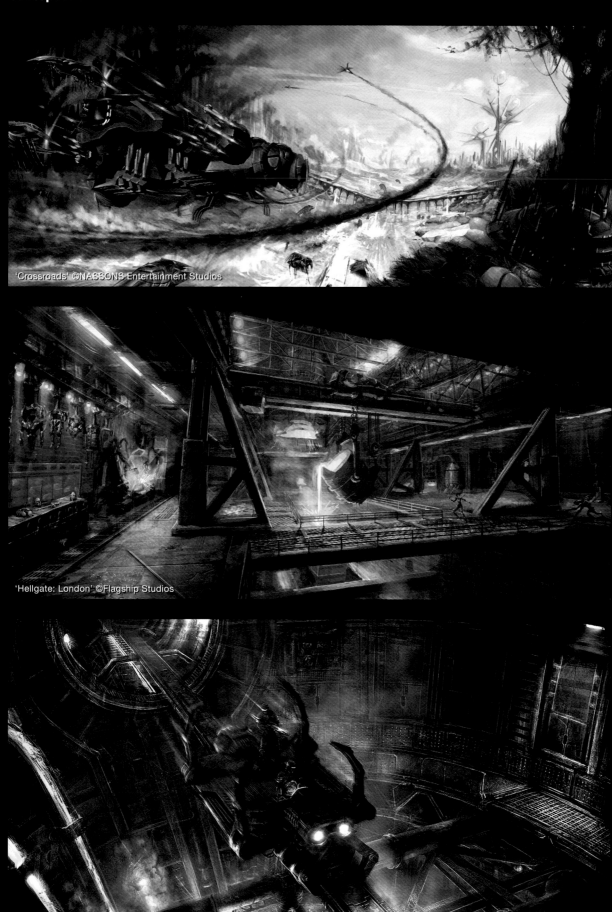

'Crossroads' ©NASSONS Entertainment Studios

'Hellgate: London' ©Flagship Studios

'Natural Selection 2' ©Unknown Worlds

Crossroads: Waves of conflicts
Photoshop, Painter
Client: NASSONS Entertainment Studios
Wala`a Haddad, JORDAN
[top]

Hellgate: London (Templar Foundry)
Photoshop
Client: Flagship Studios
Ben Shafer, USA
[center]

Natural Selection 2: Hot Ride
Photoshop
Client: Unknown Worlds
Cory Strader, USA
[above]

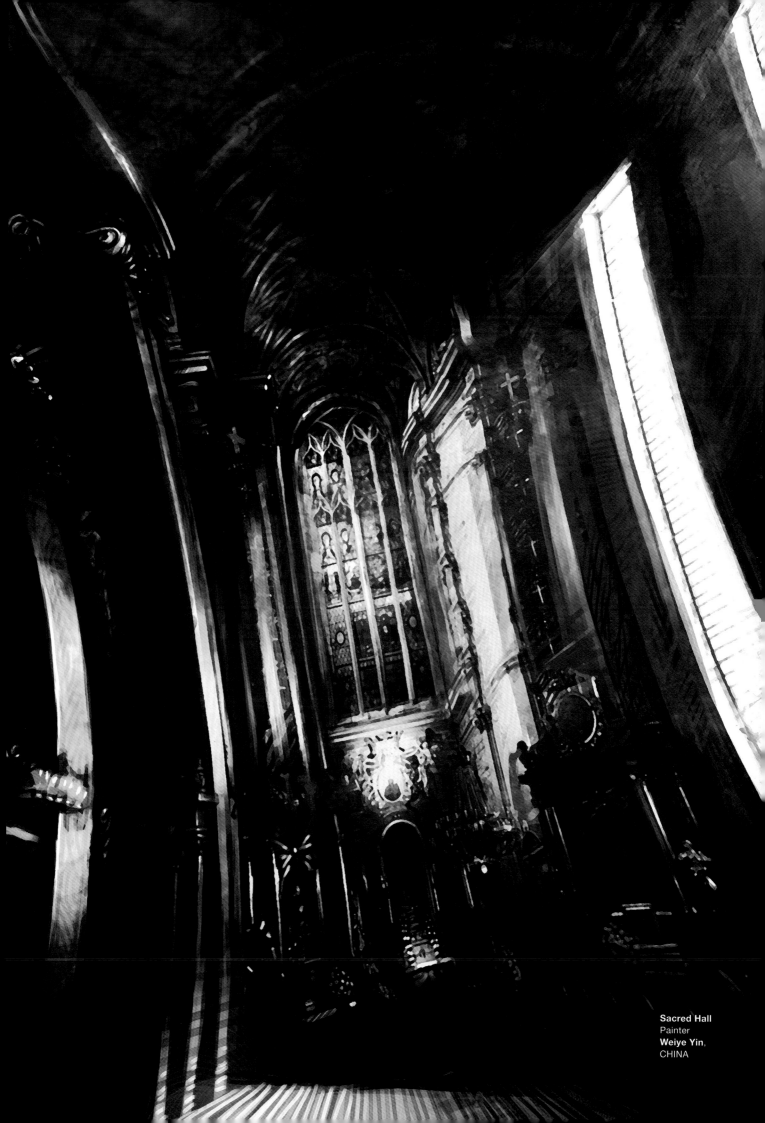

Sacred Hall
Painter
Weiye Yin,
CHINA

Wolf
Photoshop
Martin Deschambault
CANADA
[left]

The Hunter
Photoshop
Pablo Vicentin,
ARGENTINA
[right]

Yeti
Photoshop
Martin Deschambault,
CANADA
[left]

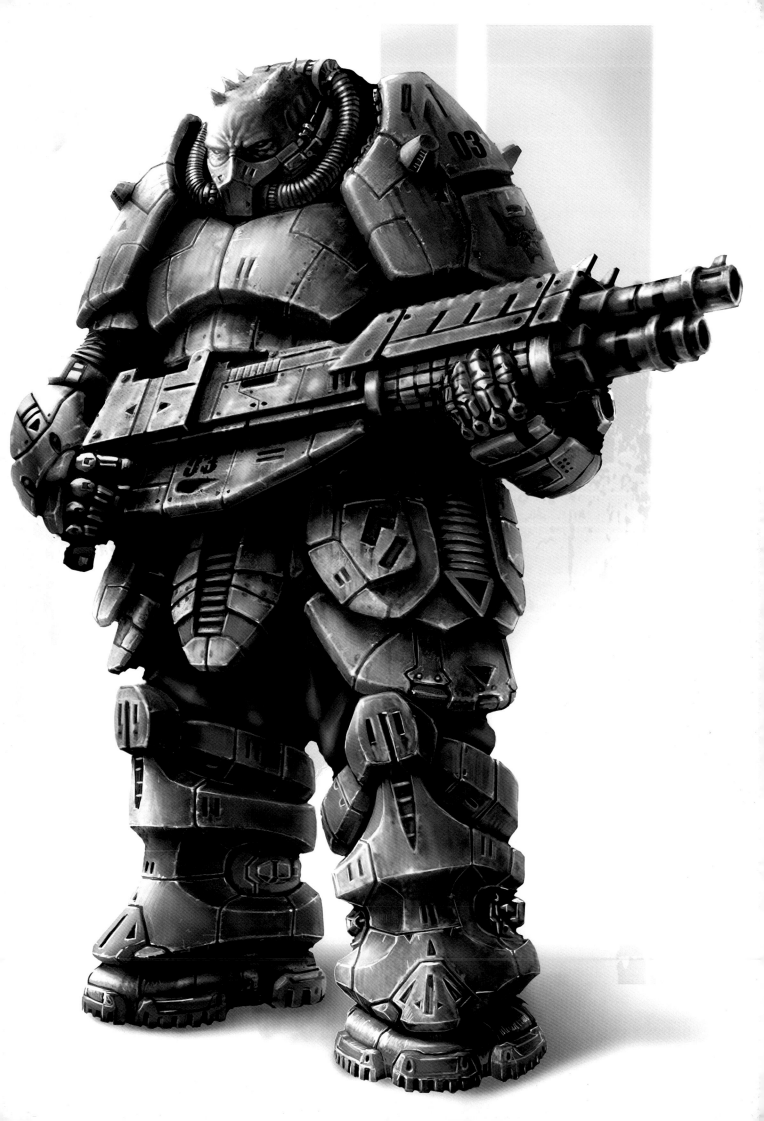

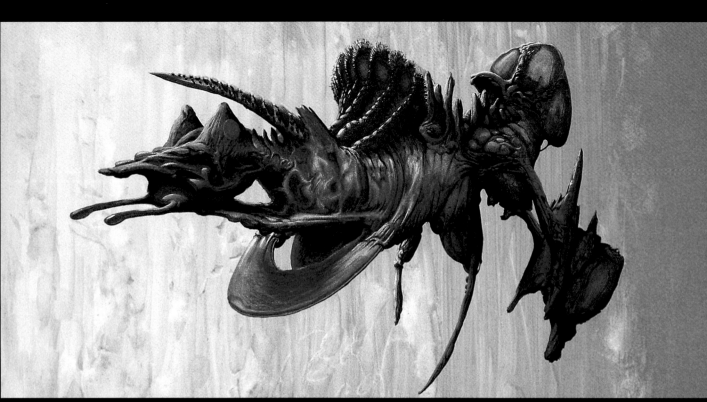

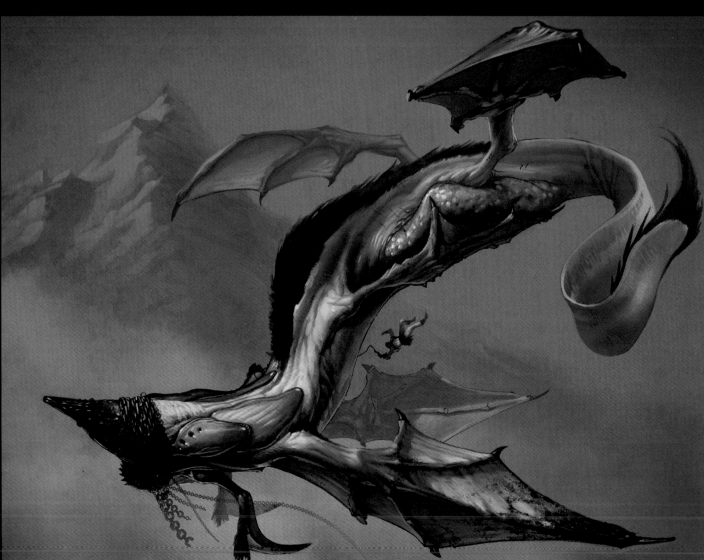

Gasfloater II

Blind Dragon concept

Space Cowboys

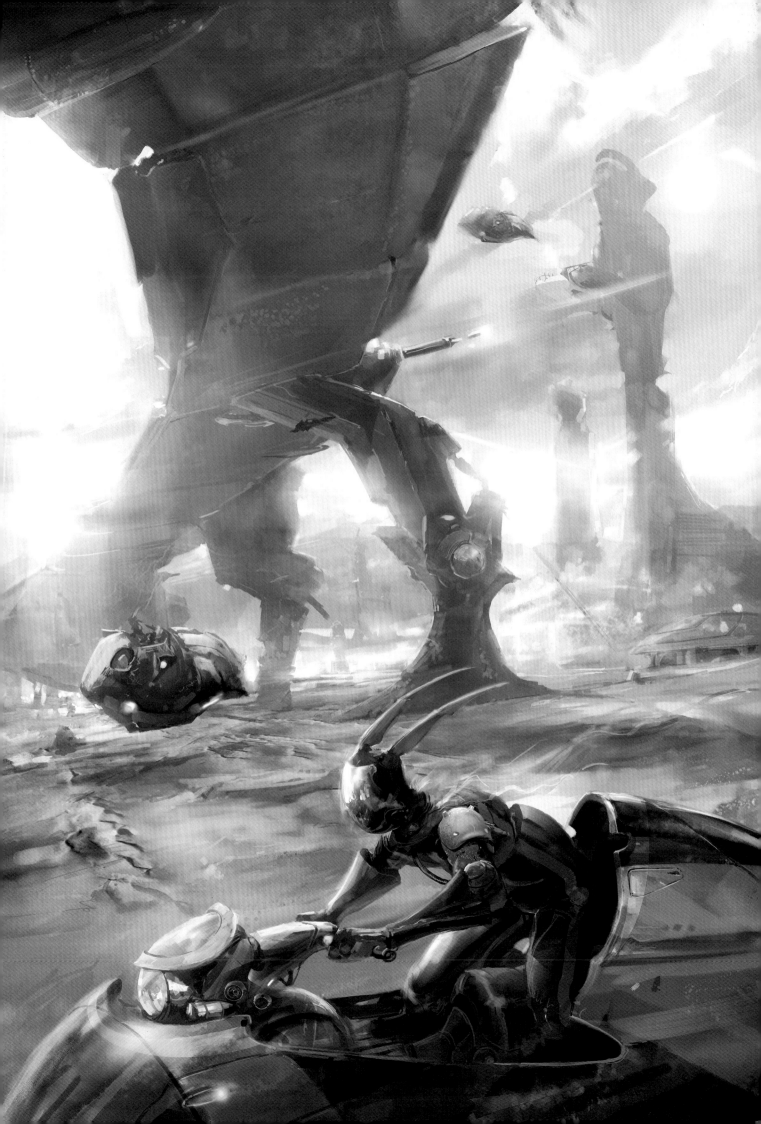

Dreaming Rome
Photoshop, Maya, Combustion
Marco Genovesi, ITALY
[top]

City of delusion
Photoshop
Martin Bland, GREAT BRITAIN
[above]

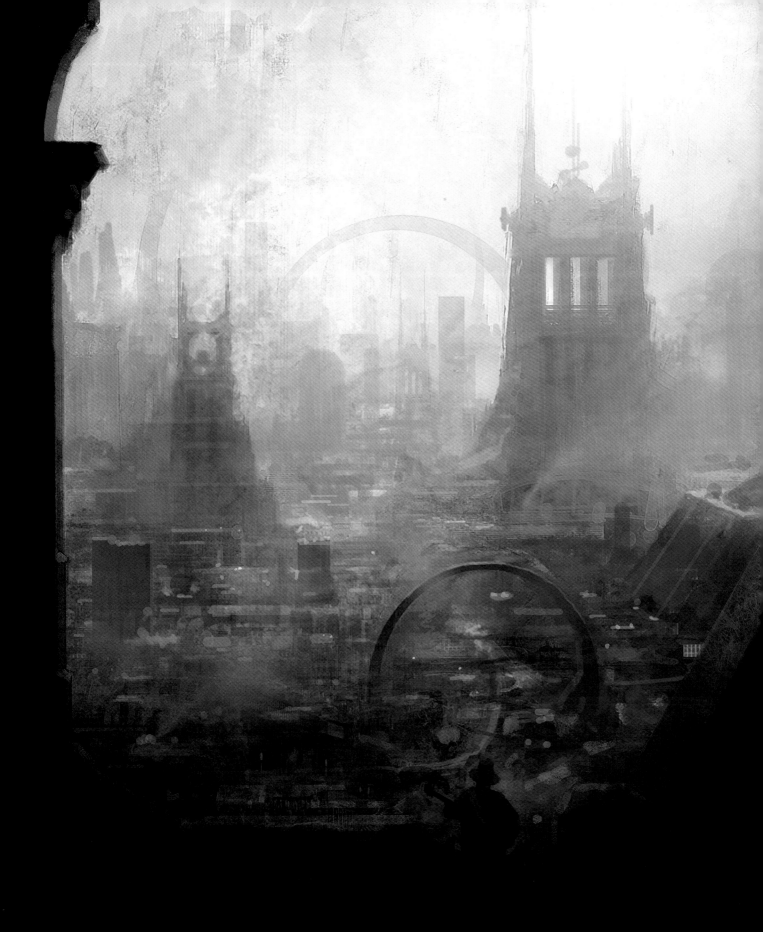

Rooftop Blues
Photoshop
Joe Studzinski,
USA

Master
Matte Painting

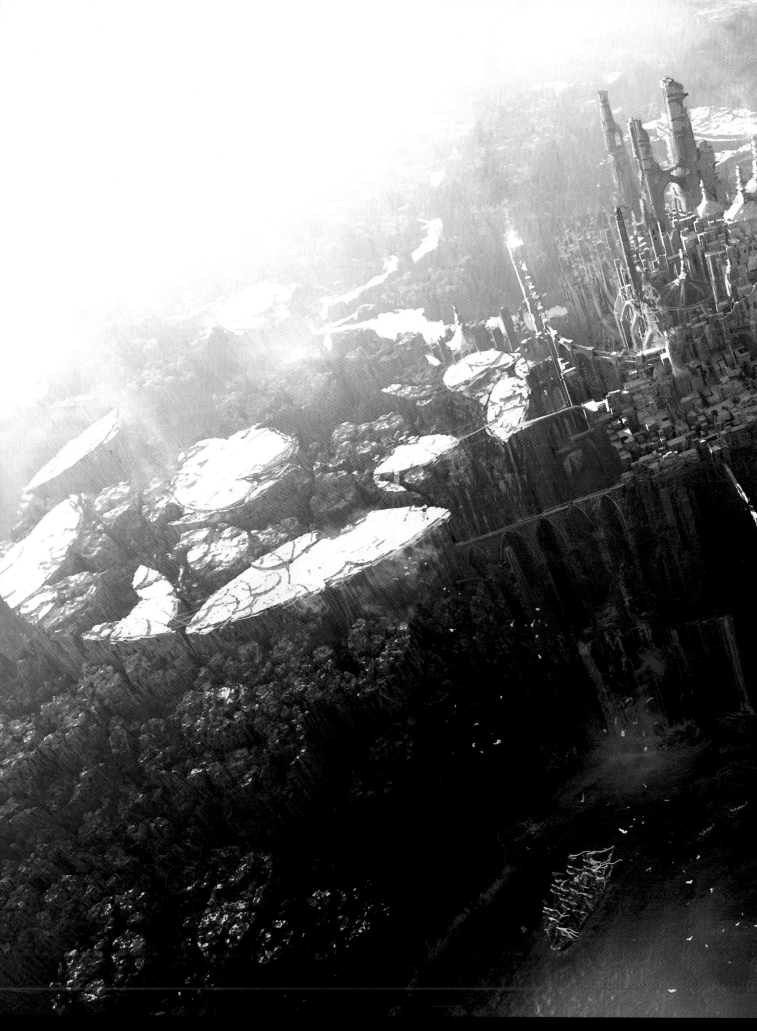

Excellence
Matte Painting

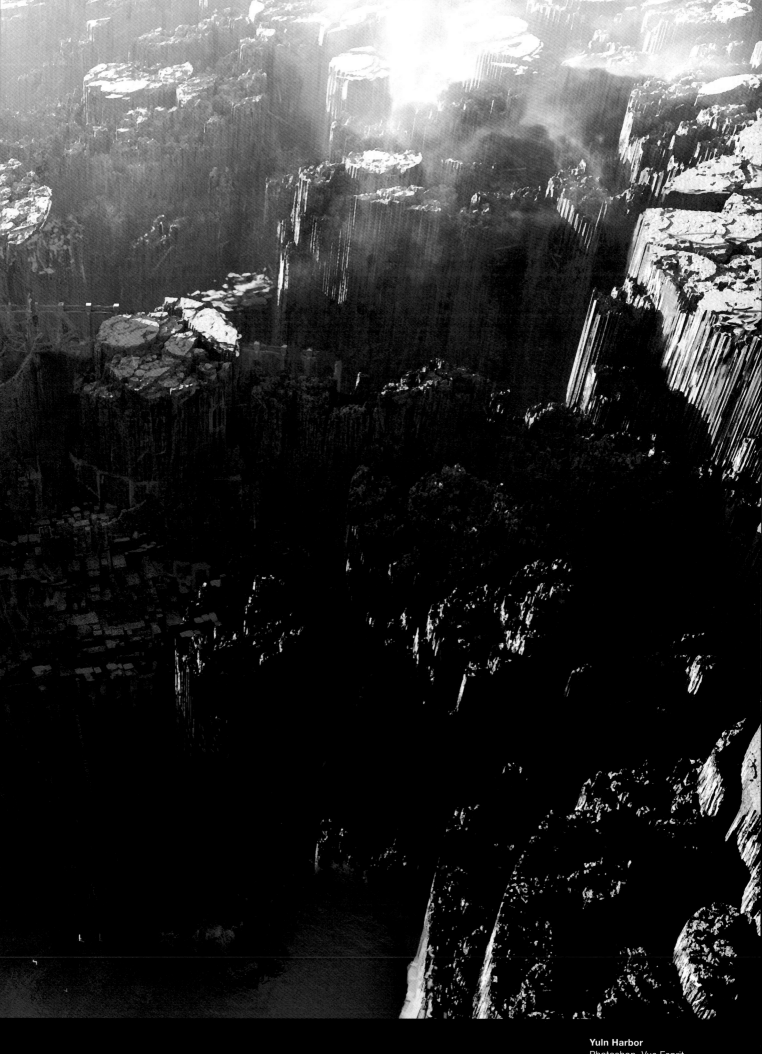

Yuln Harbor
Photoshop, Vue Esprit
Mark Goldsworthy, USA

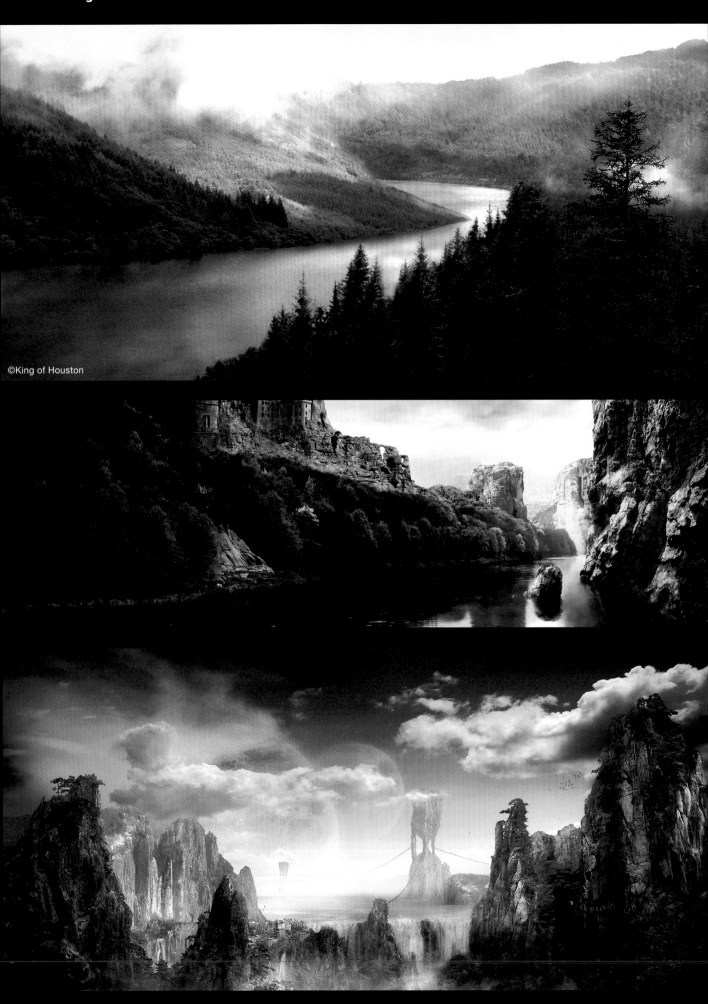

Hokkaido
Photoshop
Tiberius Hoaghea-Viris,
King of Houston, ROMANIA
[top]

Remnants of the Past
Photoshop
Daniel Alekow,
GERMANY
[center]

Long Way Home
Photoshop
Christian 'Tigaer' Hecker,
GERMANY
[above]

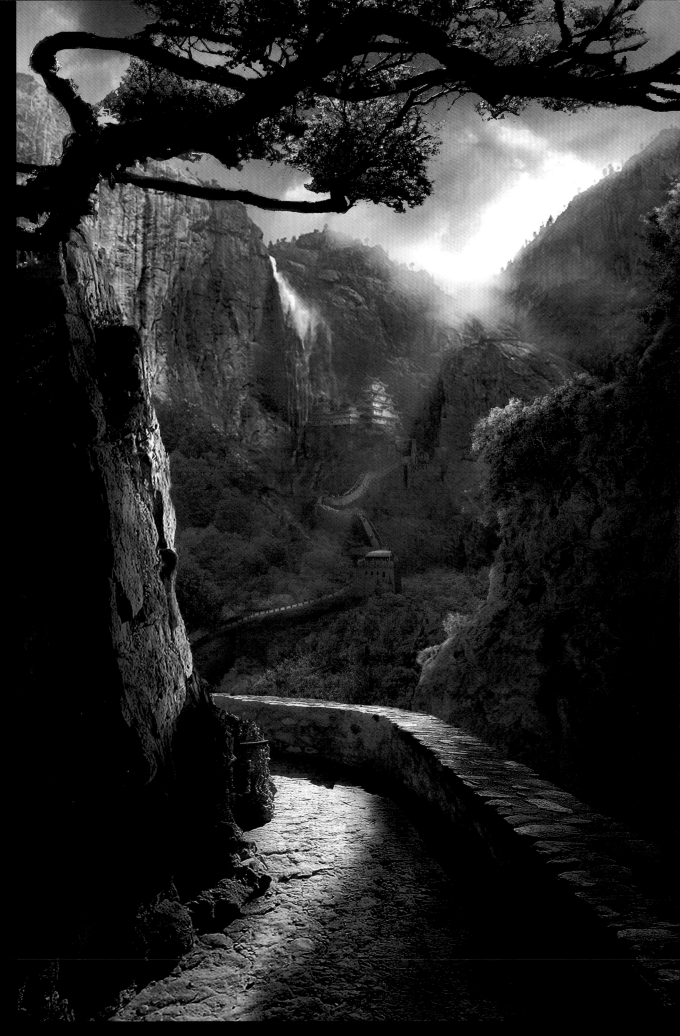

Hall of the Dragon Mist
Photoshop
Tiberius Hoaghea-Viris,
King of Houston, ROMANIA

Excellence
Matte Painting

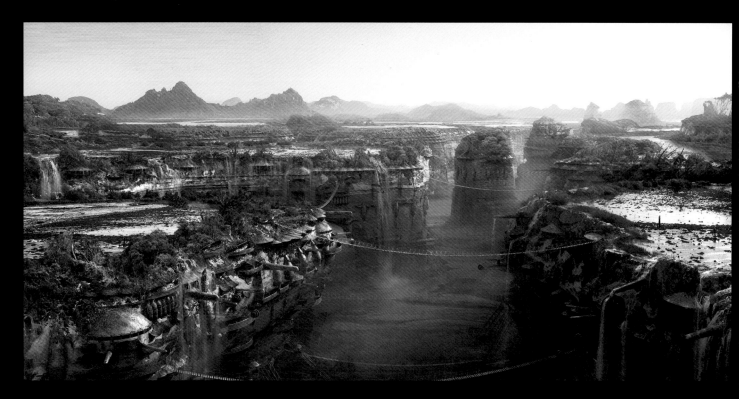

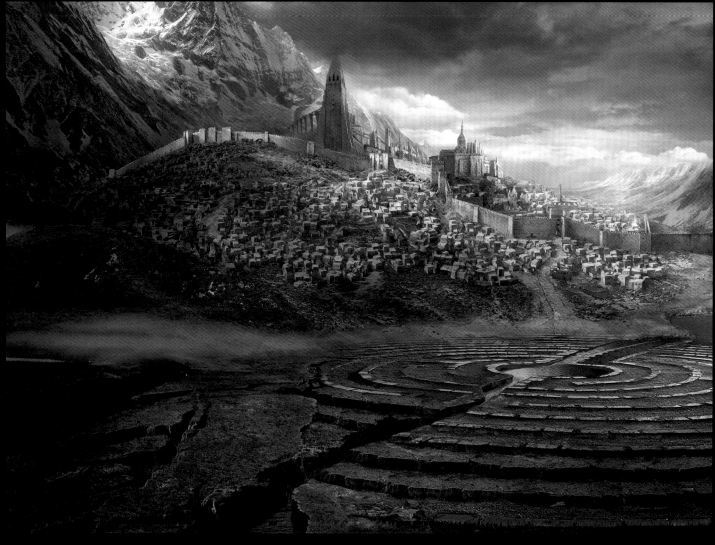

Cliff dwellings
Photoshop, 3ds Max
Brenton Cottman, USA
[top]

Kingdom
Photoshop
Dana Daukshta, LATVIA
[above]

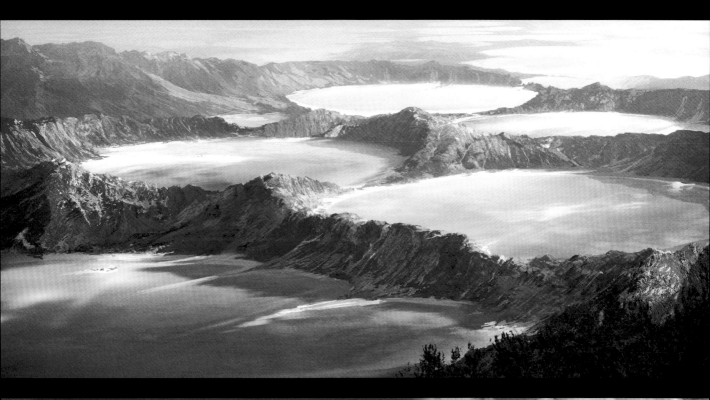

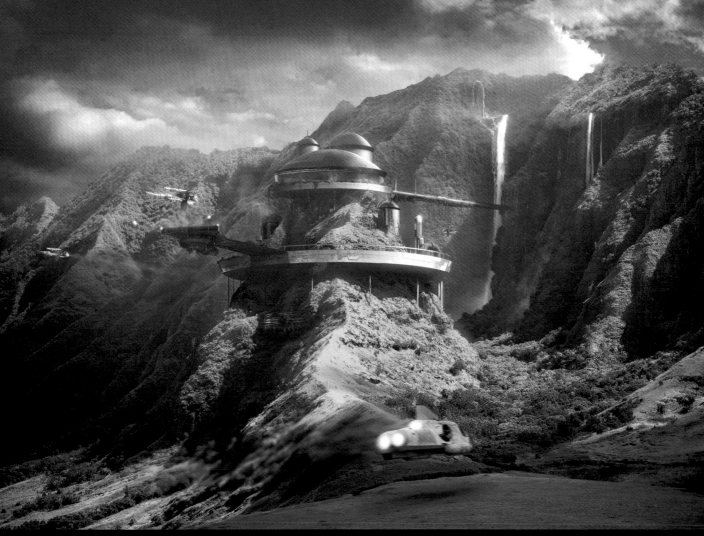

Mars Terraformed
Photoshop
Tuomas Korpi, FINLAND
[top]

Area 53
Photoshop
Amir Salehi, USA
[above]

Matte Painting

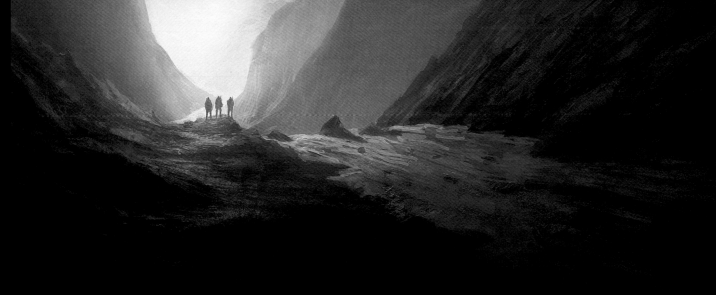

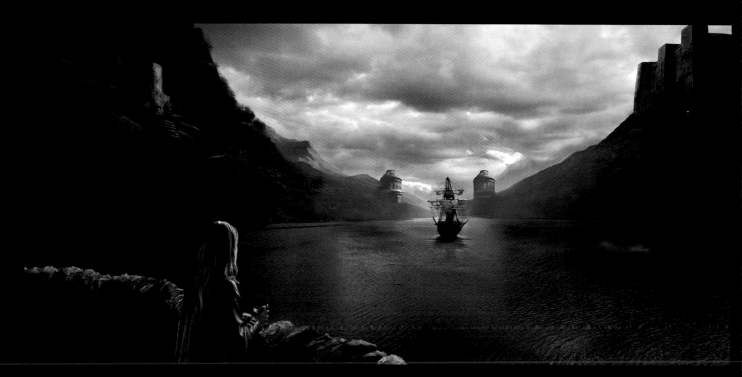

Before the storm
Photoshop, Vue Esprit
Dimitar Tzvetanov,
BULGARIA
[top]

Checkpoint C
Photoshop
Joe Studzinski,
USA
[center]

The last ship
Photoshop
Ehsan Dabbaghi,
IRAN
[above]

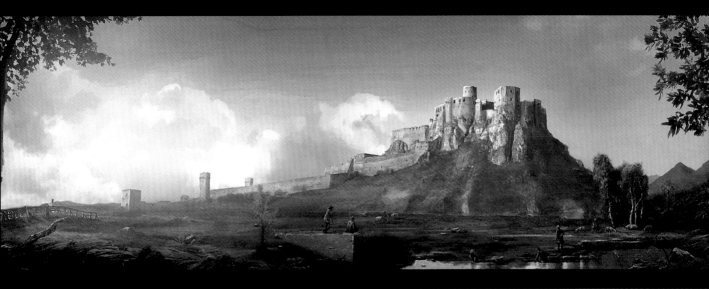

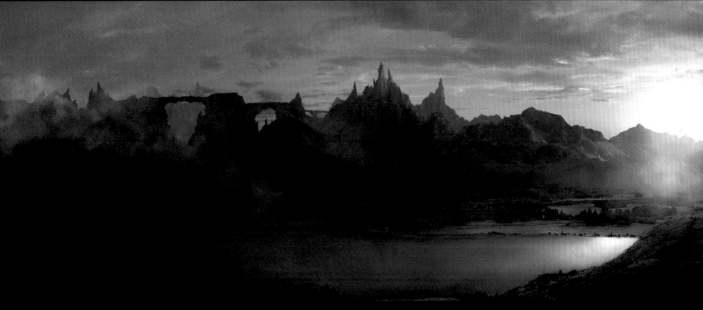

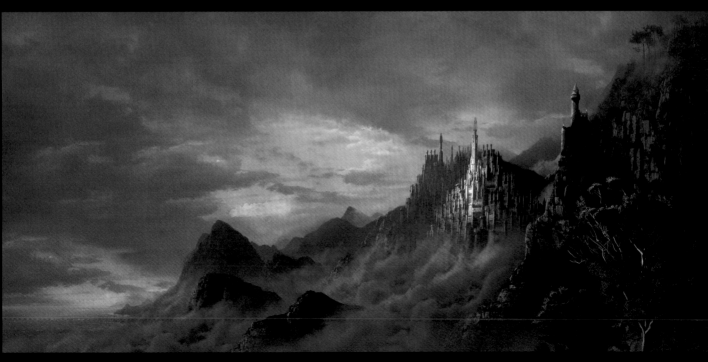

A man in the red hat
Photoshop
Lubos dE Gerardo Surzin, dE Gerard-Studio,
GREAT BRITAIN
[top]

Drakko: At the Edge of the Realm
Photoshop
Tiberius Hoaghea-Viris, King of Houston,
ROMANIA
[center]

Dreamscape
Photoshop
Sarel Theron,
SOUTH AFRICA
[above]

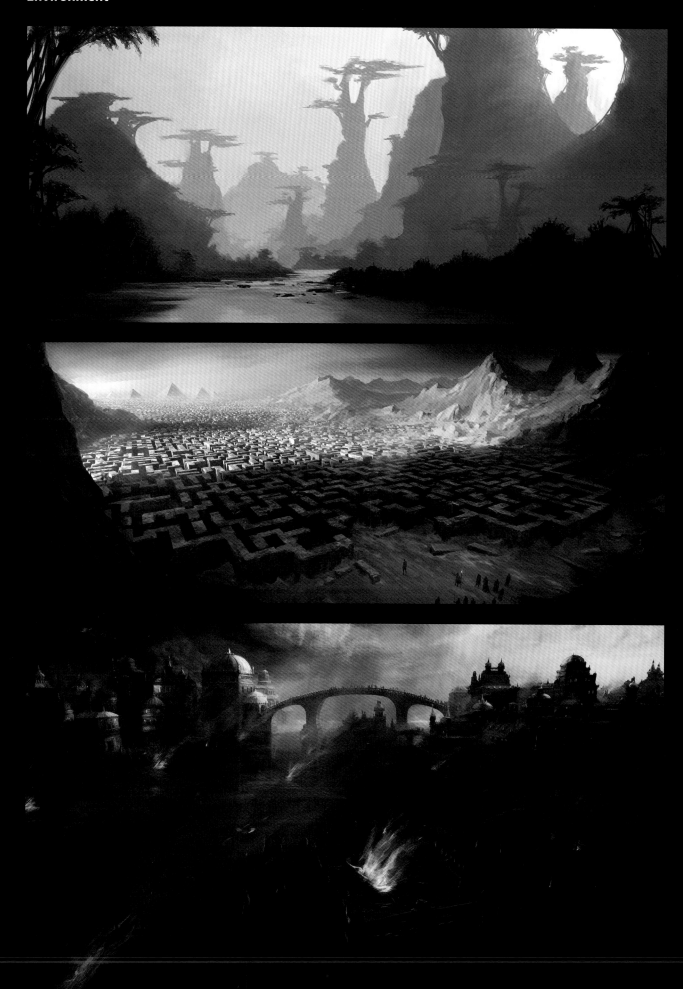

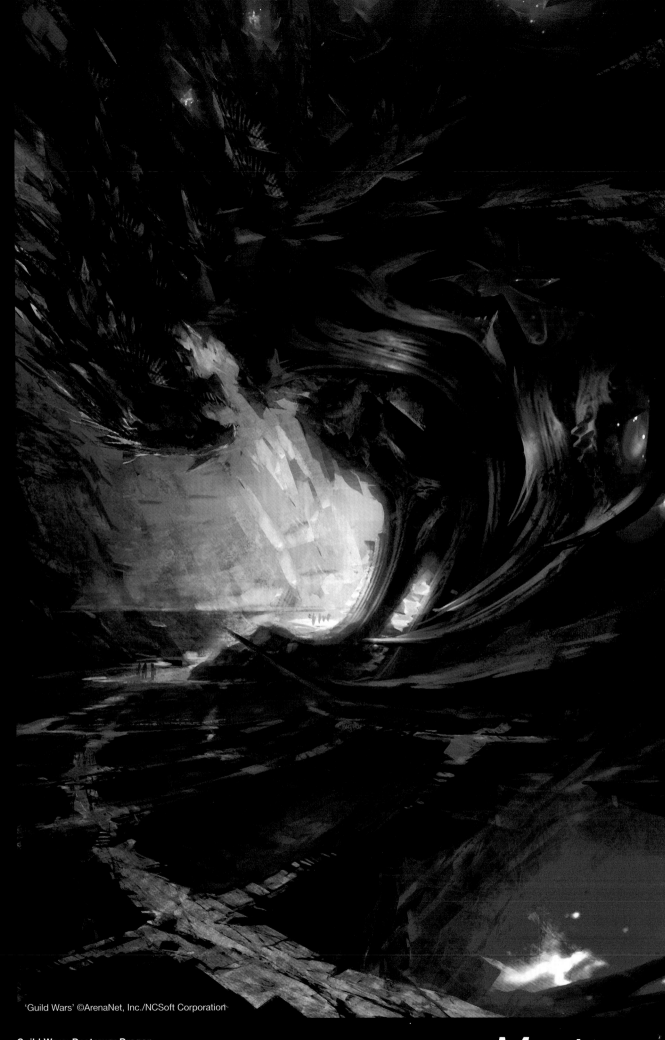

Guild Wars: Destroyer Dragon
Photoshop
Daniel Dociu, ArenaNet, USA

Master
Environment

Excellence

Environment

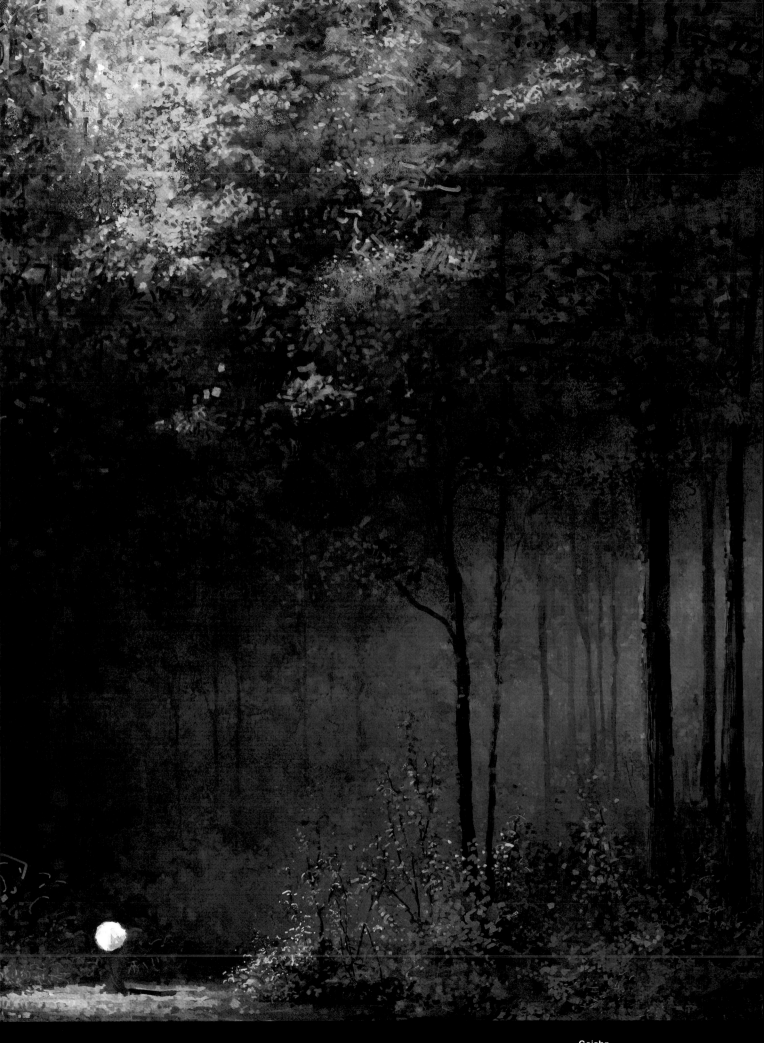

Geisha
Painter, Photoshop
Lukasz Pazera, GREAT BRITAIN

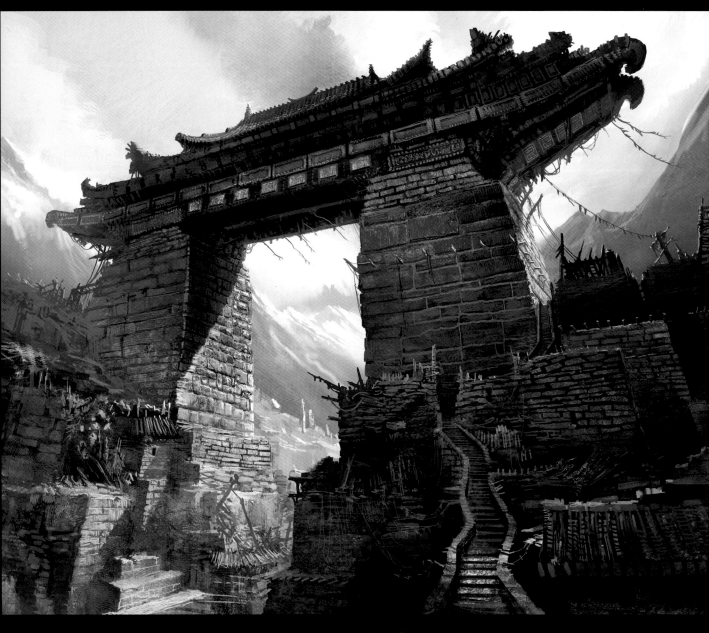

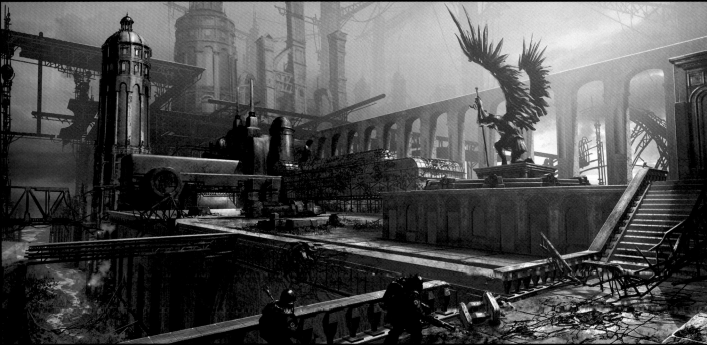

Gate of Gods
Photoshop
Jussi Lehtiniemi, FINLAND
[top]

Lost city
Photoshop
Tomasz Jedruszek, POLAND
[above]

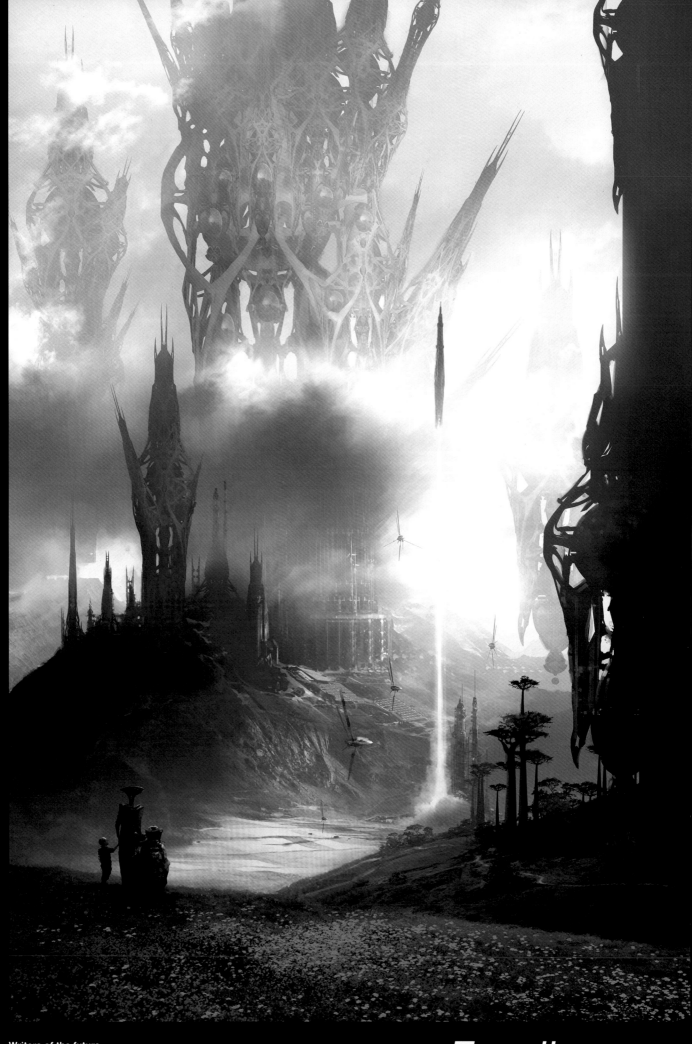

Writers of the future
Photoshop, Painter
Client: Galaxy Press
Stephan Martiniere, USA

Excellence
Environment

Environment

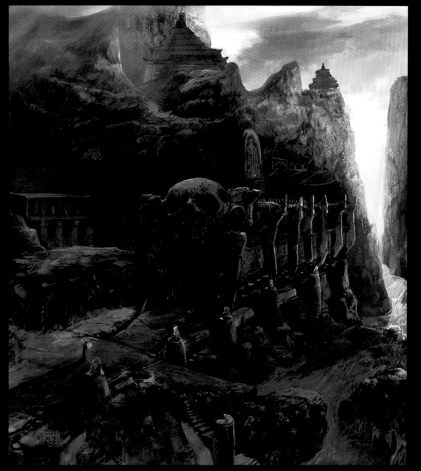

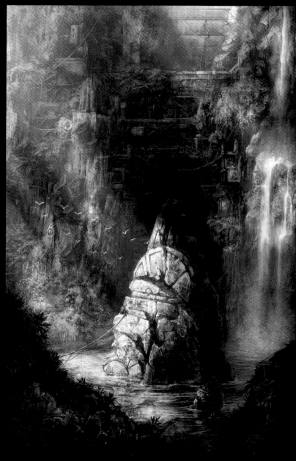

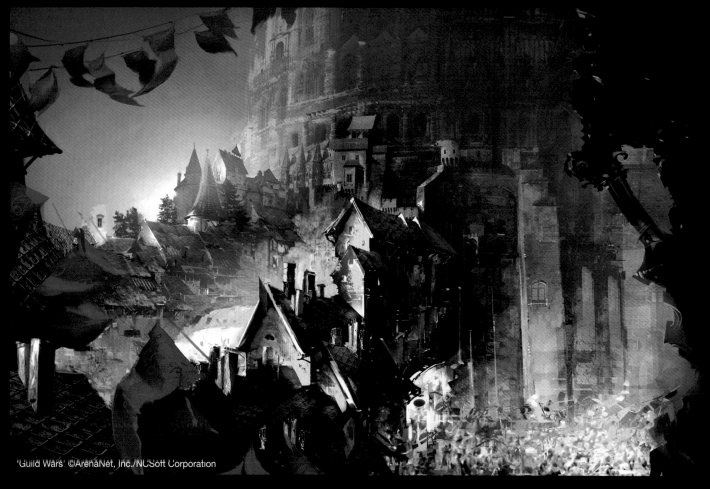

'Guild Wars' ©ArenaNet, Inc./NCSoft Corporation

Grave of Souls
Photoshop
Hong Kuang, SINGAPORE
[top]

Guild Wars: Carnival Season
Photoshop
Daniel Dociu, ArenaNet, USA
[above]

Fantasy Island
Photoshop
Peter Lee, USA
[top]

Waterfall
Photoshop
Client: ImagineFX
Hong Kuang, SINGAPORE [right]

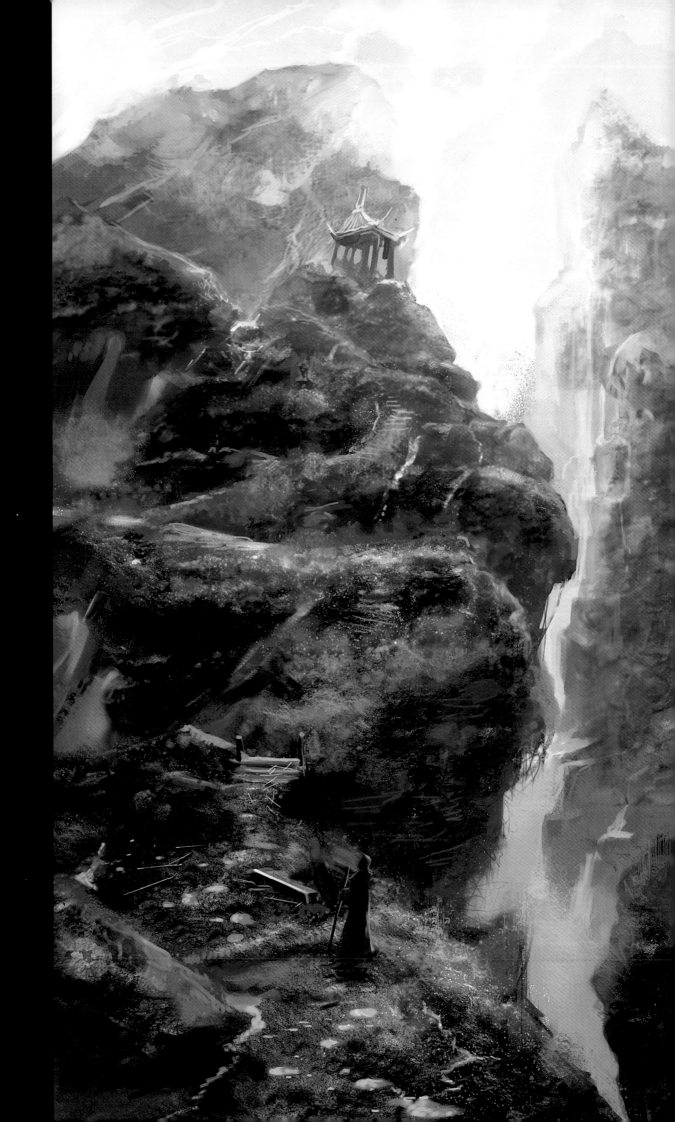

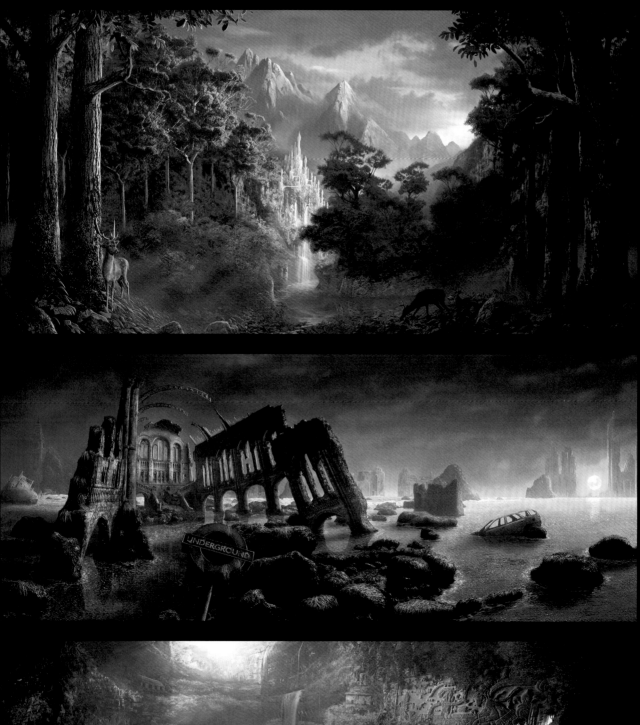
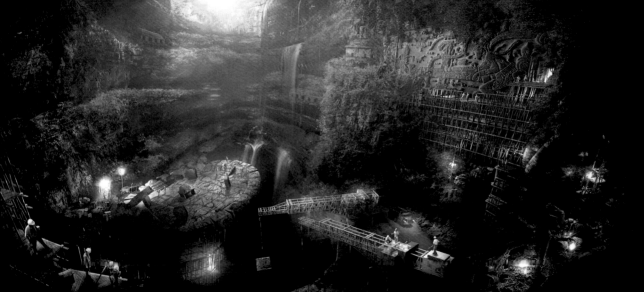

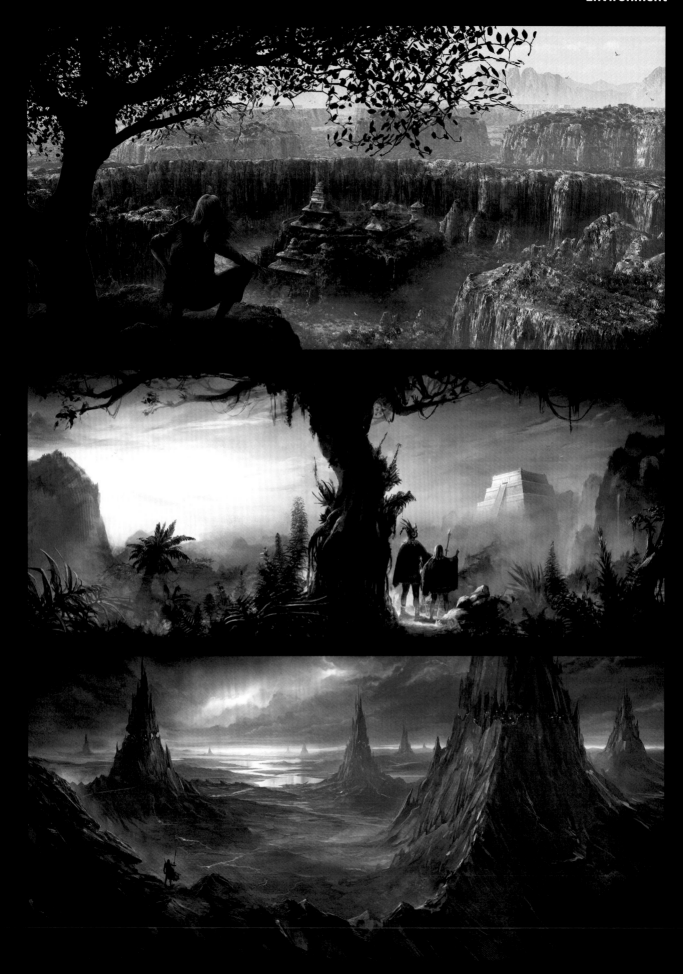

Lost
Photoshop, Vue xStream
Kerem Beyit,
TURKEY
[top]

First Sight
Photoshop
Client: Suhrkamp
Björn Wirtz, GERMANY
[center]

Cliff dwellings
Photoshop
Jesse van Dijk,
NETHERLANDS
[above]

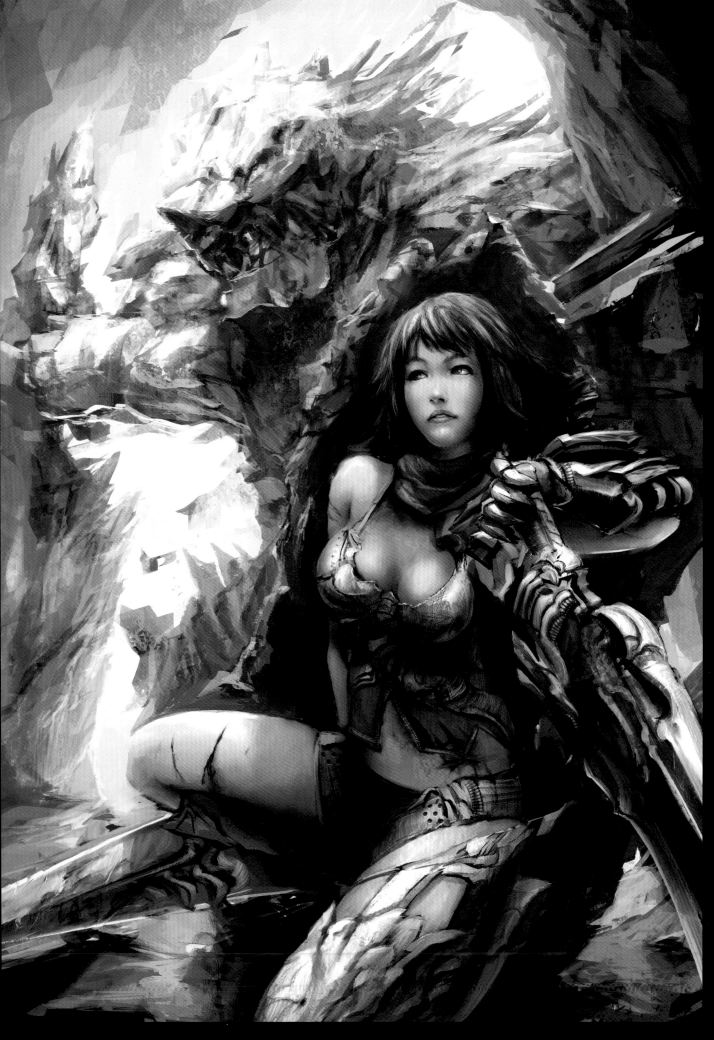

Master
Warriors

One Knight One Monster
Photoshop, Painter
Takkaya Leeladechakul,
THAILAND

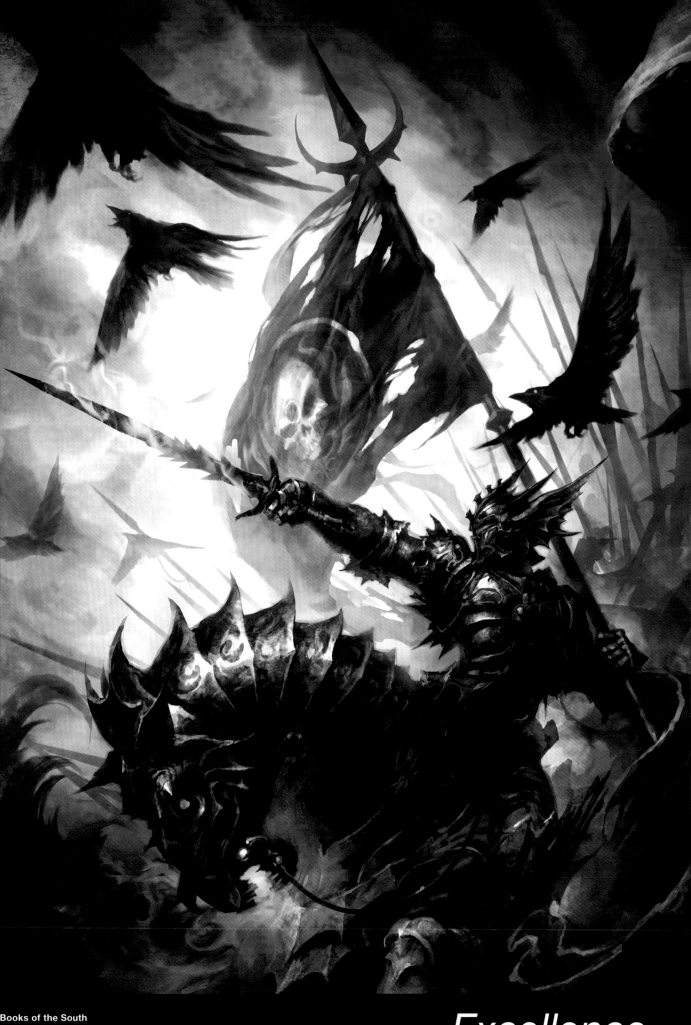

Books of the South
Photoshop
Client: Tor Books
Art Director: Irene Gallo
Raymond Swanland, USA

Excellence
Warriors

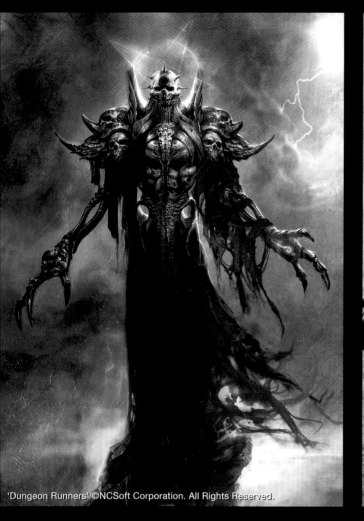

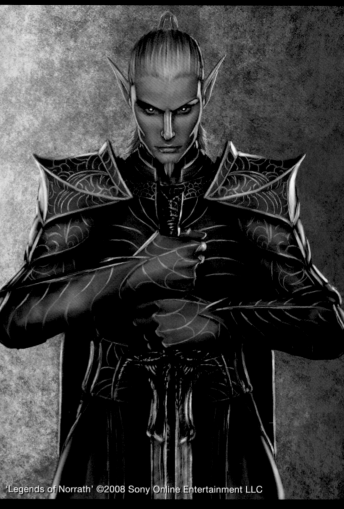

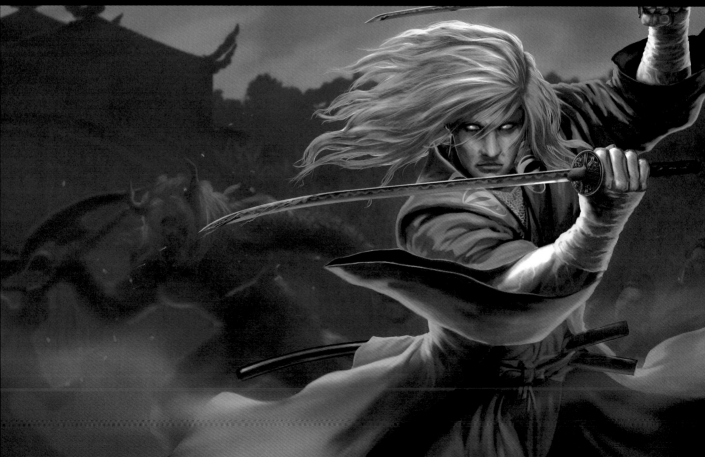

Dungeon Runners: Ghost image
Photoshop
Client: NCSoft Corporation
Art Director: Jon Jones
Aleksi Briclot, FRANCE *[top]*

Ghost Samurai
Photoshop
Anthony Moy,
USA
[above]

Legends of Norrath: Mayong Mistmoore
Photoshop
Derek Herring, Sony Online Entertainment LLC,
USA
[top]

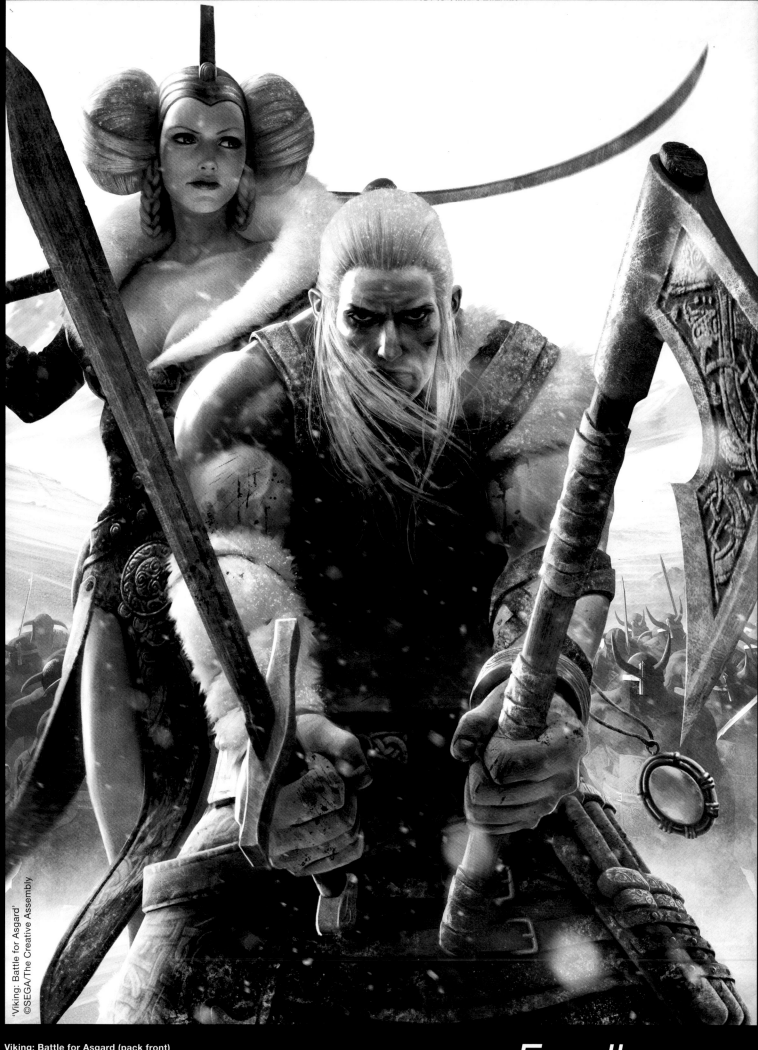

Viking: Battle for Asgard (pack front)
Painter, Photoshop
Client: SEGA/The Creative Assembly
Michael Kutsche,
GERMANY

Excellence

Warriors

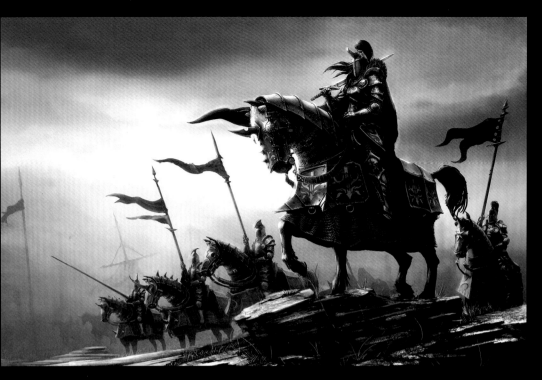

Caballery
Photoshop
Pablo Vicentin,
ARGENTINA
[left]

Dragon's Knight
Photoshop
Pablo Vicentin,
ARGENTINA
[right]

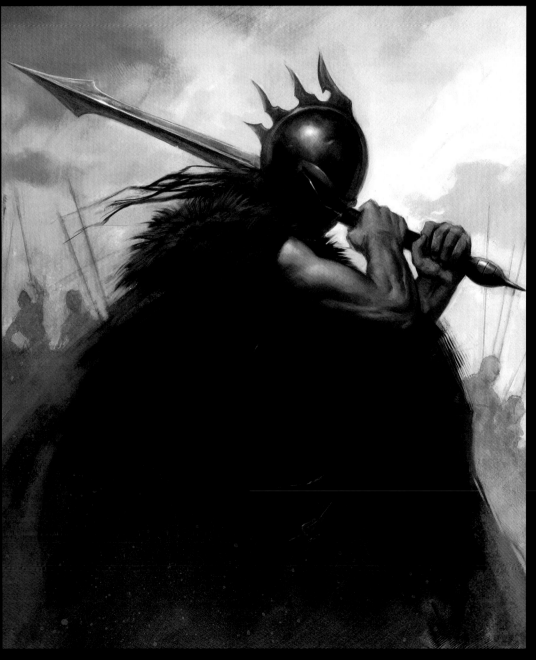

The Warrior
Painter
Alan Lathwell,
GREAT BRITAIN
[left]

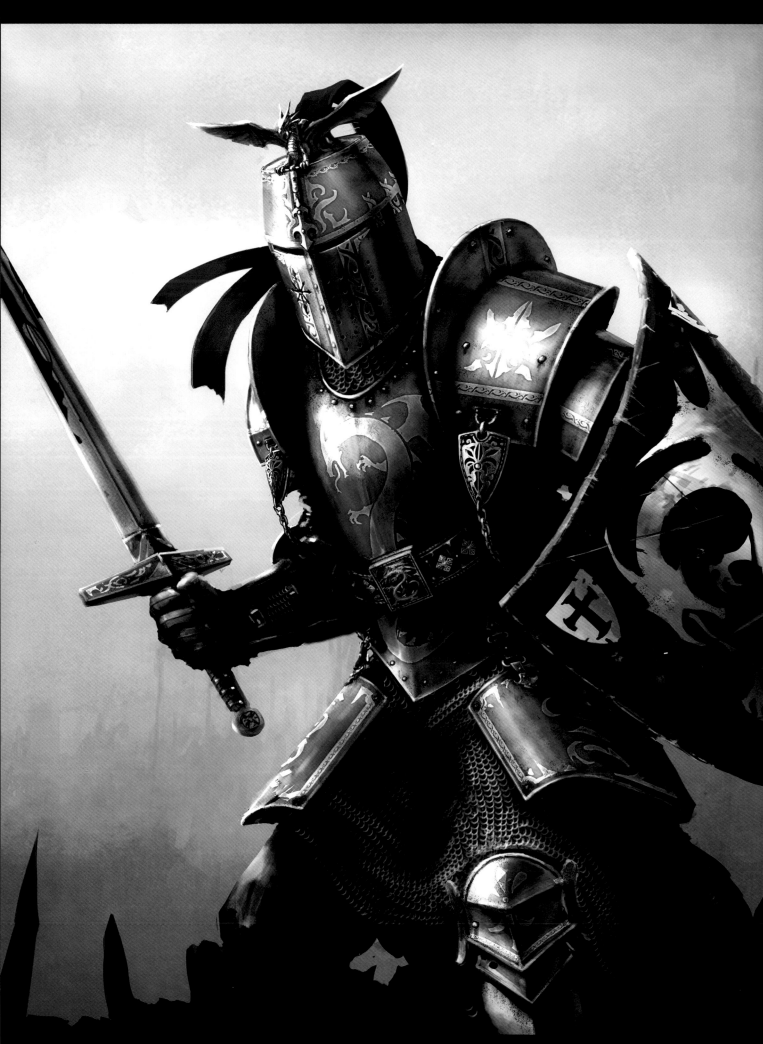

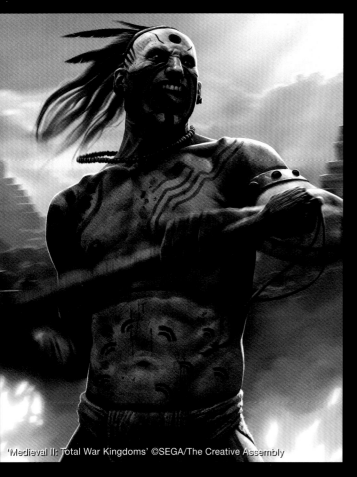

'Medieval II: Total War Kingdoms' ©SEGA/The Creative Assembly

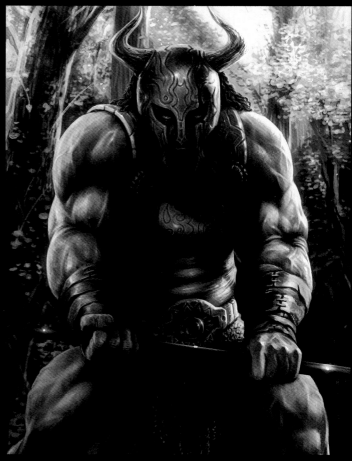

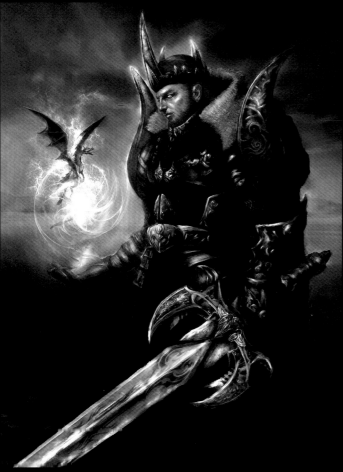

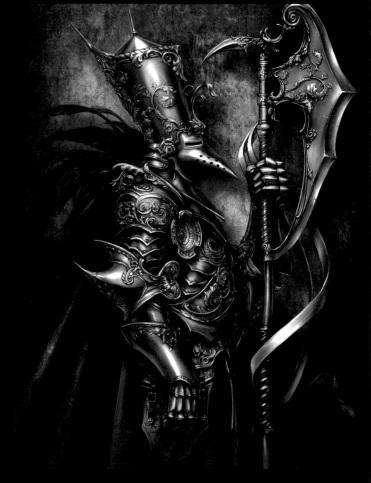

Medieval II: Total War Kingdoms (Indian)
Photoshop, Painter
Client: SEGA/The Creative Assembly
Michael Kutsche, GERMANY
[top]

Dark Spell
Painter, Photoshop
Kyushik Shin,
USA
[above]

Forest Warrior
Photoshop
Galan Pang,
HONG KONG
[top]

Knight
Photoshop
Ruslan Svobodin,
RUSSIA
[above]

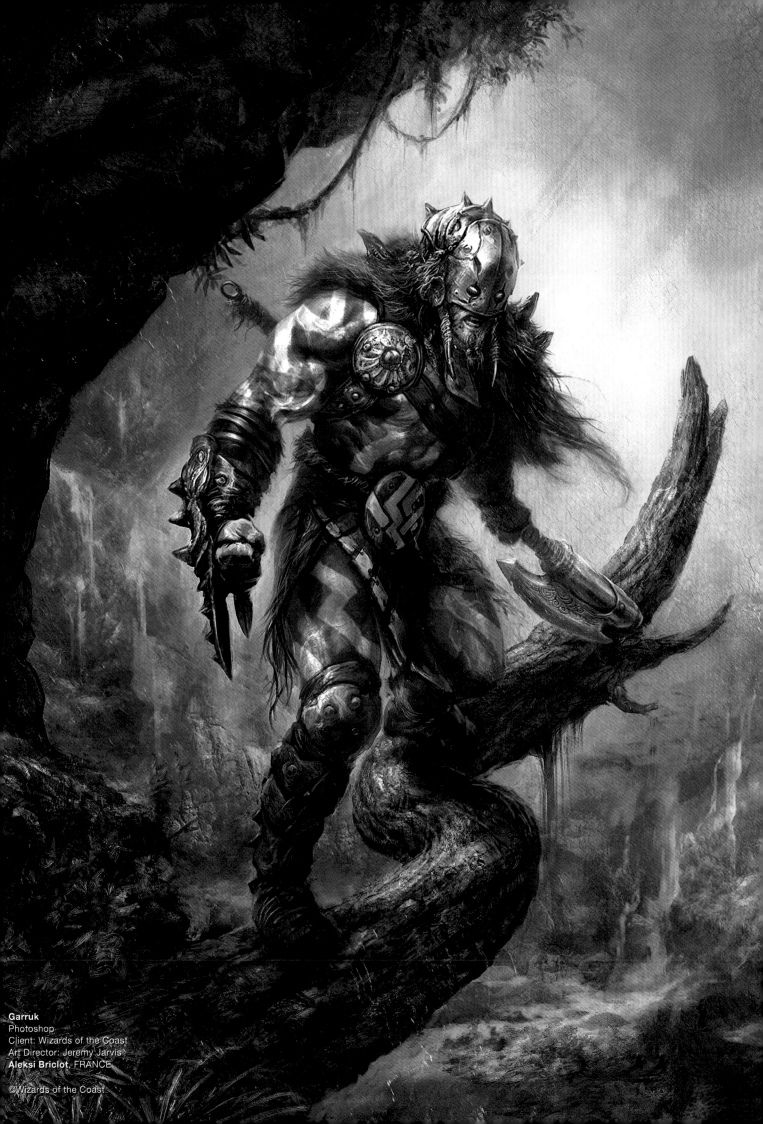

Garruk
Photoshop
Client: Wizards of the Coast
Art Director: Jeremy Jarvis
Aleksi Briclot, FRANCE

©Wizards of the Coast

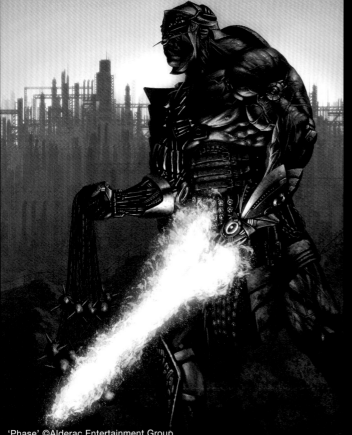

'Phase' ©Alderac Entertainment Group

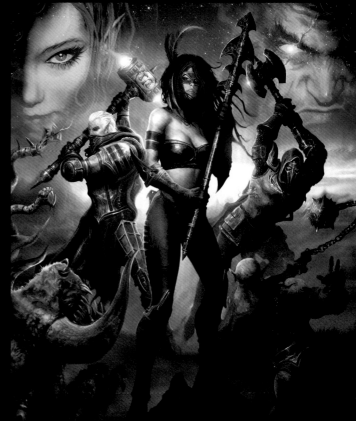

'Legends of Norrath' ©2008 Sony Online Entertainment LLC

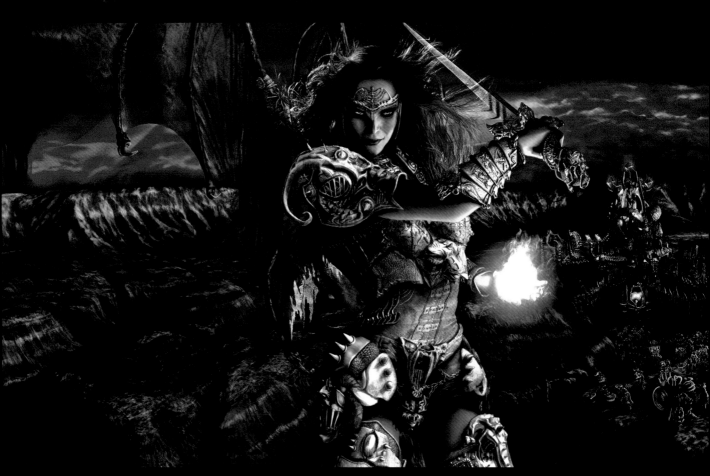

Phase: Gladiator
Photoshop
Client: Alderac Entertainment Group
Steve Argyle,
USA
[top]

Mystria
Poser, ZBrush, GIMP
Client: Mystria
Yohan Dupuy,
FRANCE
[above]

Legends of Norrath: Oathbound
Photoshop
Client: Eclipse Advertising
**Clint Langley, Rob Tepper, Deanna Dolph and
Lagi Apostolou**, Sony Online Entertainment LLC, USA
[top]

The war is coming
Photoshop
Client: Vector EA/Artes
Electronicas
Alon Chou, TAIWAN
[right]

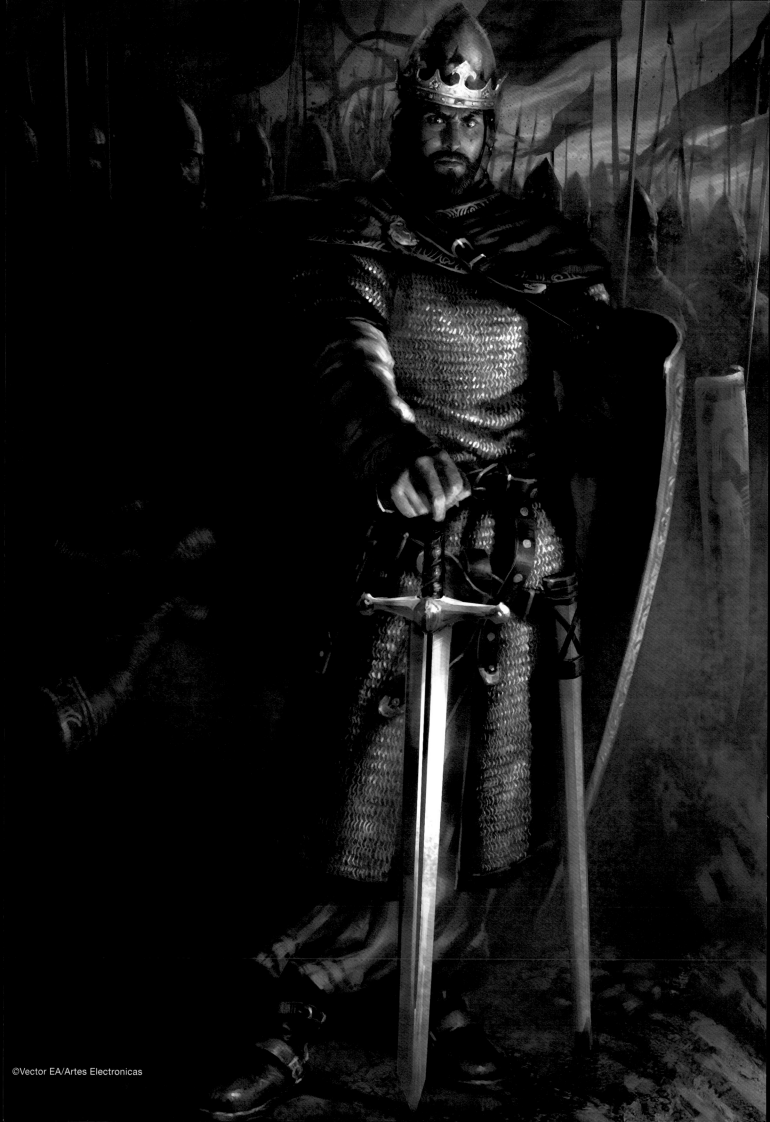

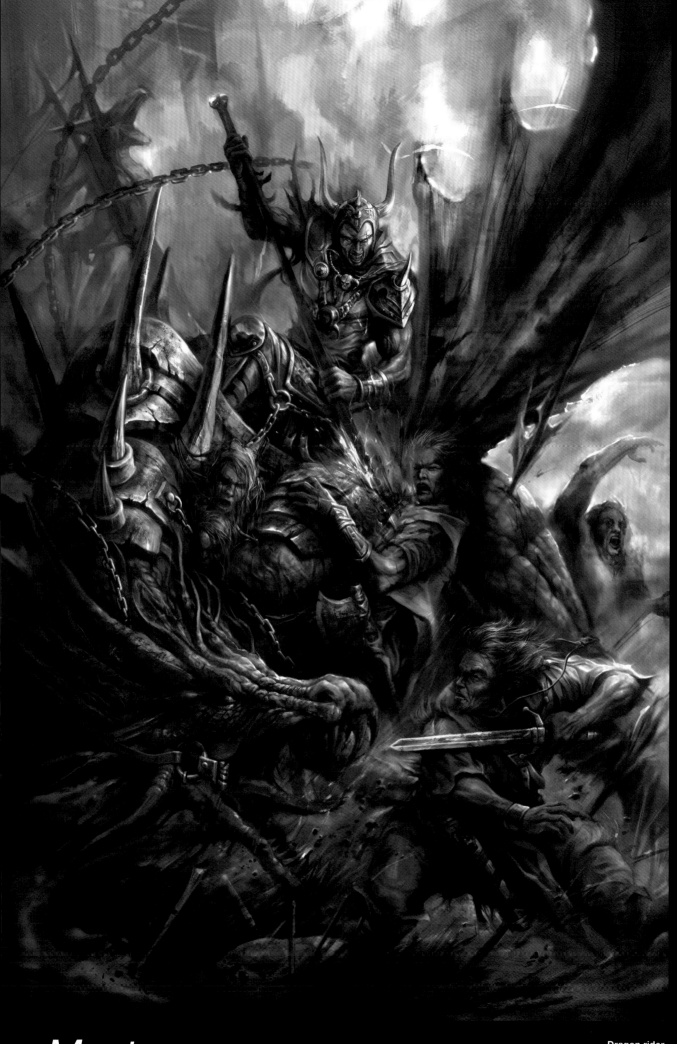

Master

Conflict

Dragon rider
Photoshop
Derrick Song,
SINGAPORE

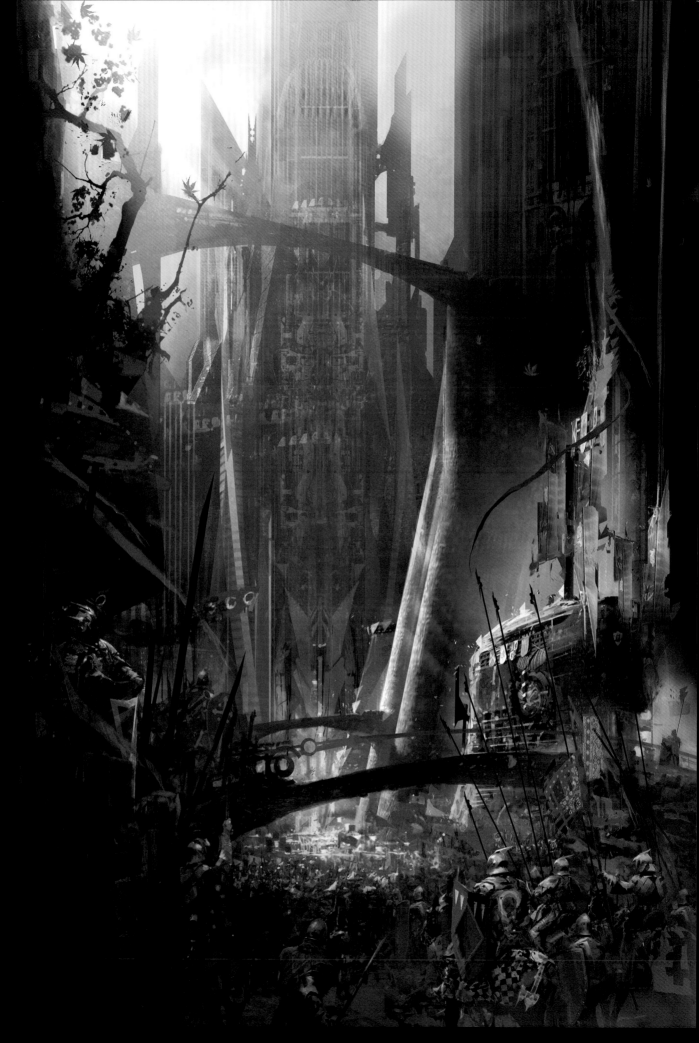

Autumn war
Photoshop, Painter
Client: Tor Books
Stephan Martiniere, USA

Excellence
Conflict

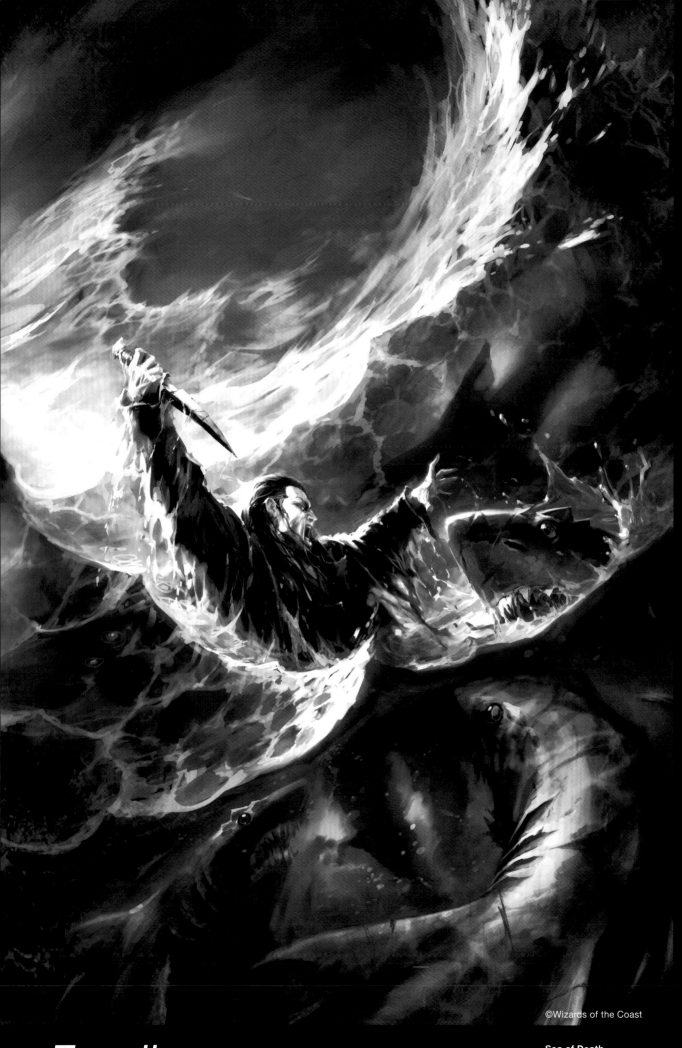

Excellence
Conflict

Sea of Death
Photoshop
Client: Wizards of the Coast
Art Director: Matt Adelsperger
Raymond Swanland, USA

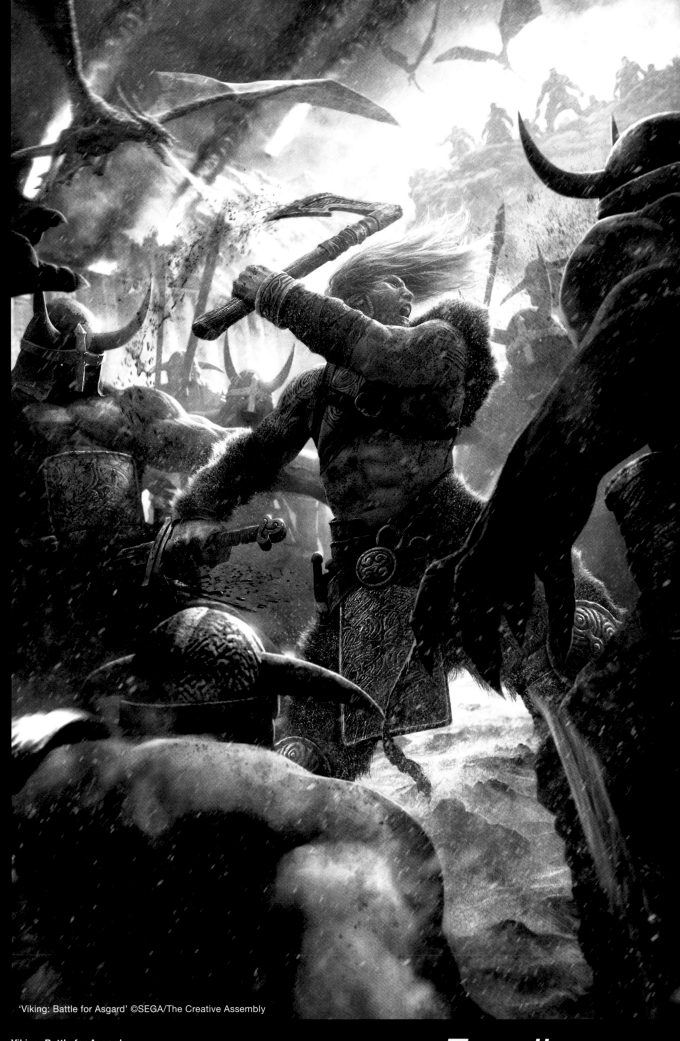

'Viking: Battle for Asgard' ©SEGA/The Creative Assembly

Viking: Battle for Asgard
Photoshop, Painter, Softimage|XSI
Client: SEGA/The Creative Assembly
Michael Kutsche, GERMANY

Excellence
Conflict

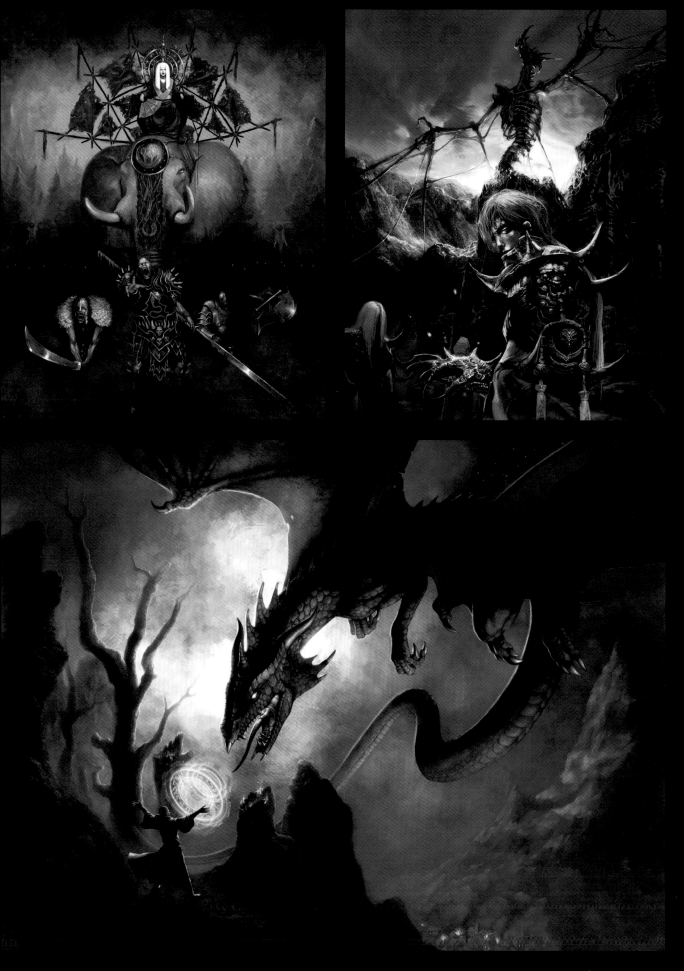

The princess and her servants
Photoshop
Dennis Chan, SWEDEN
[top]

Dragon Mountains
Photoshop
Jason Juta, GREAT BRITAIN
[above]

Relic of the Dragon
Photoshop
Hong Kuang, SINGAPORE
[top]

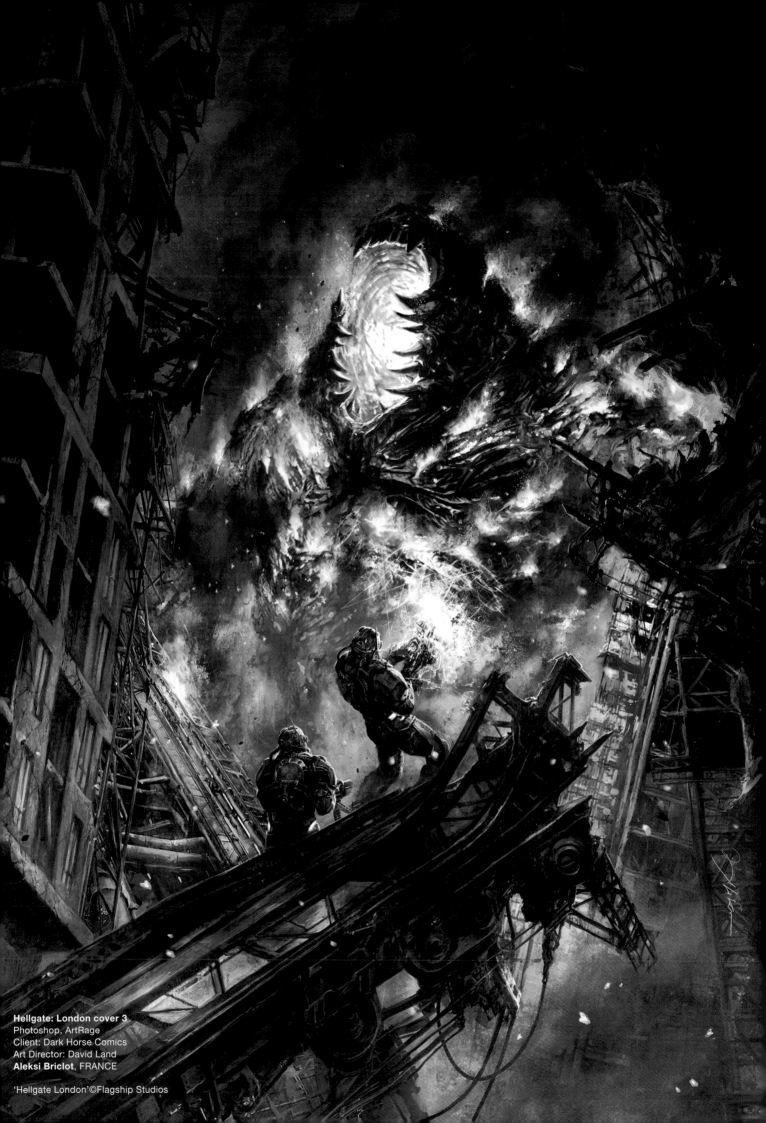

Hellgate: London cover 3
Photoshop, ArtRage
Client: Dark Horse Comics
Art Director: David Land
Aleksi Briclot, FRANCE

'Hellgate London'©Flagship Studios

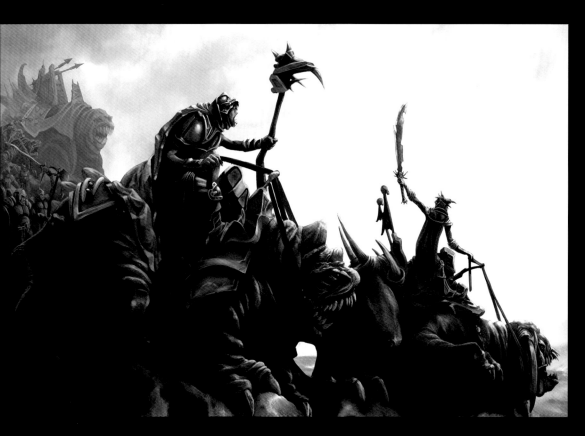

Before War
Photoshop
Ilker Serdar Yildiz,
TURKEY
[left]

Dragon Style
Photoshop
Mathias Kollros,
AUSTRIA
[right]

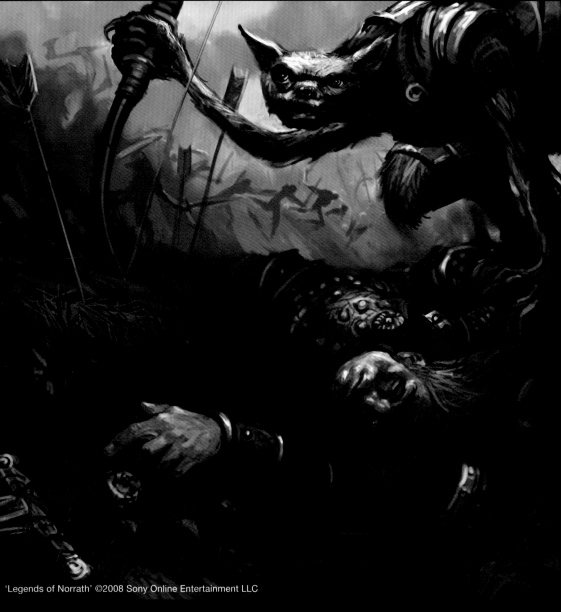

Legends of Norrath: Play dea
Photoshop
Art Directors: Derek Herring,
Joe Shoopack
Sony Online Entertainment LLC
Roel Jovellanos, USA
[left]

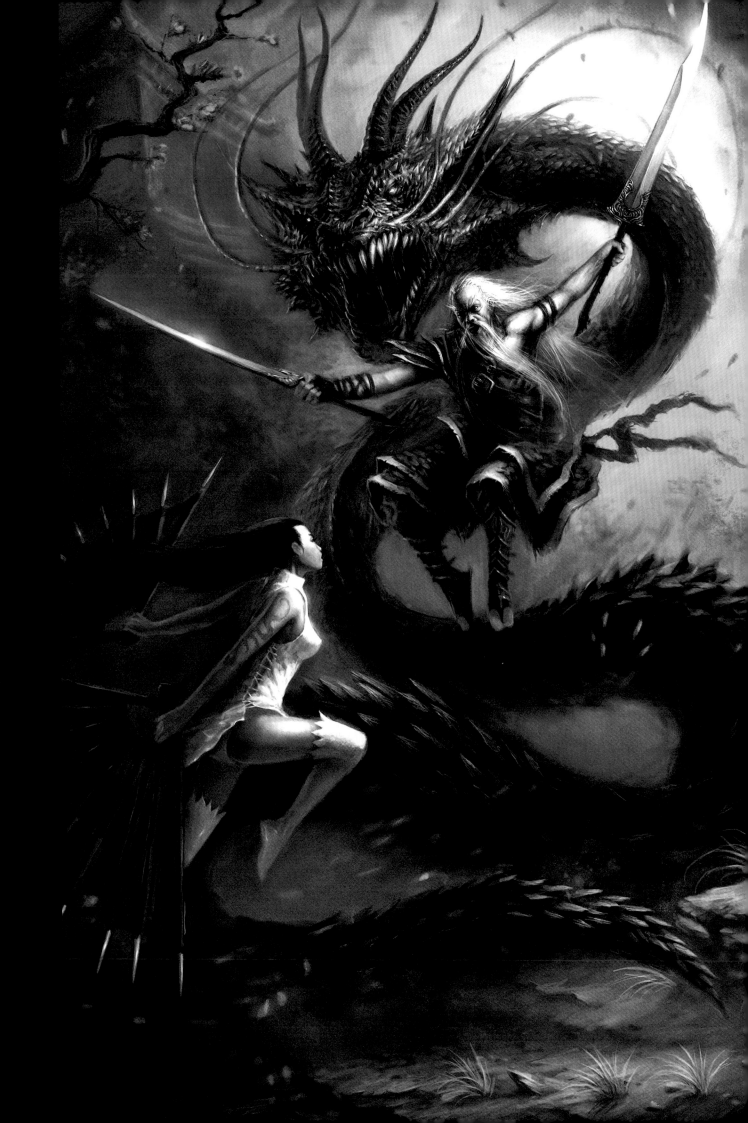

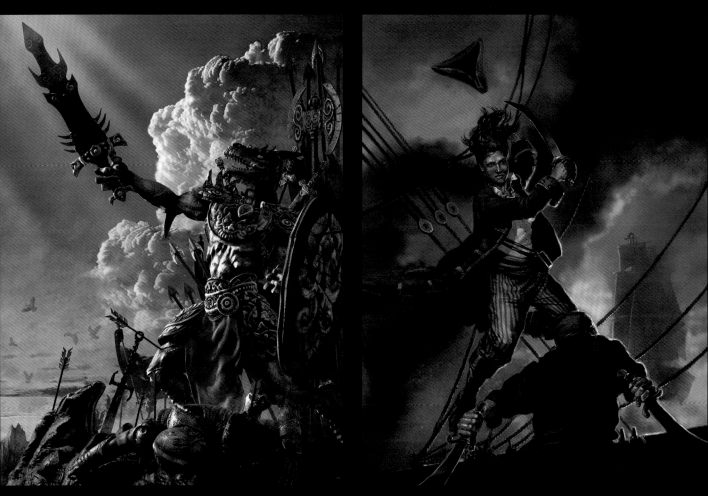

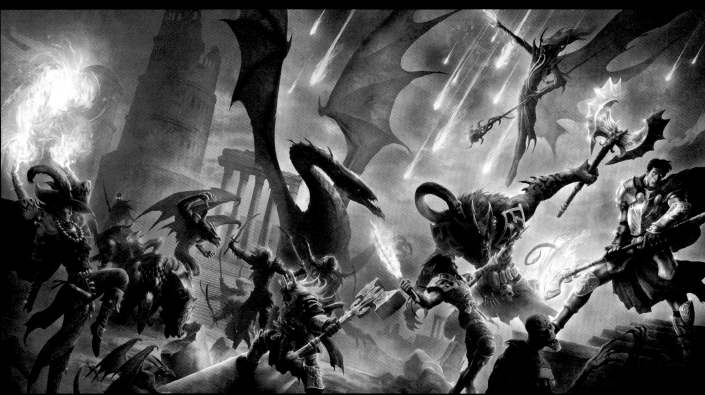

Victory
Maya, mental ray,
BodyPaint 3D, Photoshop
Udom Ruangpaisitporn, THAILAND
[top]

Battle of Four Armies
Photoshop
Client: Magnificent Egos Miniatures
Jason Engle, USA
[above]

Anne Bonny
Photoshop, Painter
Nicole Cardiff,
USA
[top]

Qin: Tian Xia 2
Photoshop, Painter
Client: 7éme Cercle
Marc Simonetti, FRANCE
[right]

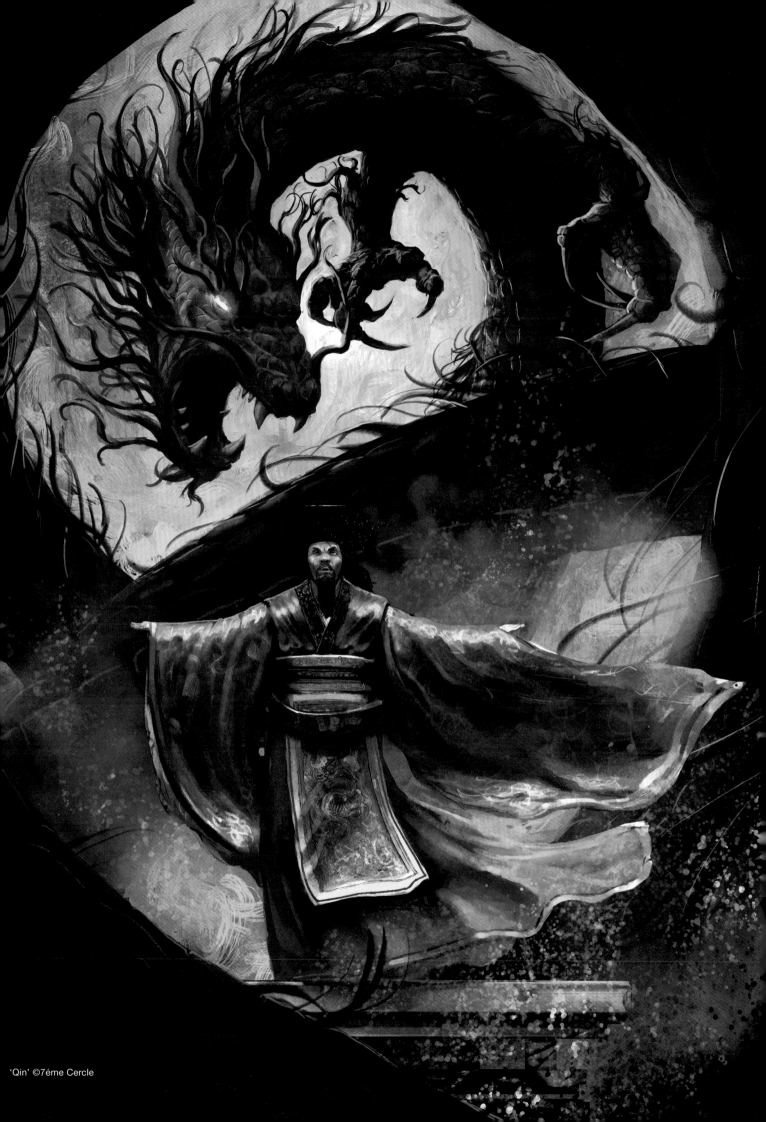

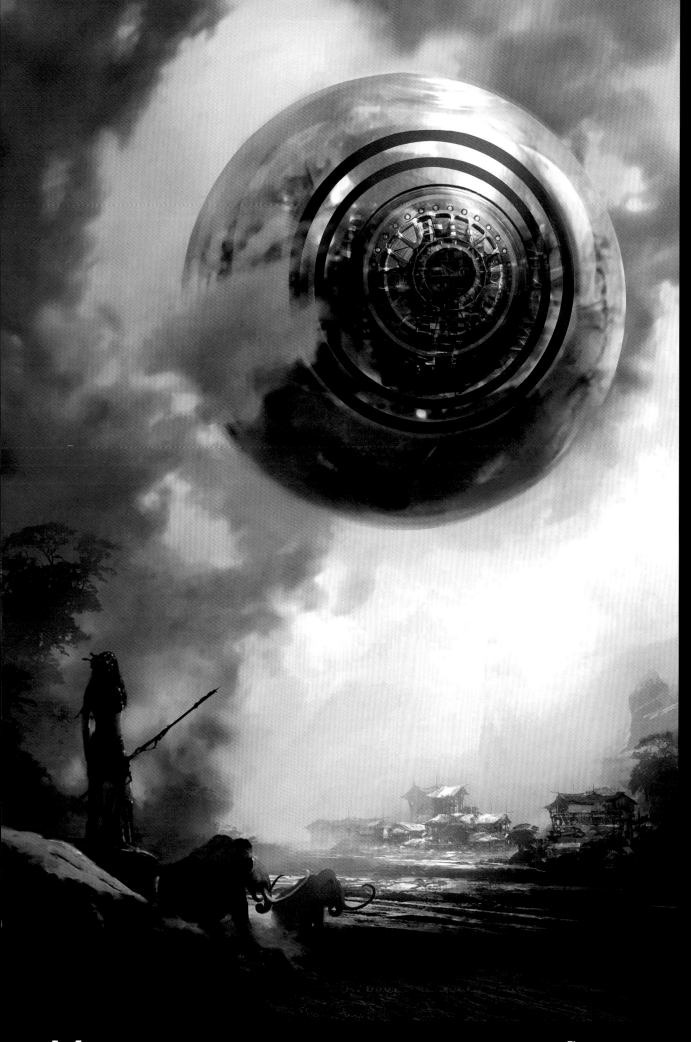

Master
Science Fiction

Elom
Photoshop, Painter
Client: Tor Books
Stephan Martiniere, USA

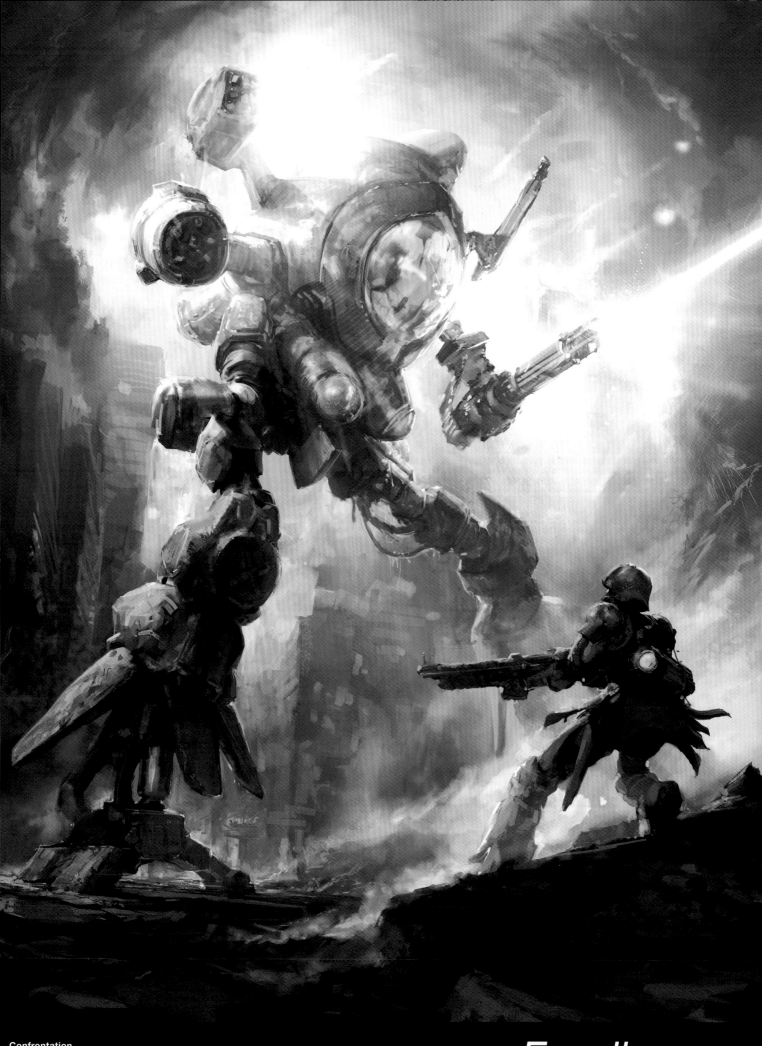

Confrontation
Painter, Photoshop
Client: ImagineFX
Tae Young Choi, USA

Excellence
Science Fiction

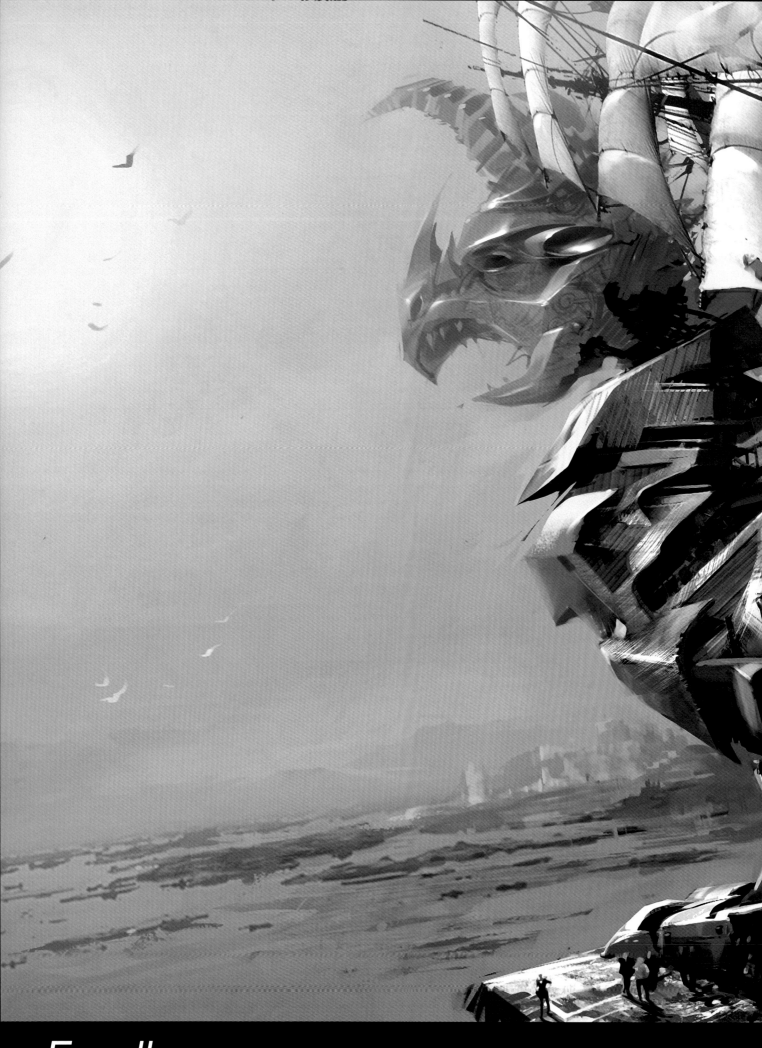

Excellence
Science Fiction

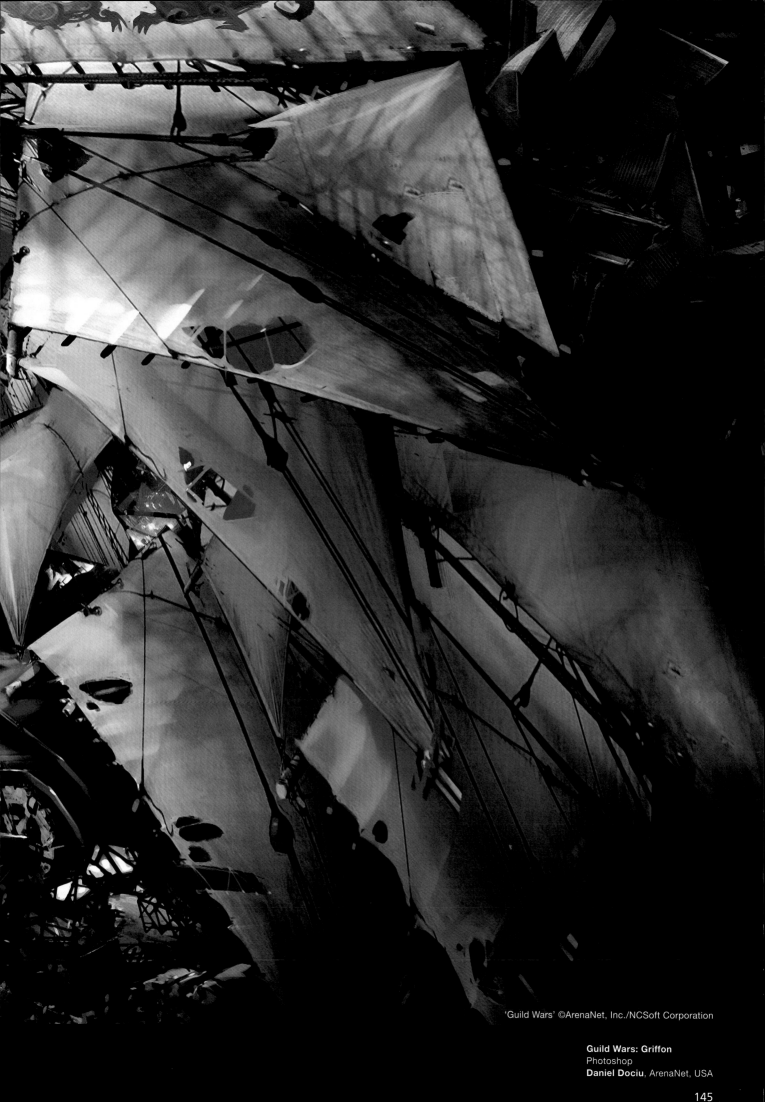

Guild Wars: Griffon
Photoshop
Daniel Dociu, ArenaNet, USA

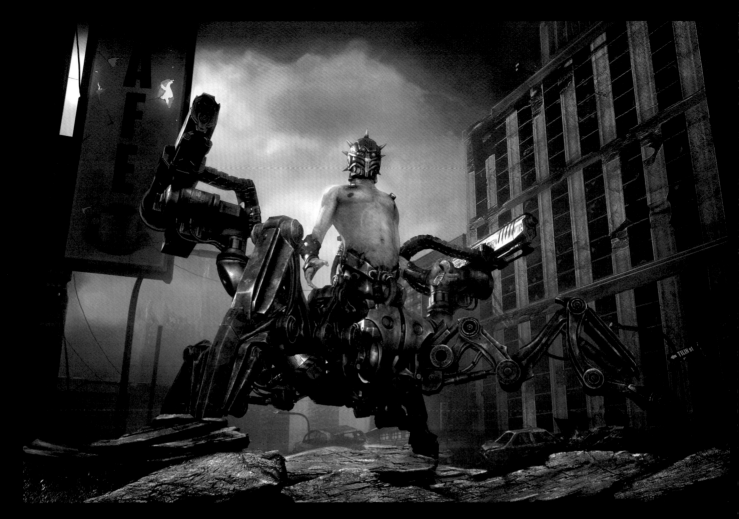

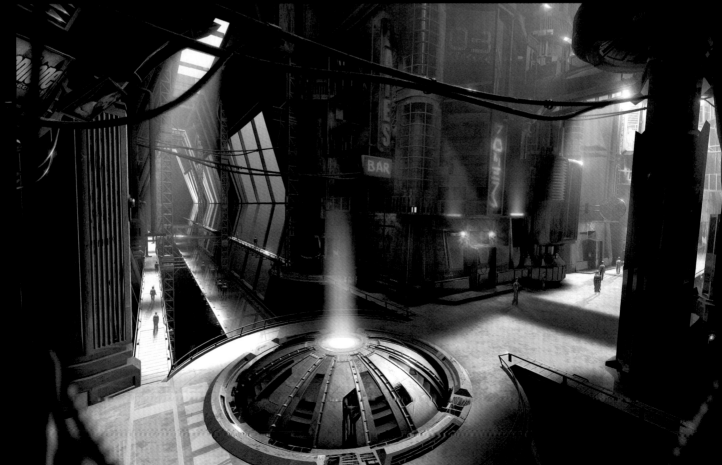

Mechspider
ZBrush, Softimage|XSI, Photoshop
Pablo Vicentin, ARGENTINA

Suburbs
CINEMA 4D, Photoshop
Rudolf Herczog, SWEDEN

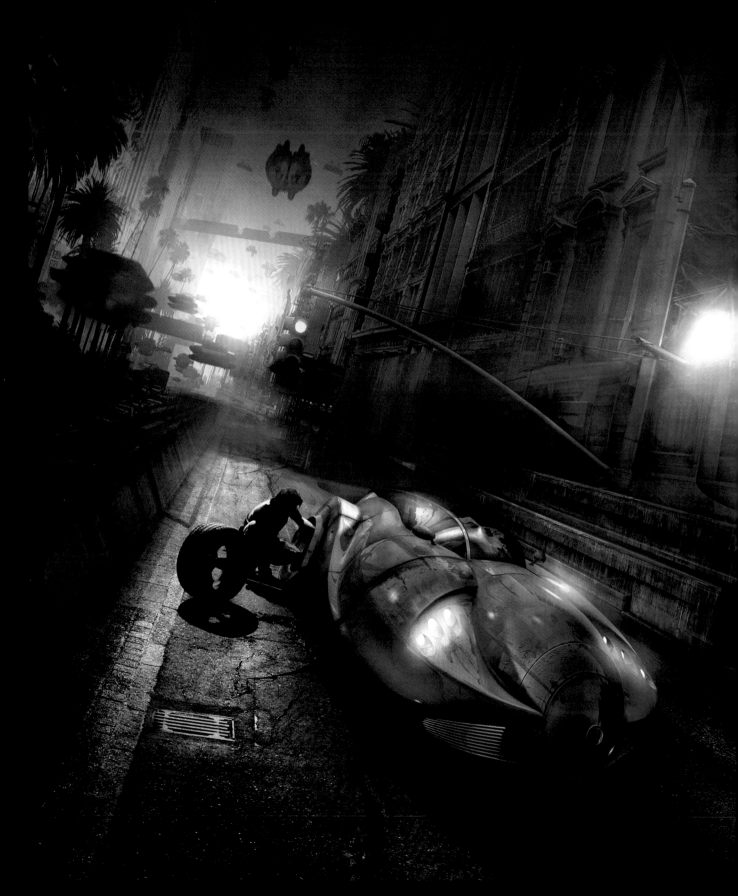

Blowout at Exit 16A
Photoshop, 3ds Max
Till Nowak,
GERMANY

Excellence
Science Fiction

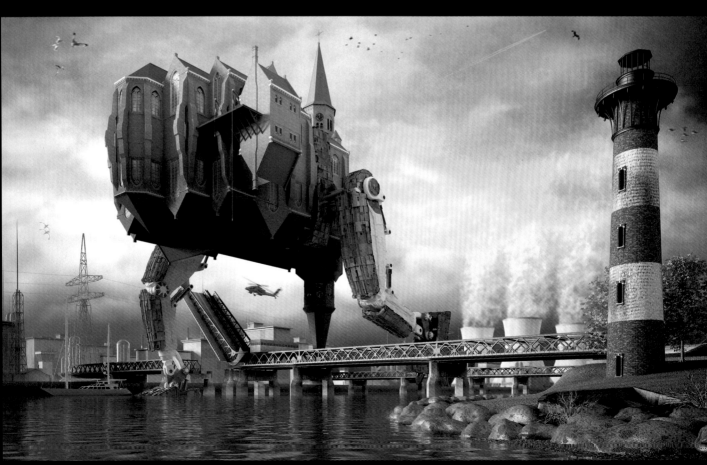

Revelations Robot **Church on the run** **Robot vs girl**

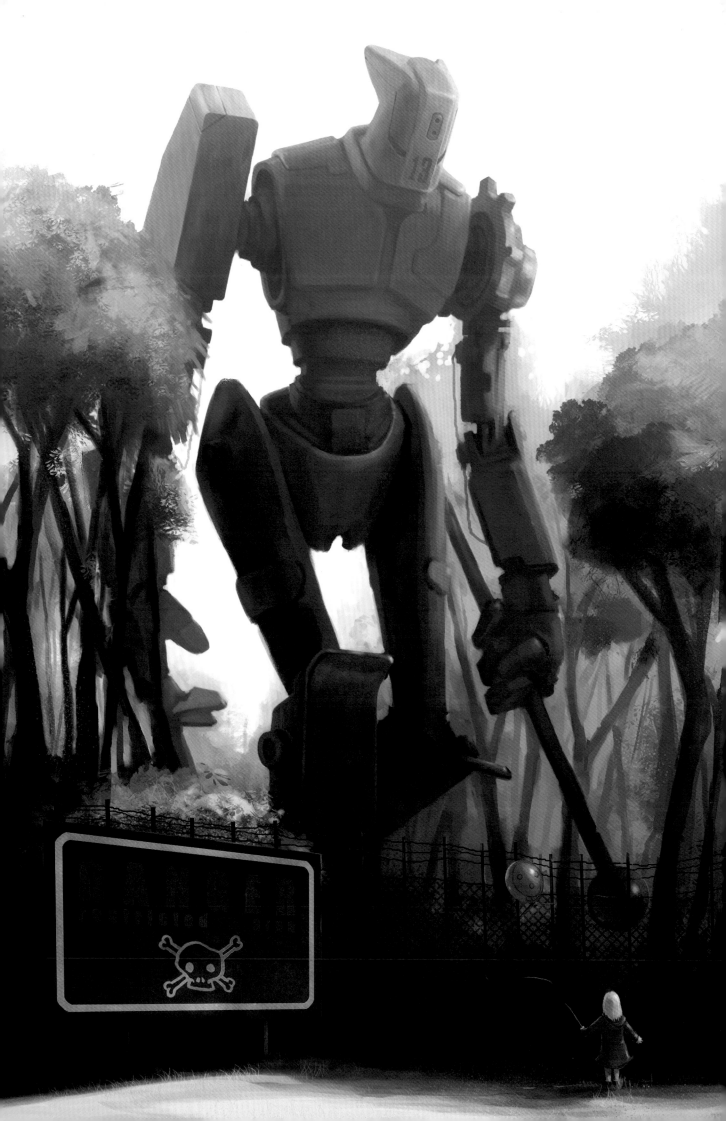

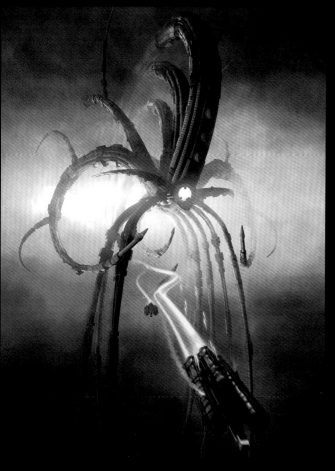

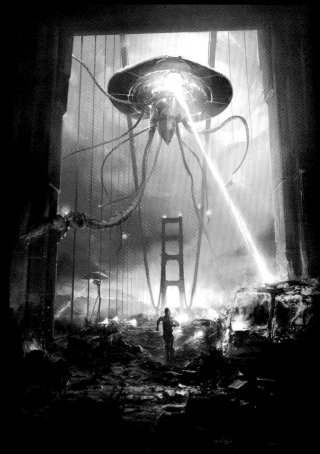

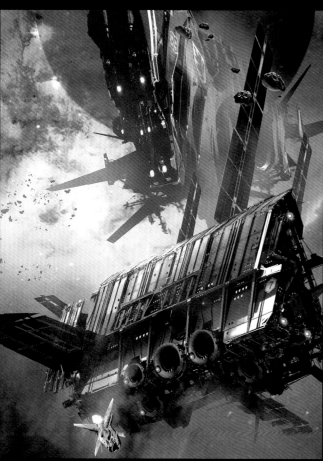

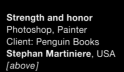

Gas Walker I
3ds Max, Brazil r/s, Photoshop
Neil Blevins,
USA
[top]

Strength and honor
Photoshop, Painter
Client: Penguin Books
Stephan Martiniere, USA
[above]

Invasion!
Painter
Client: Underwood Books
Tae Young Choi, USA
[top]

Victory Conditions
Photoshop
Client: Del Rey Books: Random House
Art Director: Dreu Pennington McNeil
Dave Seeley, USA

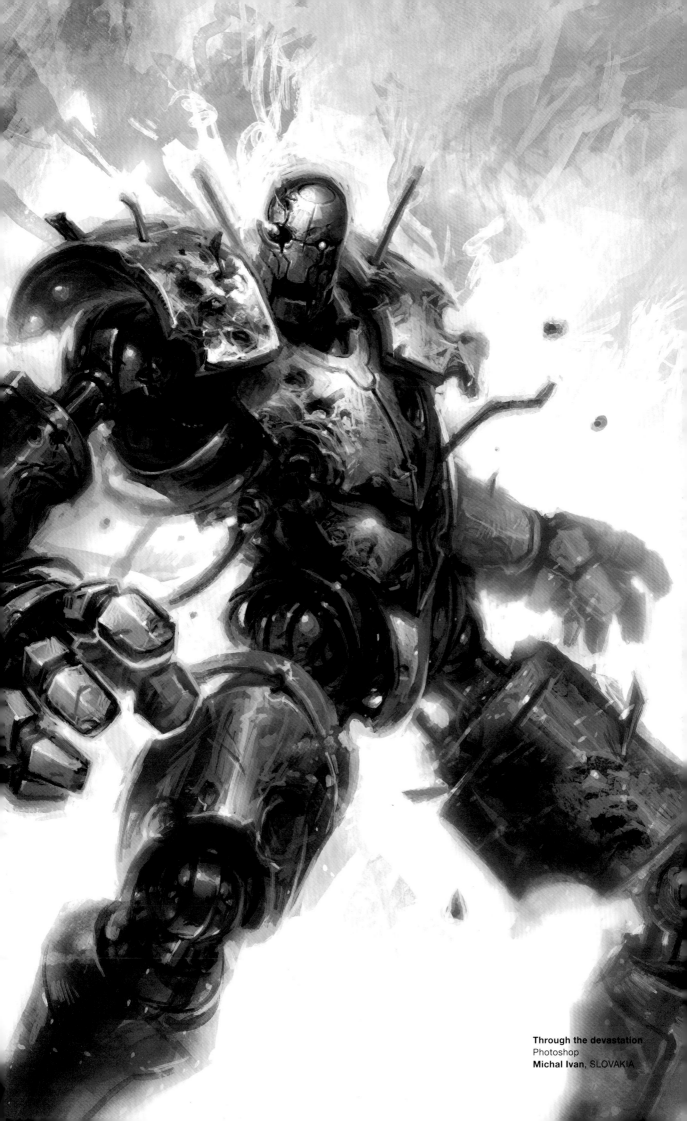

Through the devastation
Photoshop
Michal Ivan, SLOVAKIA

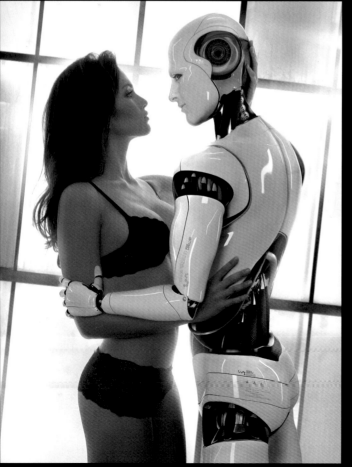

Homage to Fry
CINEMA 4D, ZBrush, fryrender
John Strieder, GERMANY
[above]

Personal Robot
3ds Max, Photoshop
Franz Steiner,
Blutsbrueder Design,
GERMANY
[left, right]

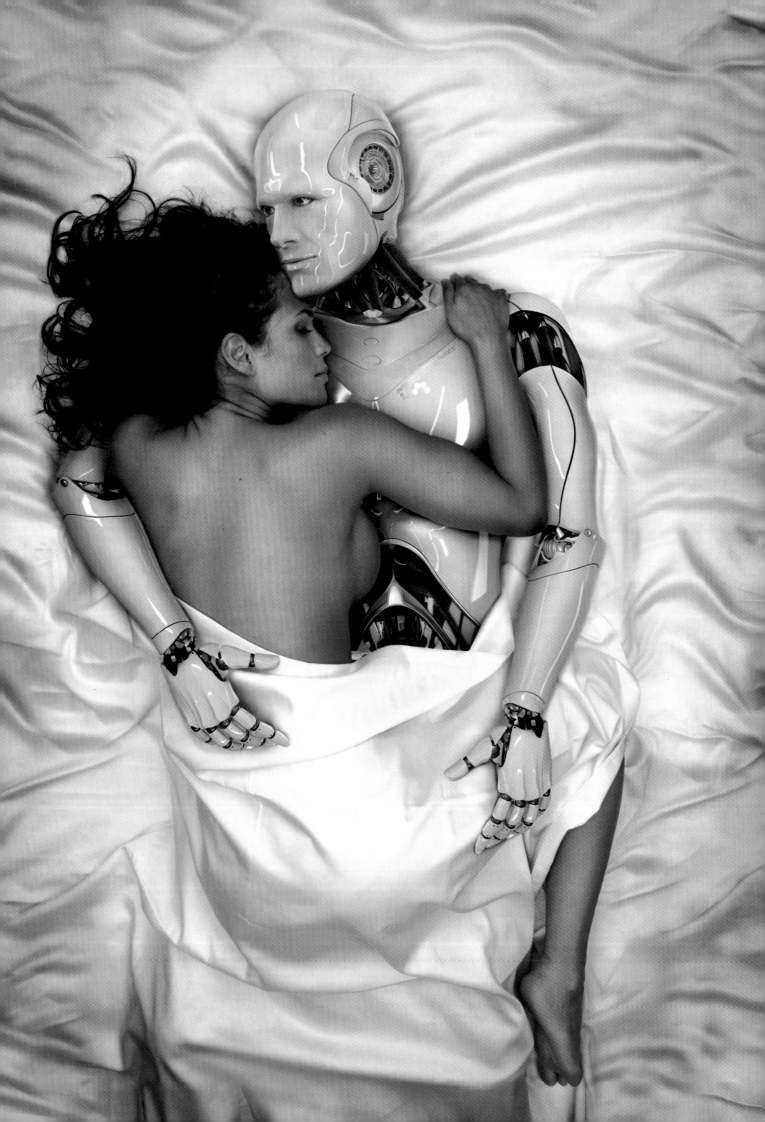

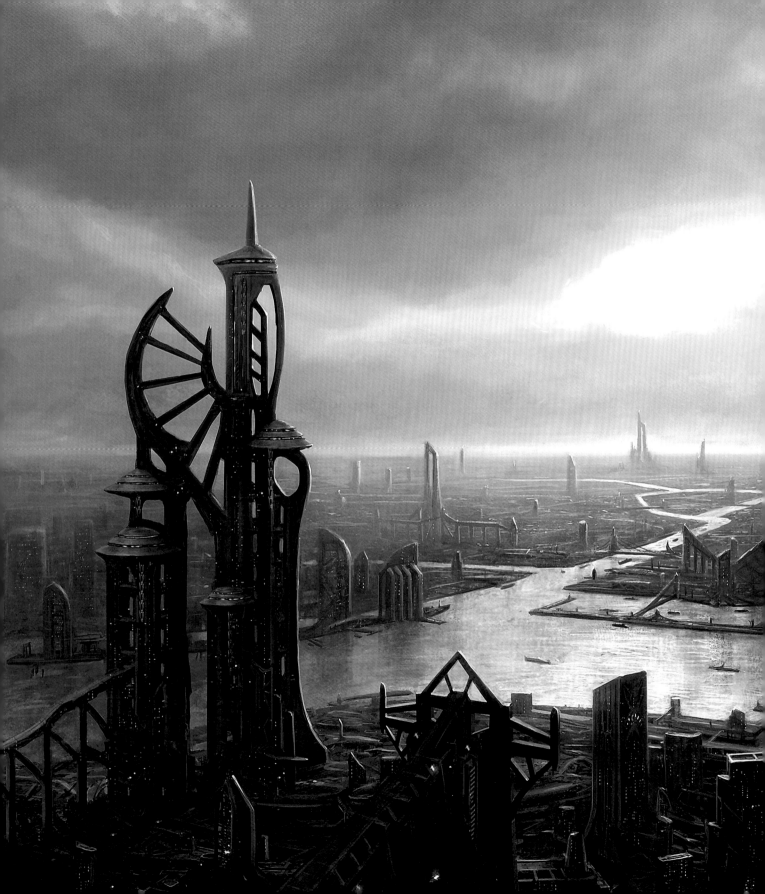

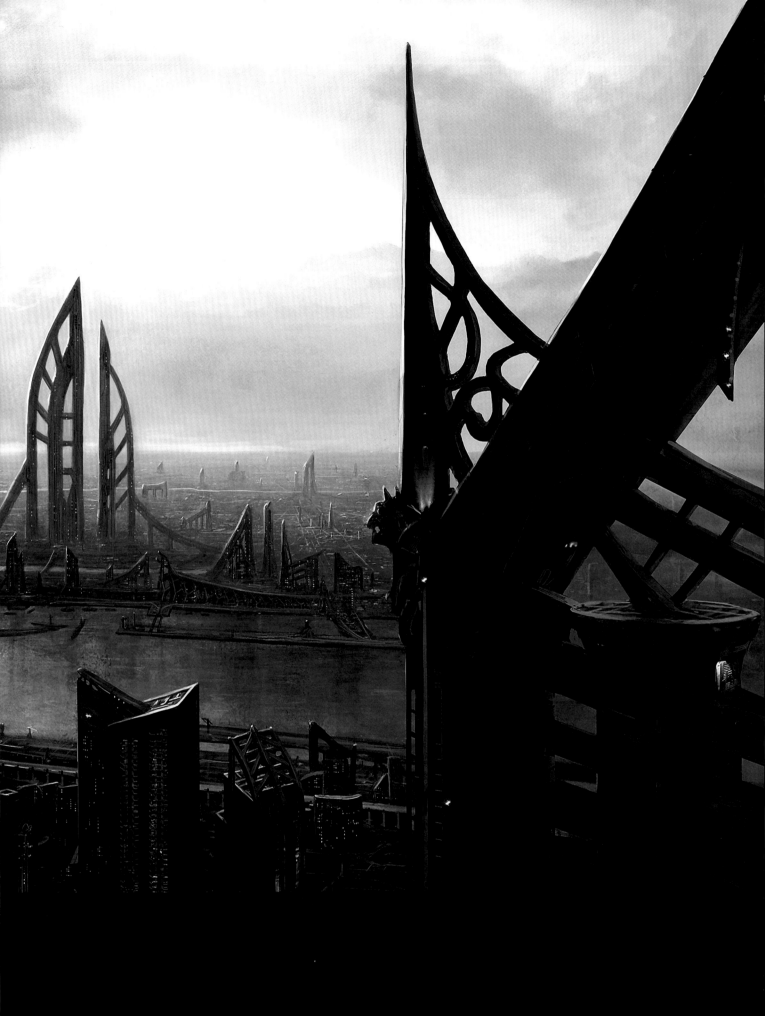

Gothic city
Photoshop
Tao Mu, CHINA

155

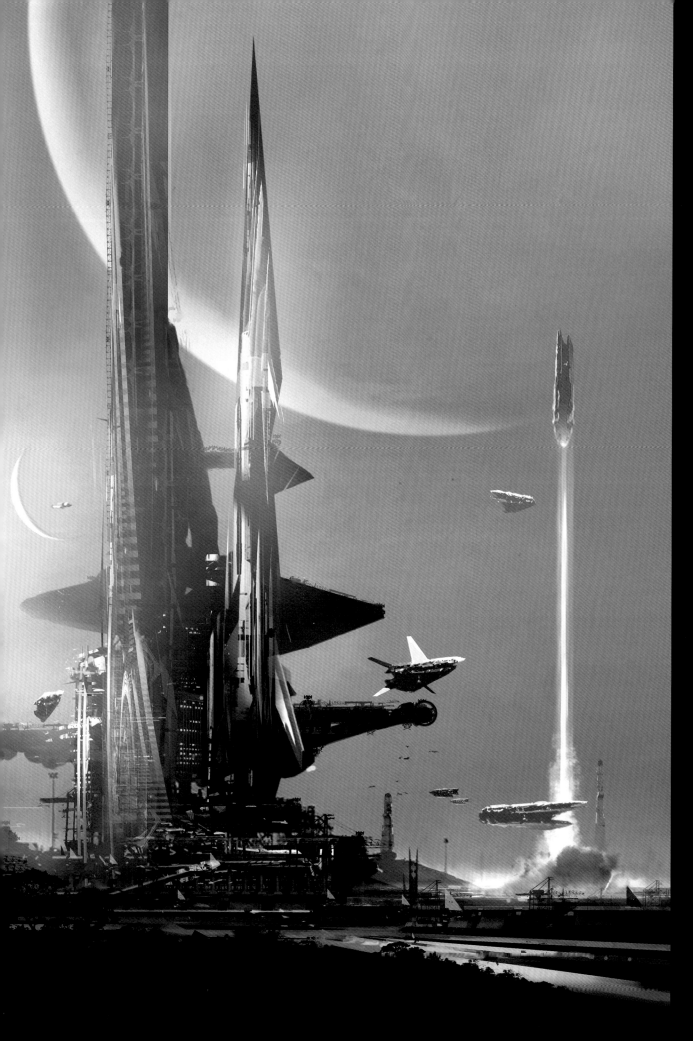

Excellence
Futurescapes

Starry rift
Photoshop
Client: Penguin Books
Stephan Martiniere, USA

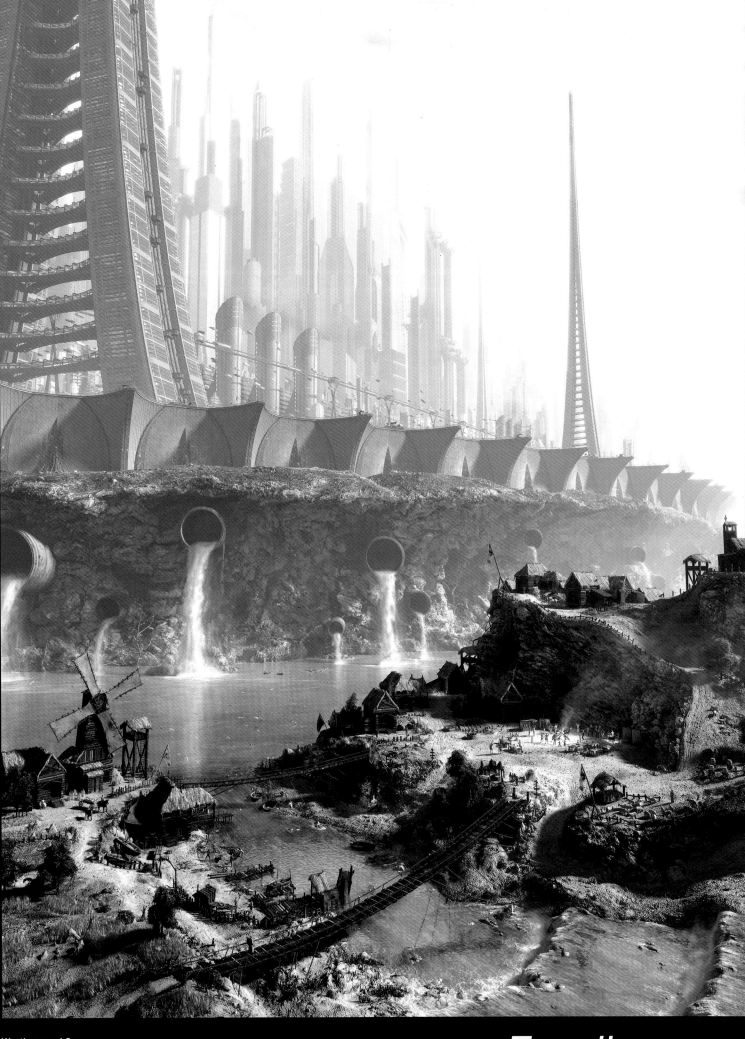

Excellence

Futurescapes

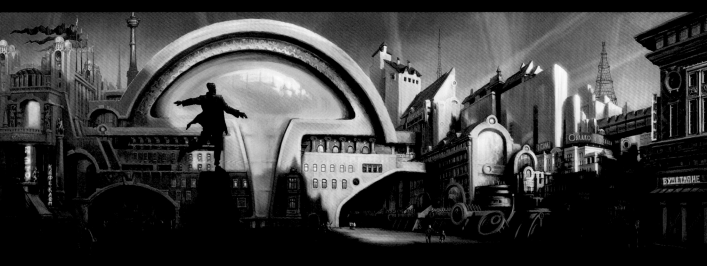

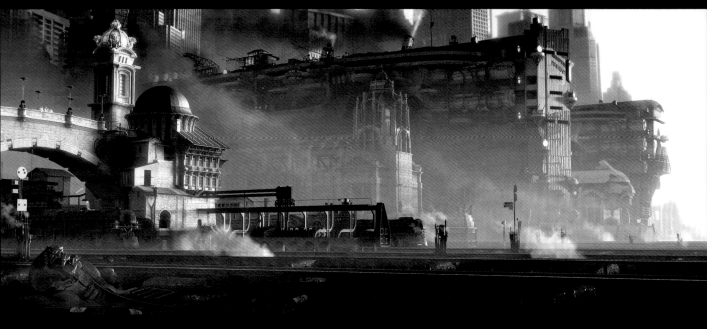

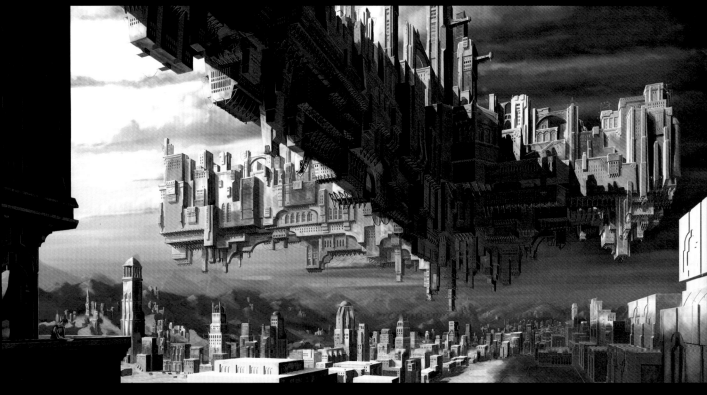

Poet's Square
Photoshop
Sergey Skachkov, RUSSIA

Rail haven
3ds Max, V-Ray
Marco Edel Rolandi, ITALY

Fortress
Photoshop, Painter
César Rizo, VENEZUELA

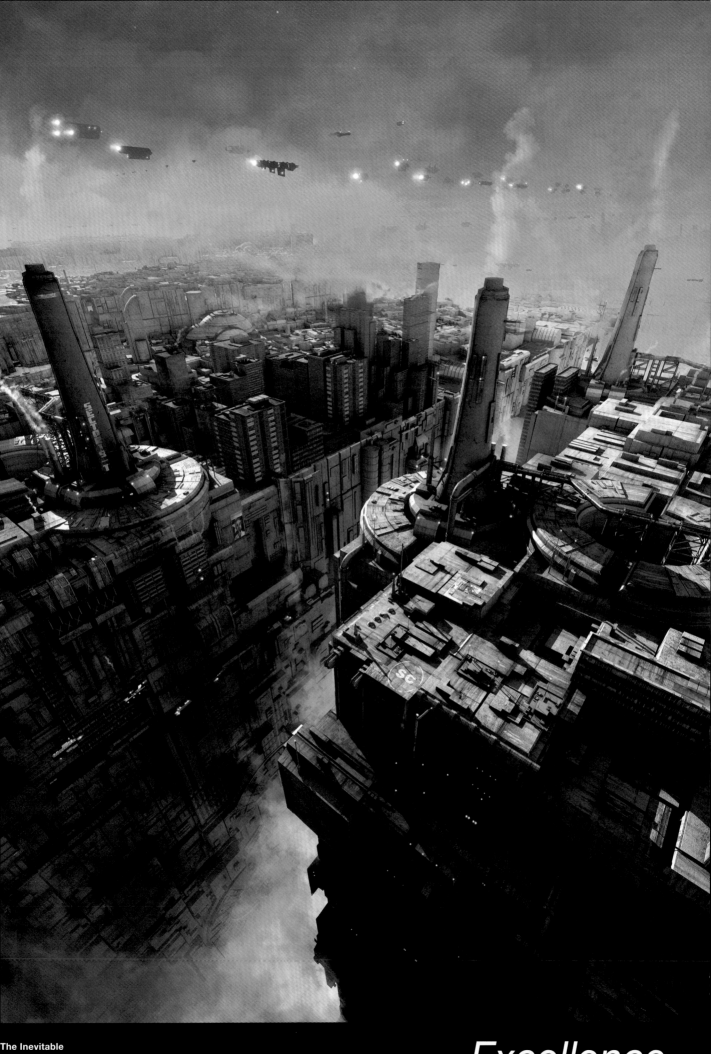

The Inevitable
3ds Max, Photoshop
Stefan Morrell, NEW ZEALAND

Excellence
Futurescapes

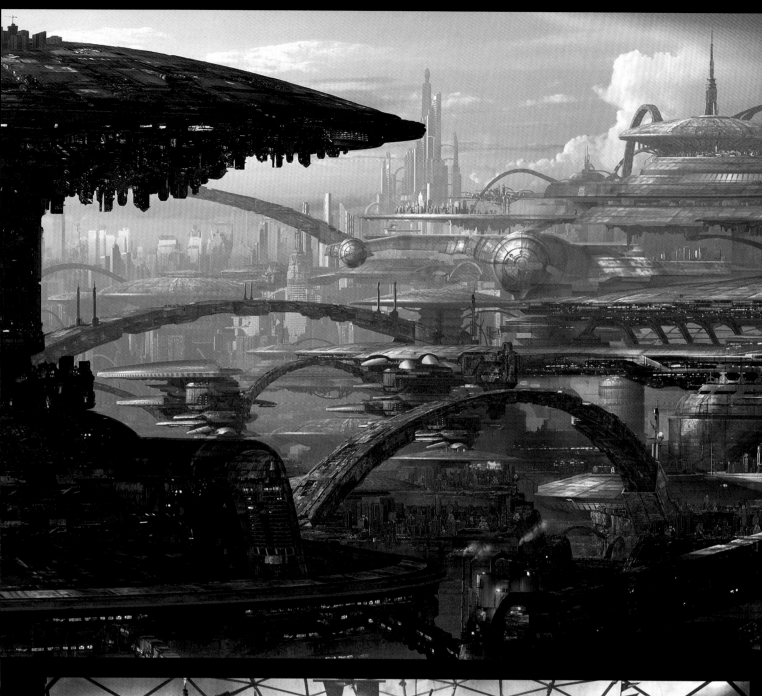

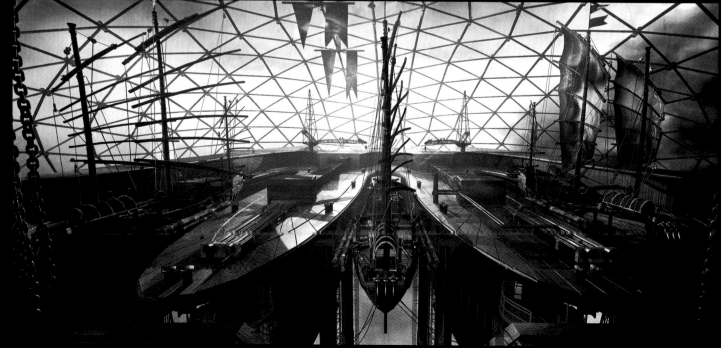

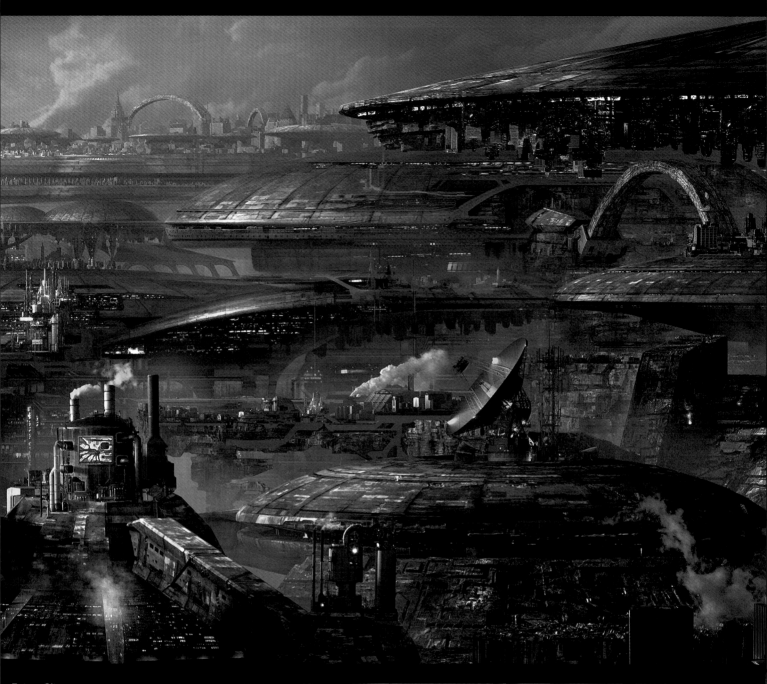

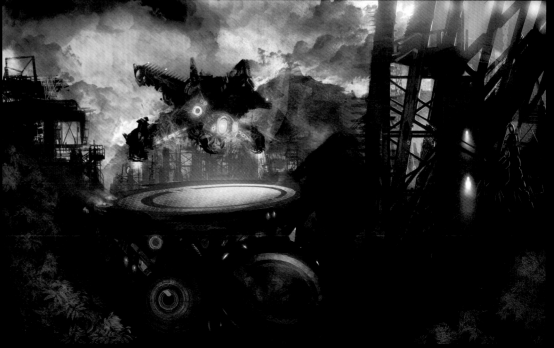

Future City
Photoshop, Maya
Benjamin Ross, GERMANY
[above]

Docking Station
LightWave 3D, Photoshop
Neil Maccormack, bearfootfilms,
SWITZERLAND
[left]

Devastation
Photoshop
Gary Jamroz-Palma, FRANCE
[right]

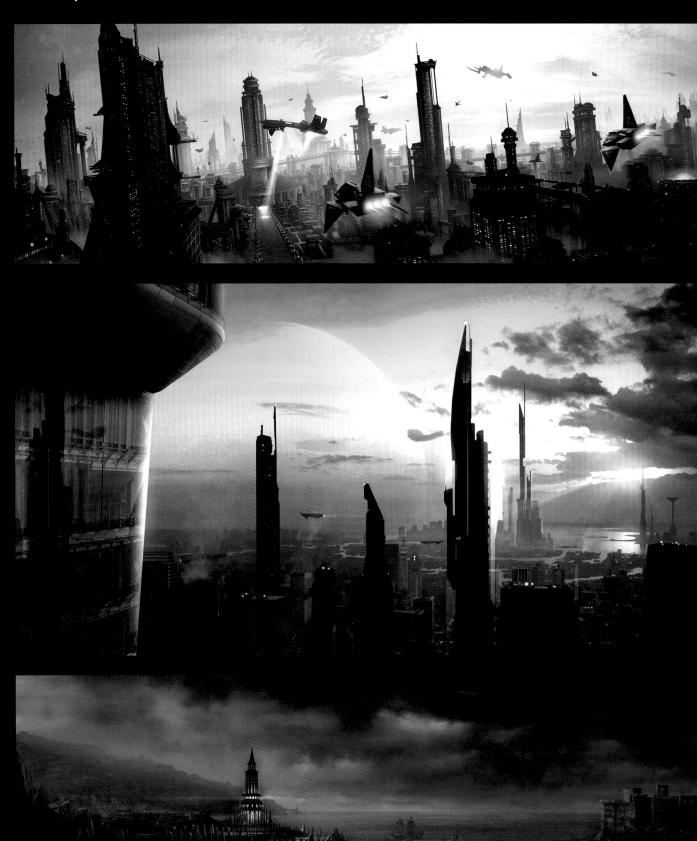

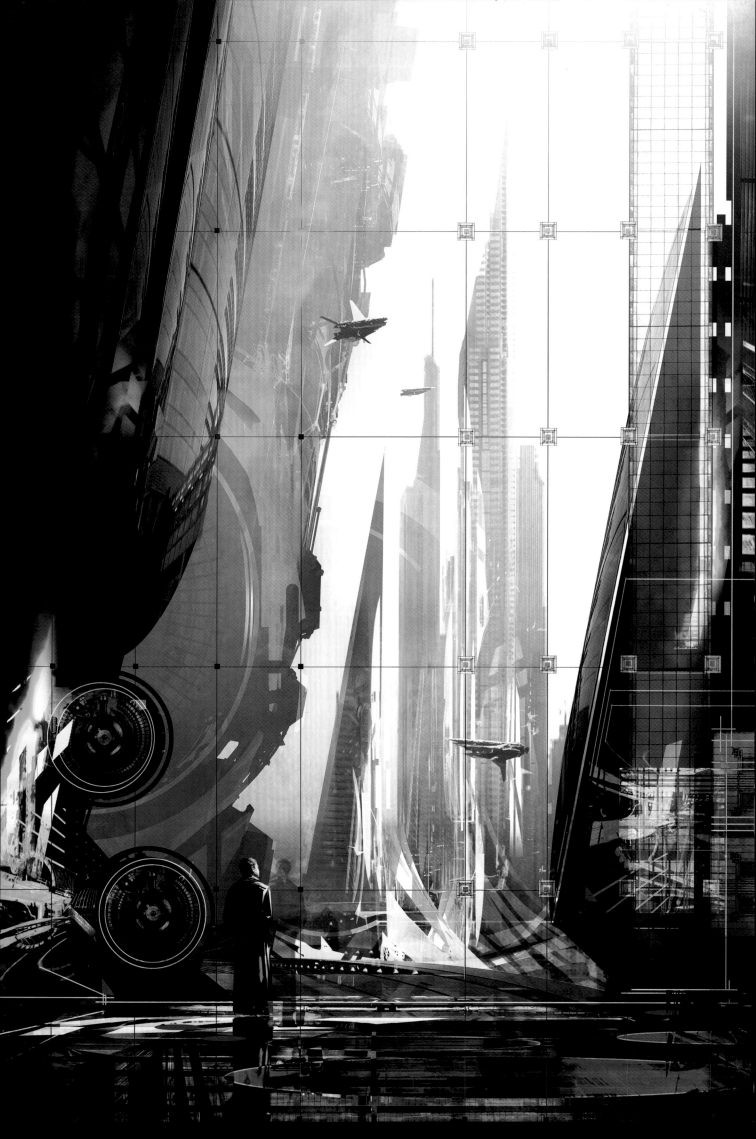

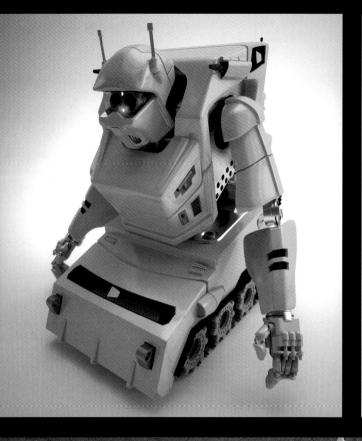

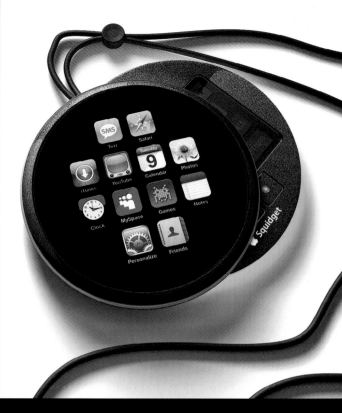

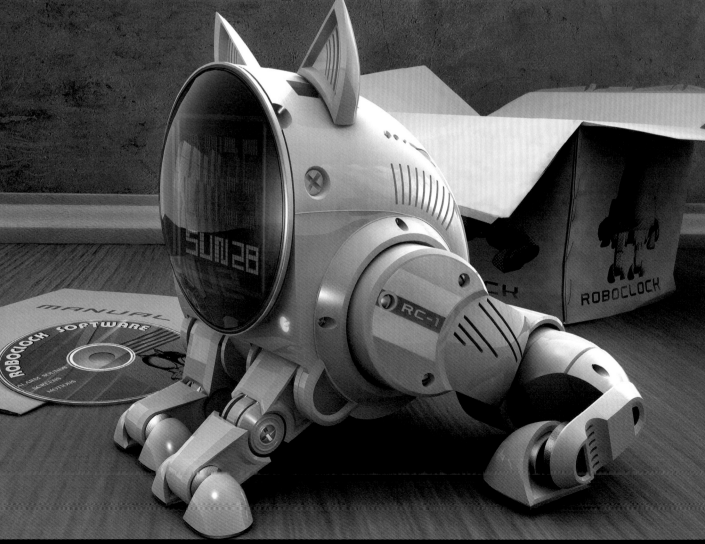

Bottrax
CINEMA 4D, Photoshop, fryrender
Dave Davidson,
GREAT BRITAIN
[top]

Roboclock
3ds Max, Photoshop
Juliy Trub, International Art Found.,
RUSSIA
[above]

Apple Squidget
CINEMA 4D
Client: Future US/MacLife
Adam Benton, GREAT BRITAIN
[top]

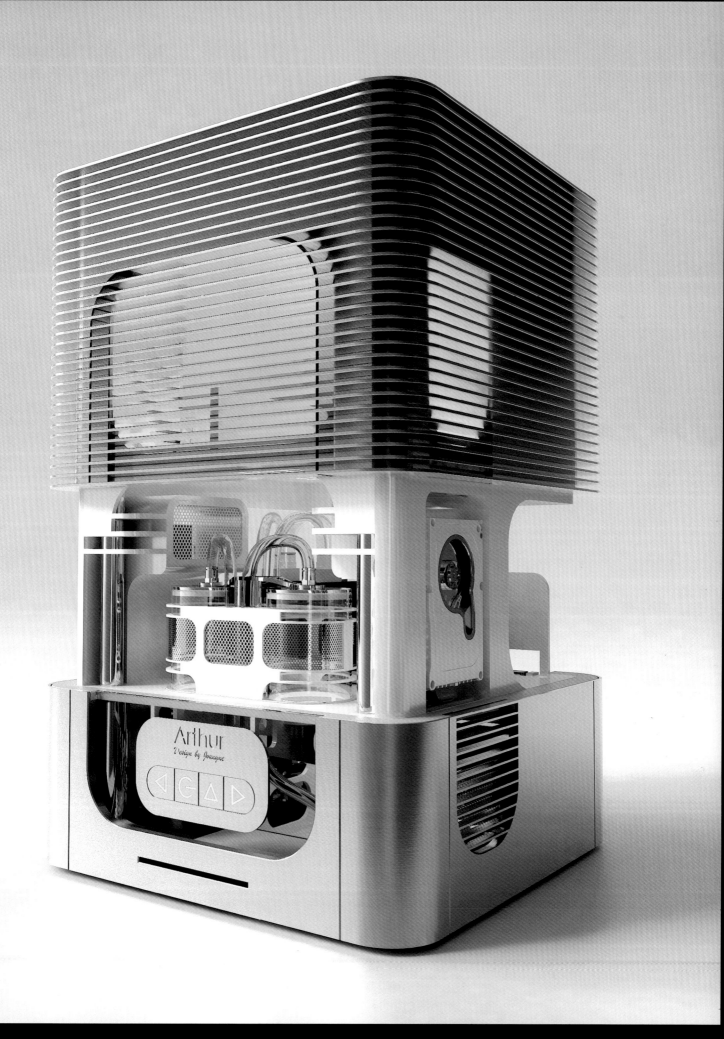

Arthur
3ds Max, V-Ray, Photoshop
Gert Swolfs, G2 BVBA,
BELGIUM

Master
Product Design & Still Life

Turbo Charger
3ds Max, V-Ray, Photoshop
Paul Ingram, Smoothe,
GREAT BRITAIN
[top]

Océ CS10000
CINEMA 4D, V-Ray
Client: Océ Industrial Design
Albert Kiefer, NETHERLANDS
[above]

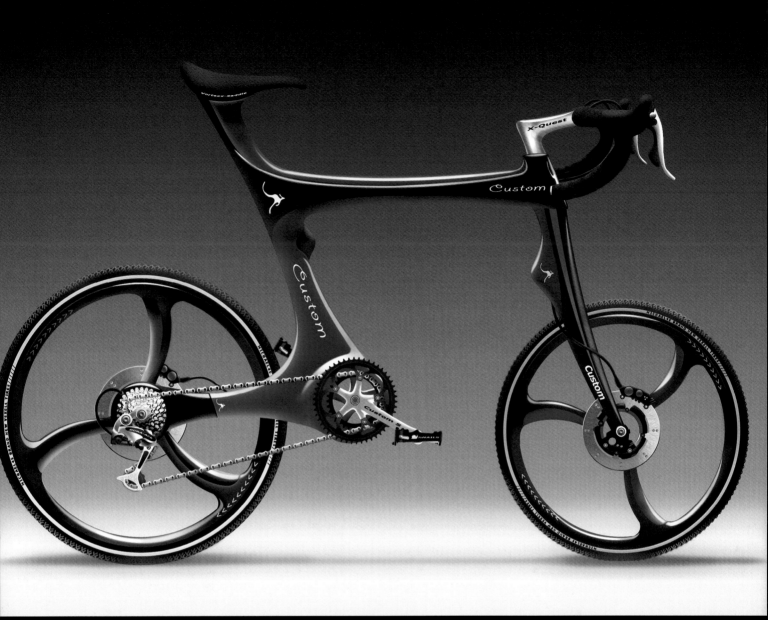

Custom bicycle render
Photoshop
Michael Mahy,
BELGIUM

Excellence
Product Design & Still Life

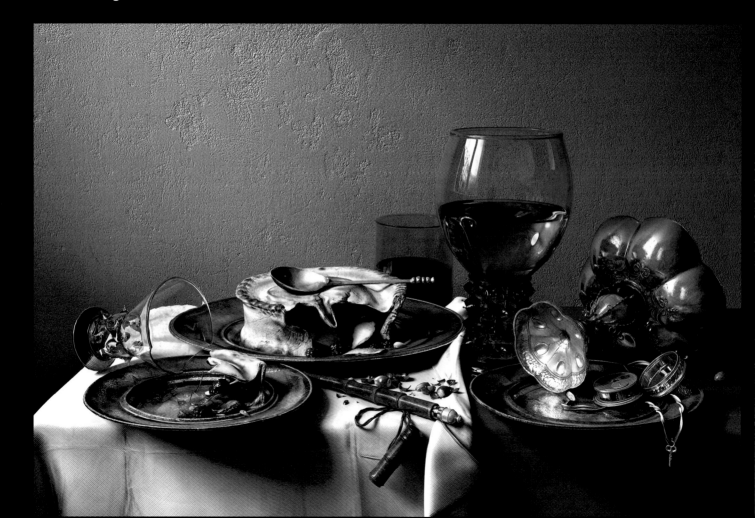

Lonely season
3ds Max
**Aiqiang Hao,
CHINA**

Small drum kit
3ds Max, V-Ray, Photoshop
Charley Cloris, FRANCE
[left]

Gothic Shoes
3ds Max, Photoshop, V-Ray
Fraisse Etienne, FRANCE
[right]

SharpTone:
Fictitious guitar brand
Photoshop
Yahya Ehsan, Anivista,
PAKISTAN
[left]

Parenthood
Apophysis, Photoshop
Georg Huebner, AUSTRIA
[top]

Dusk
Ultra Fractal
Nicholas Rougeux, USA
[above]

When Dreams Meet Reality
Ultra Fractal
Ana Lucia Pais, ROMANIA
[top]

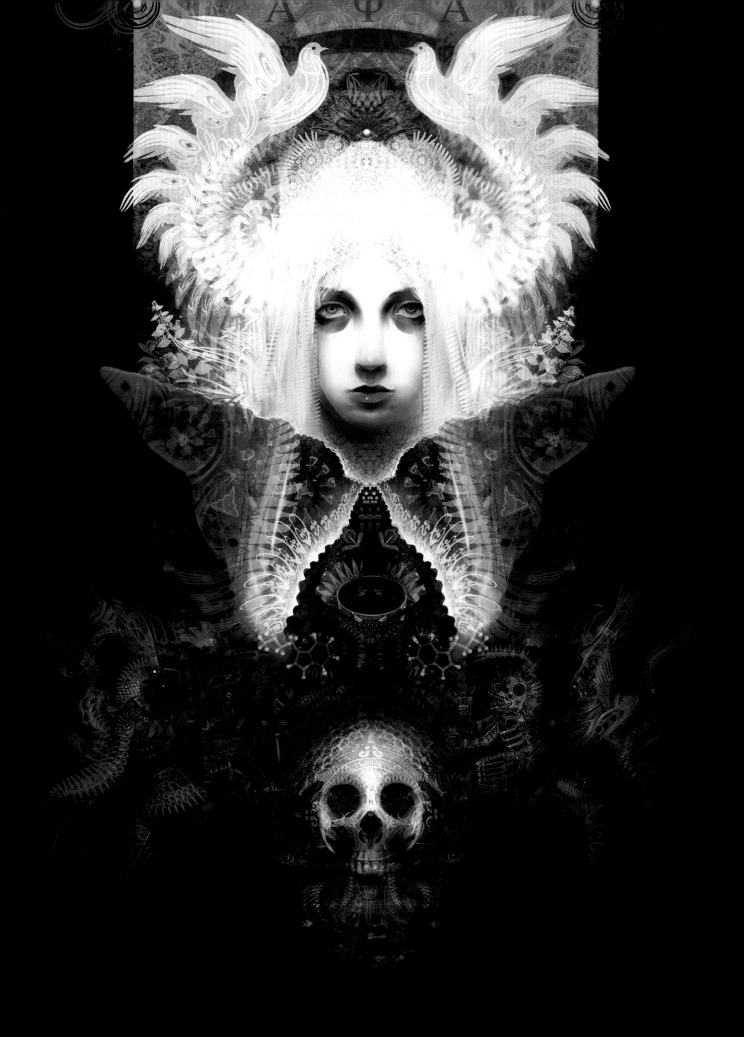

Divine Mother Ayahuasca
Painter, Photoshop
Andrew 'Android' Jones,
USA

Excellence
Abstract & Design

Excellence
Abstract & Design

Conflict
3ds Max, Photoshop
Sam A. Nassar, SYRIA

The Birth of Crystal: Life
modo, Photoshop
Alvin Tea, Liquidworks, NEW ZEALAND
top]

Torn
Maya, Photoshop
Monsit Jangariyawong, THAILAND
[above]

Fractal-8
Maya, Photoshop, mental ray
Lee Griggs, GREAT BRITAIN

Excellence
Abstract & Design

Glass Anemone I
CINEMA 4D, Photoshop
Albert Kiefer,
NETHERLANDS
[left]

fragment.0140.02b
Softimage|XSI, Photoshop
Tim Borgmann, BT-3D,
GERMANY
[right]

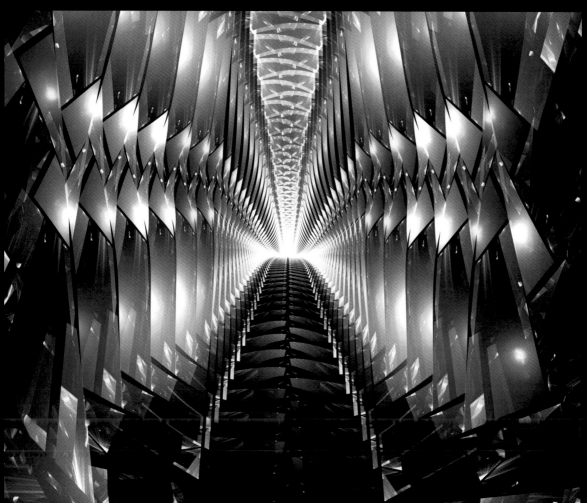

Dimensional Shift II
Apophysis
Natalie Kelsey, USA
[left]

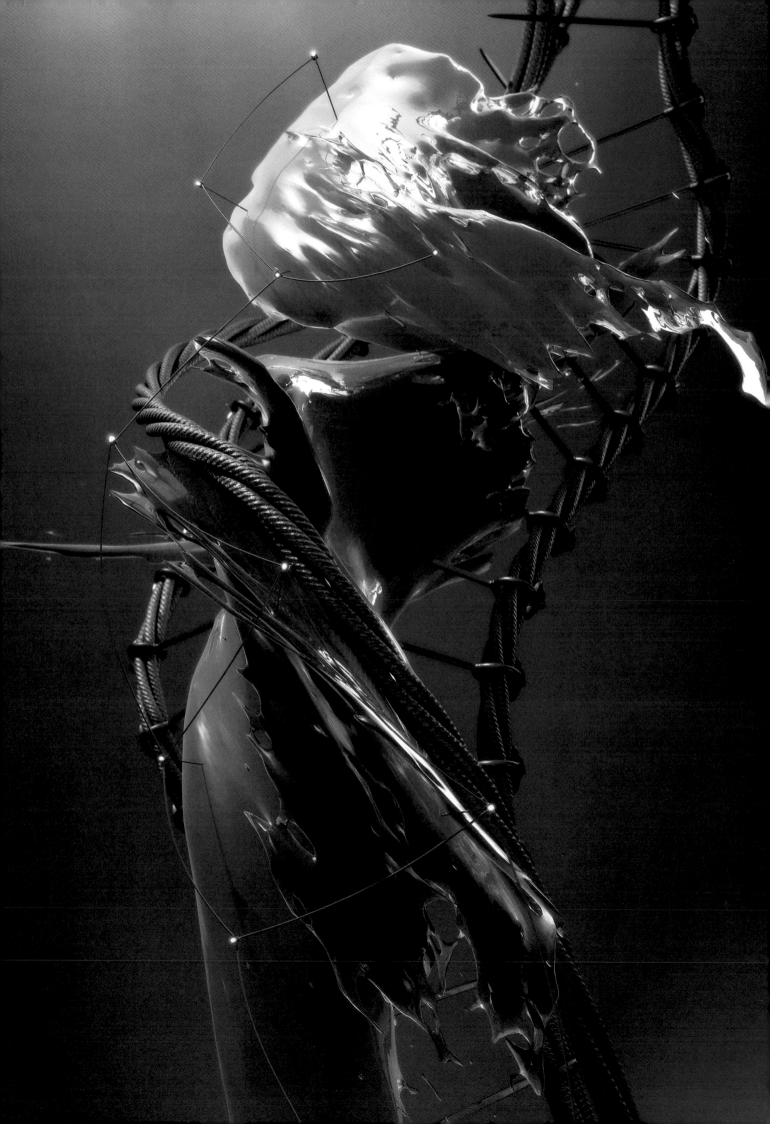

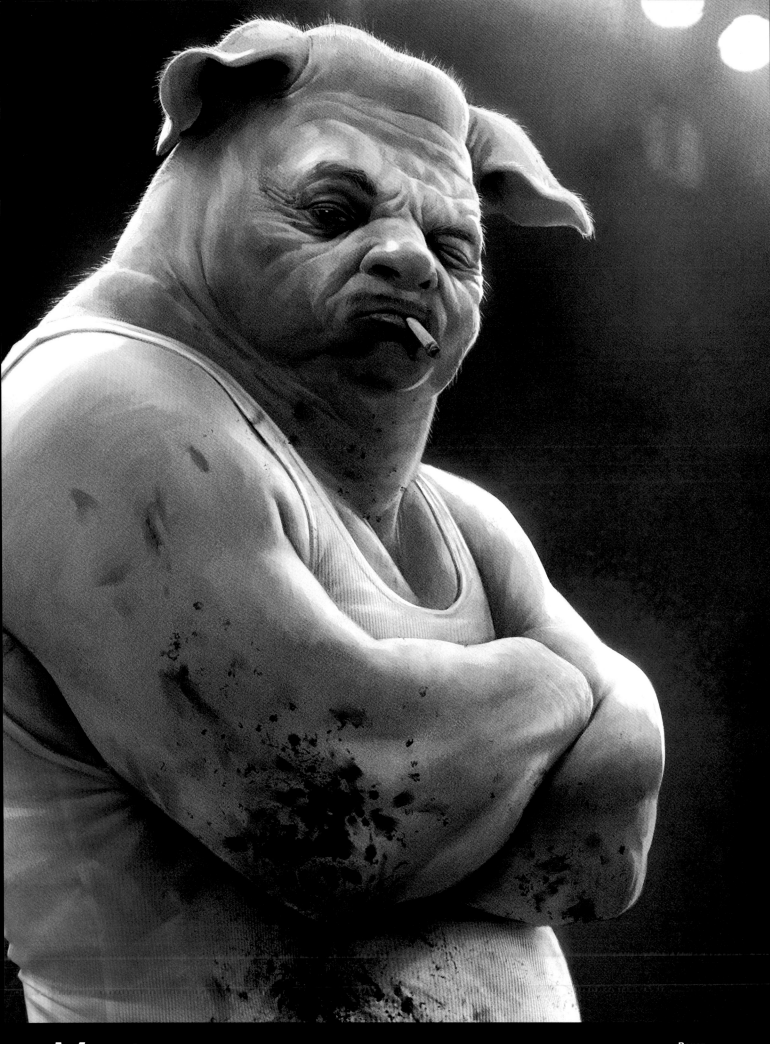

Master

Storytelling

Boxer
Painter
Michael Kutsche,
GERMANY

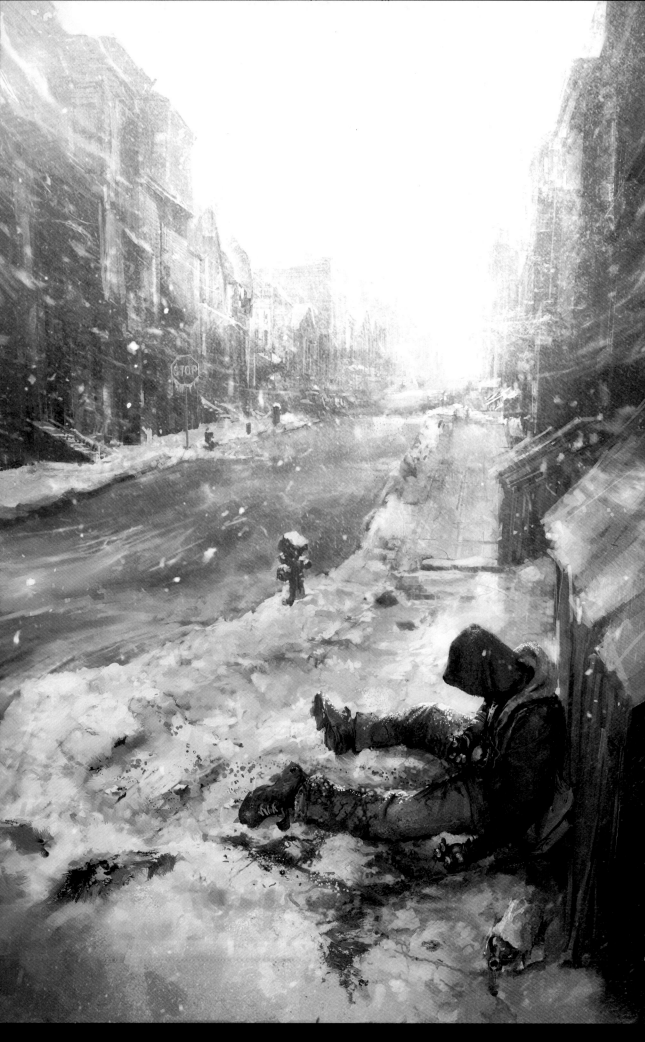

Cold Heart
Painter, Photoshop
Client: Beyond Time Comics
Tae Young Choi, USA

Excellence
Storytelling

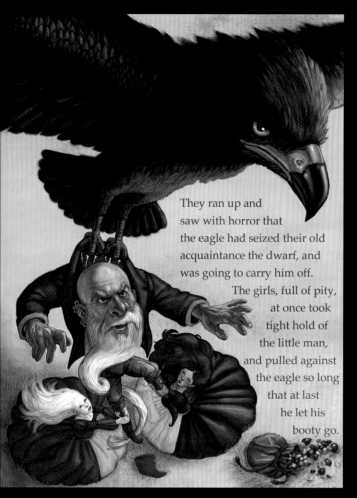

They ran up and
saw with horror that
the eagle had seized their old
acquaintance the dwarf, and
was going to carry him off.
The girls, full of pity,
at once took
tight hold of
the little man,
and pulled against
the eagle so long
that at last
he let his
booty go.

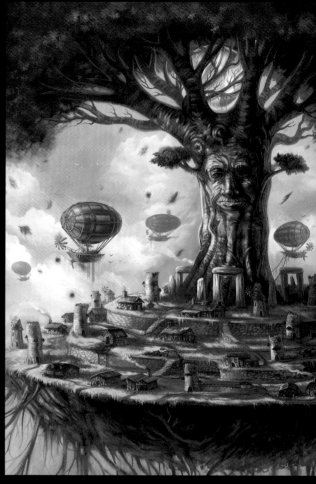

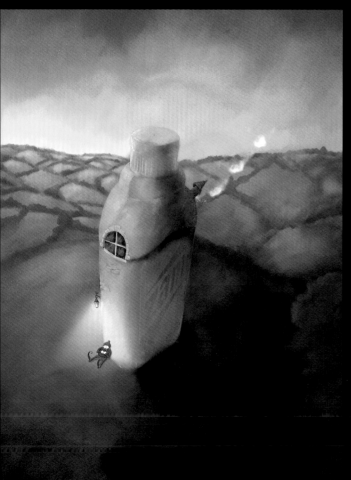

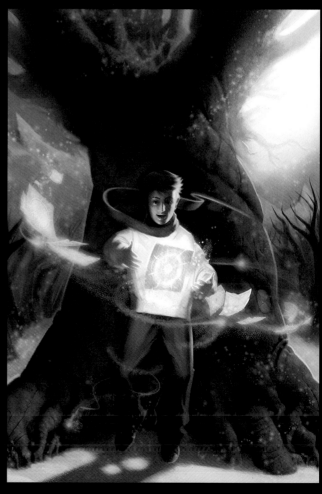

**Snow White and Rose
Red Scene with eagle**
Photoshop, Painter
Felicia Cano, USA
[top]

Waste Management
Painter, Photoshop
Keith Port,
CANADA
[above]

Wizard City
Photoshop
Client: KingsIsle Entertainment
Michael Corriero, USA
[top]

The 13th Letter
Painter
Client: Shadow Mountain
Bryan Beus, USA
[above]

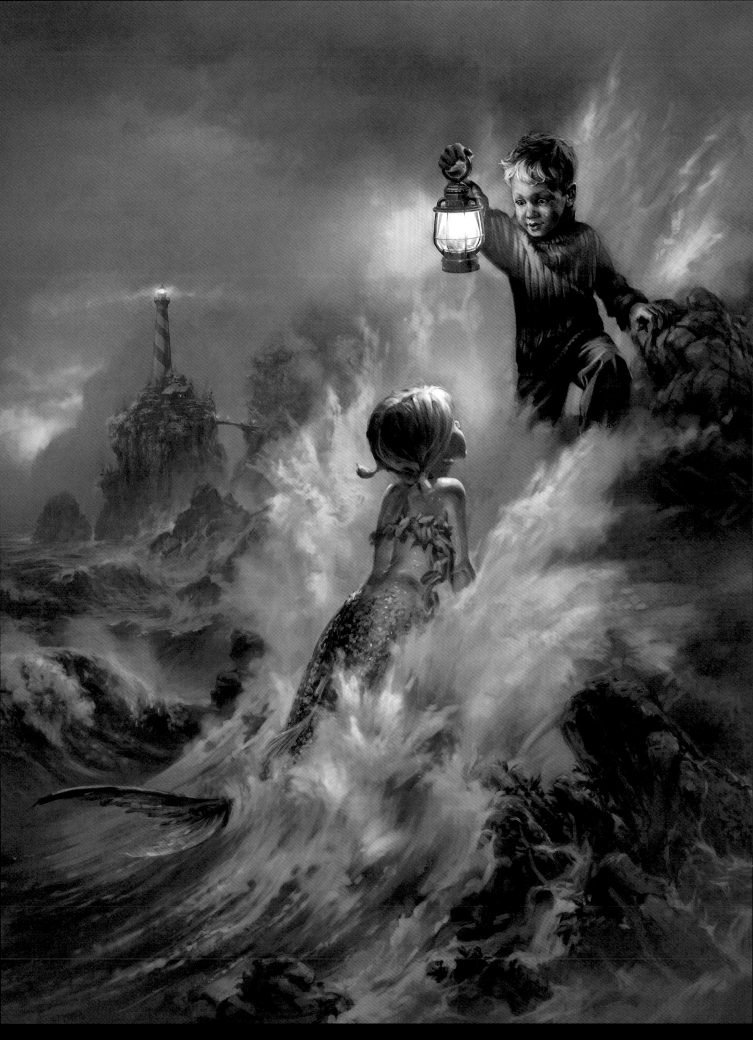

Meeting of Land and Water
Photoshop
Dan Phyillaier, USA

Excellence
Storytelling

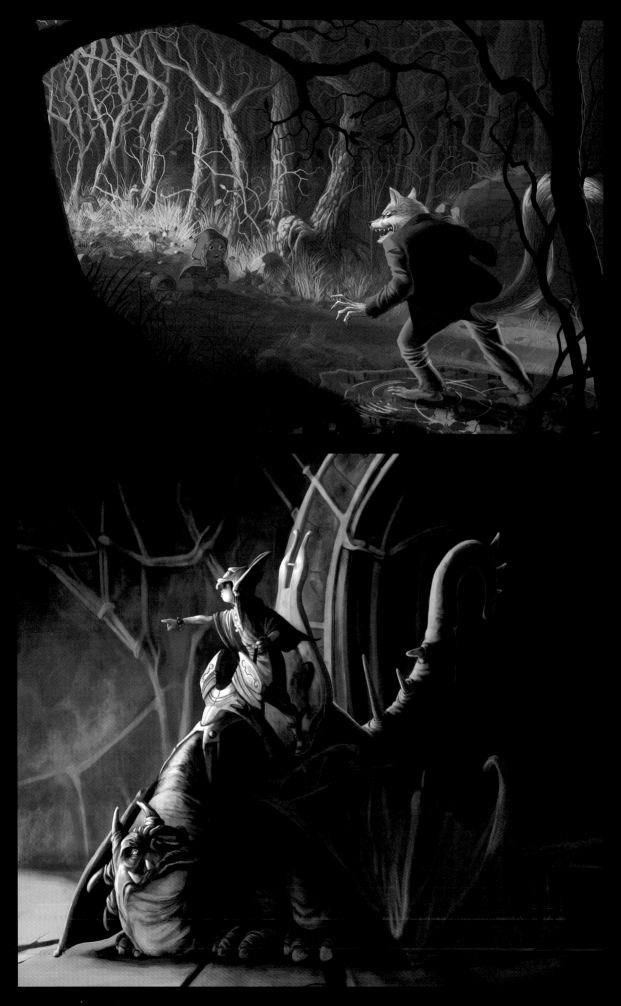

Little Red Riding Hood
Photoshop
Nicolas Villeminot, FRANCE

Forward!
Photoshop
Ilker Serdar Yildiz, TURKEY

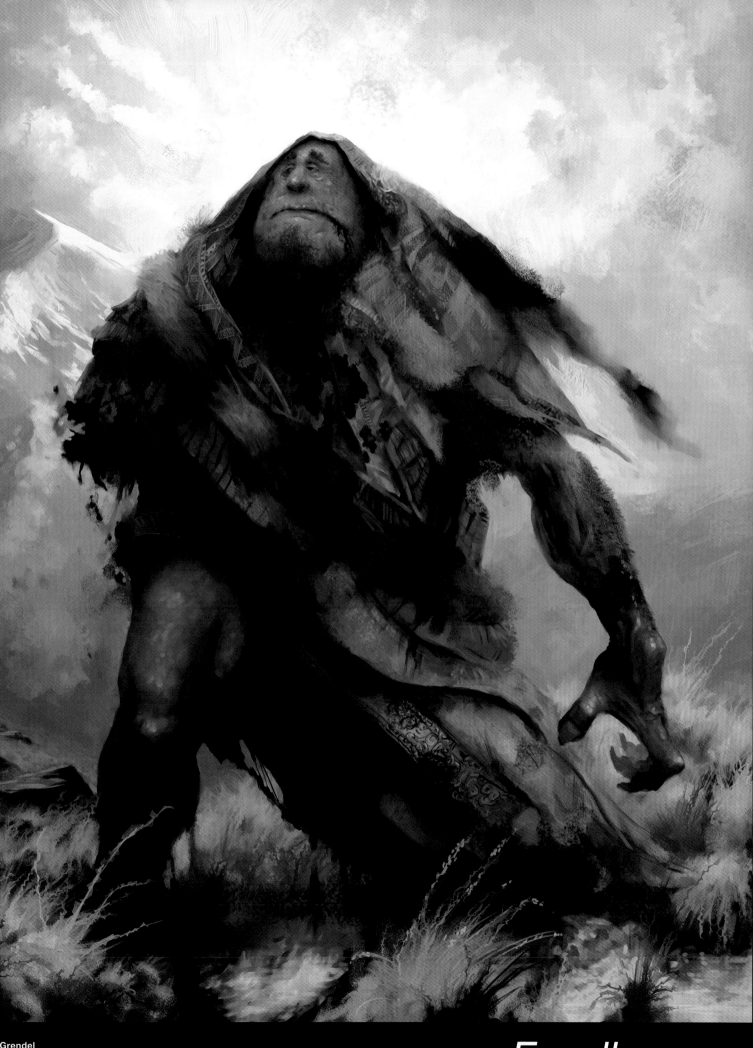

Grendel
Painter
Simon Dominic Brewer,
GREAT BRITAIN

Excellence

Storytelling

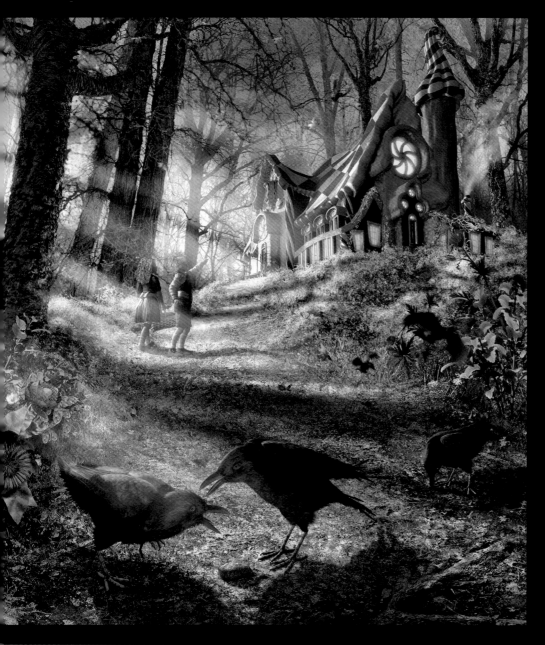

Ginger bread house
LightWave 3D, Poser, Photoshop
Bob Kayganich,
Itchy's Scratch Pad, USA
[left]

Escape from the Mountain Hall
Photoshop
Mats Minnhagen, SWEDEN
[right]

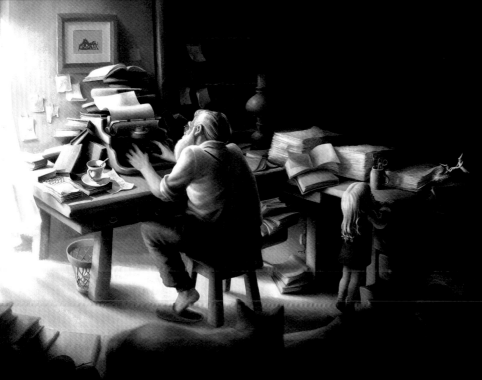

Storytellers
Photoshop
Parinaz Shajareh, IRAN
[left]

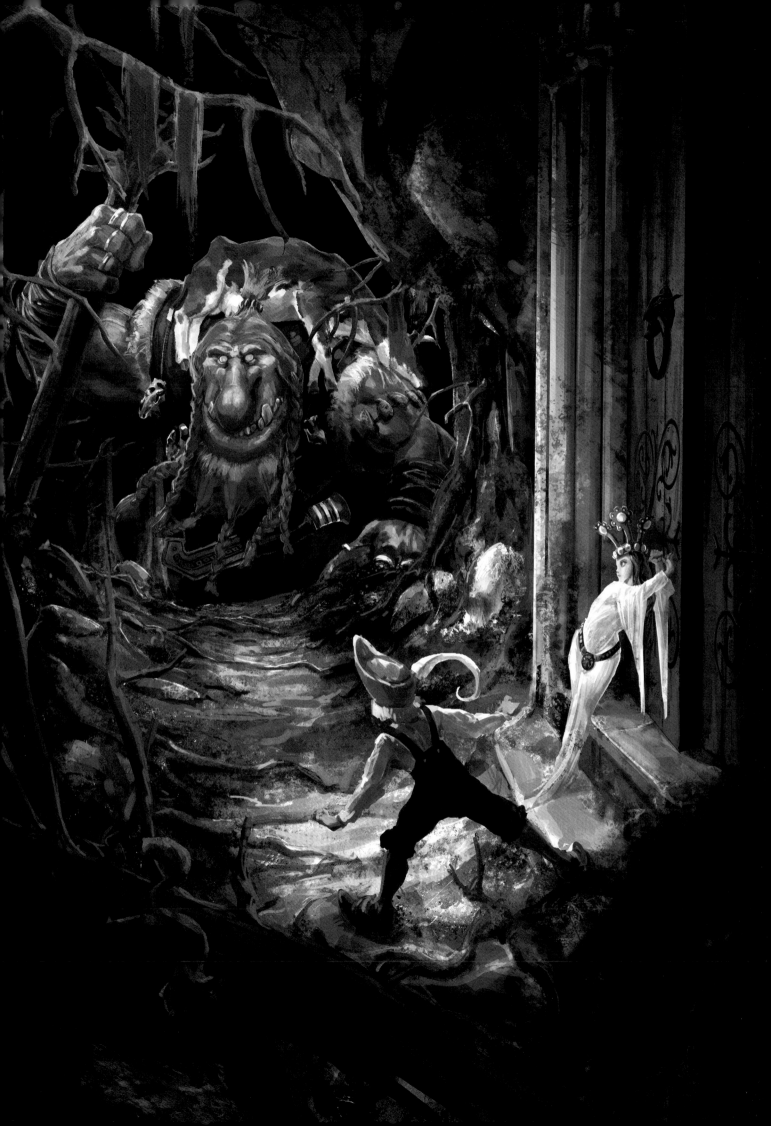

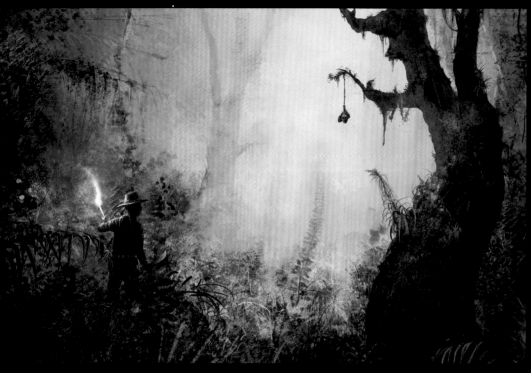

Explorer
Photoshop
Björn Wirtz, GERMANY
[left]

Spike meets the Tree
Photoshop
Lisa Allen, USA
[right]

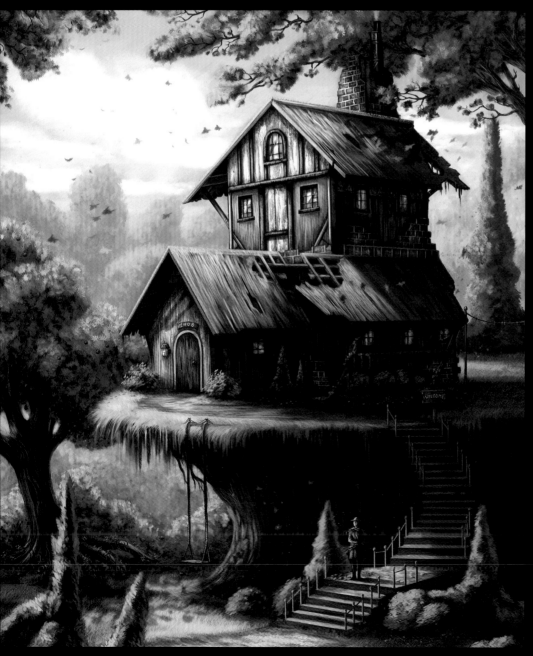

Architectural Hobbyist
Photoshop
Client: Advanced Photoshop Magazine
Michael Corriero, USA
[left]

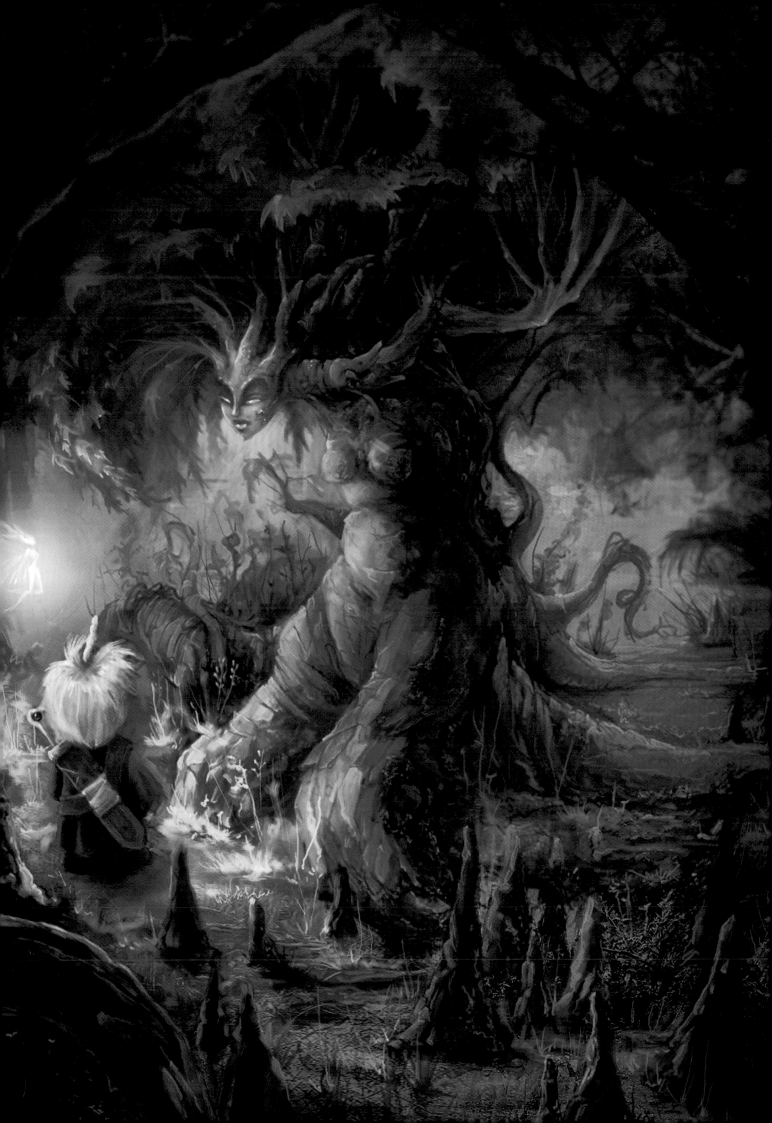

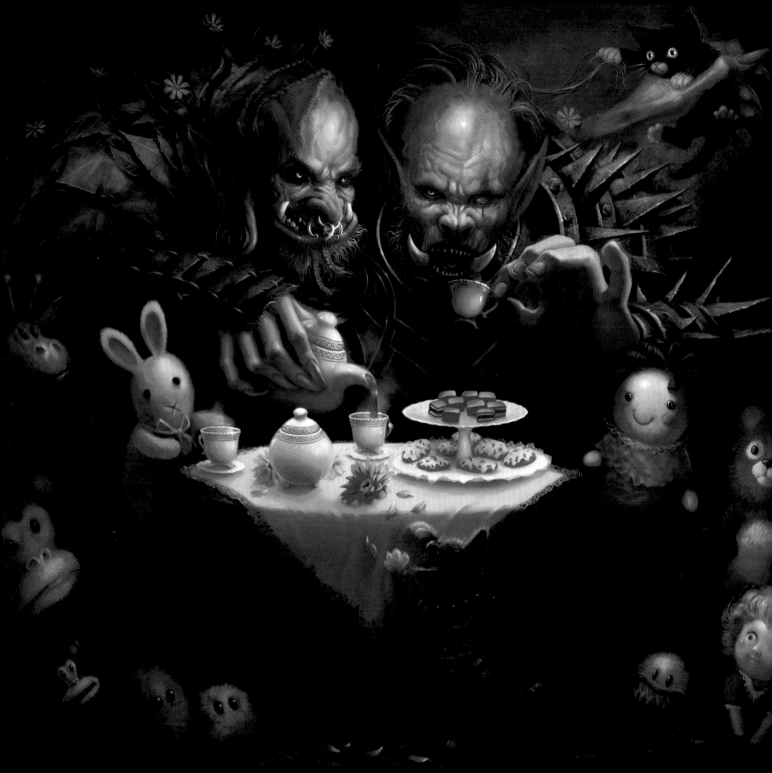

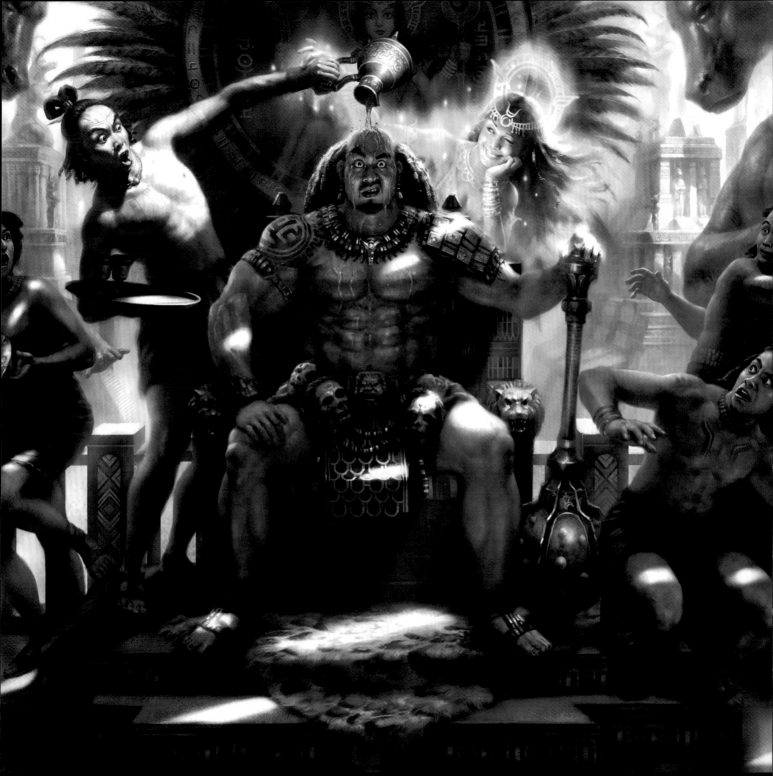

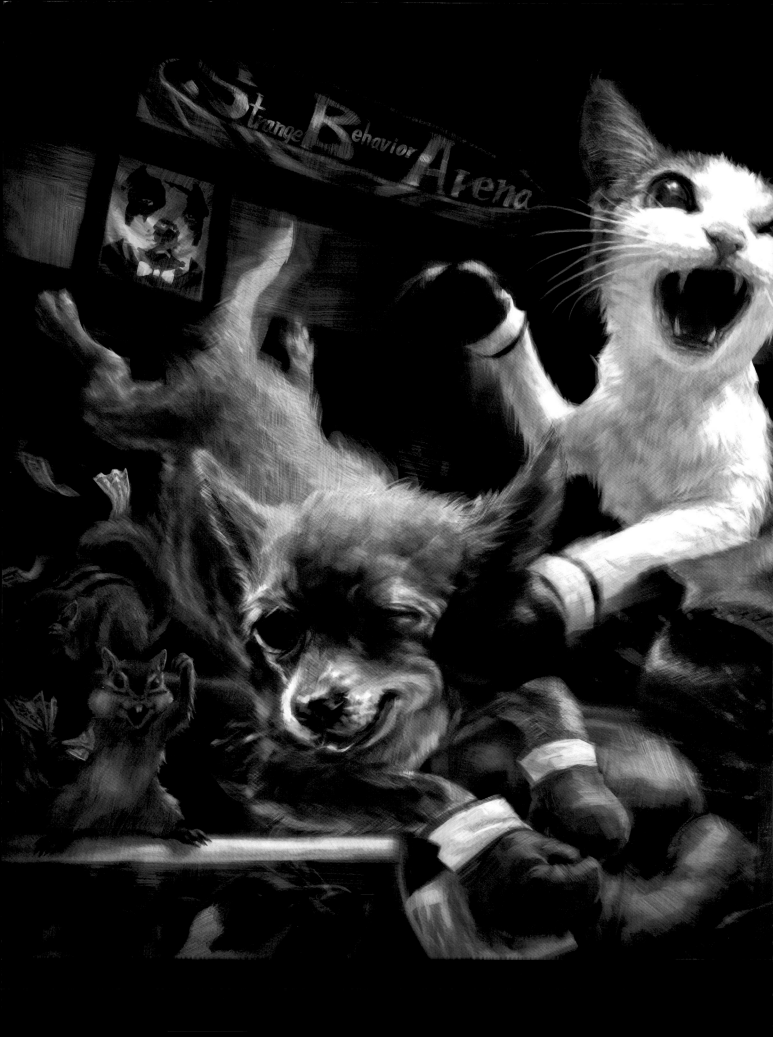

Strange Behavior Arena

Excellence

Humorous

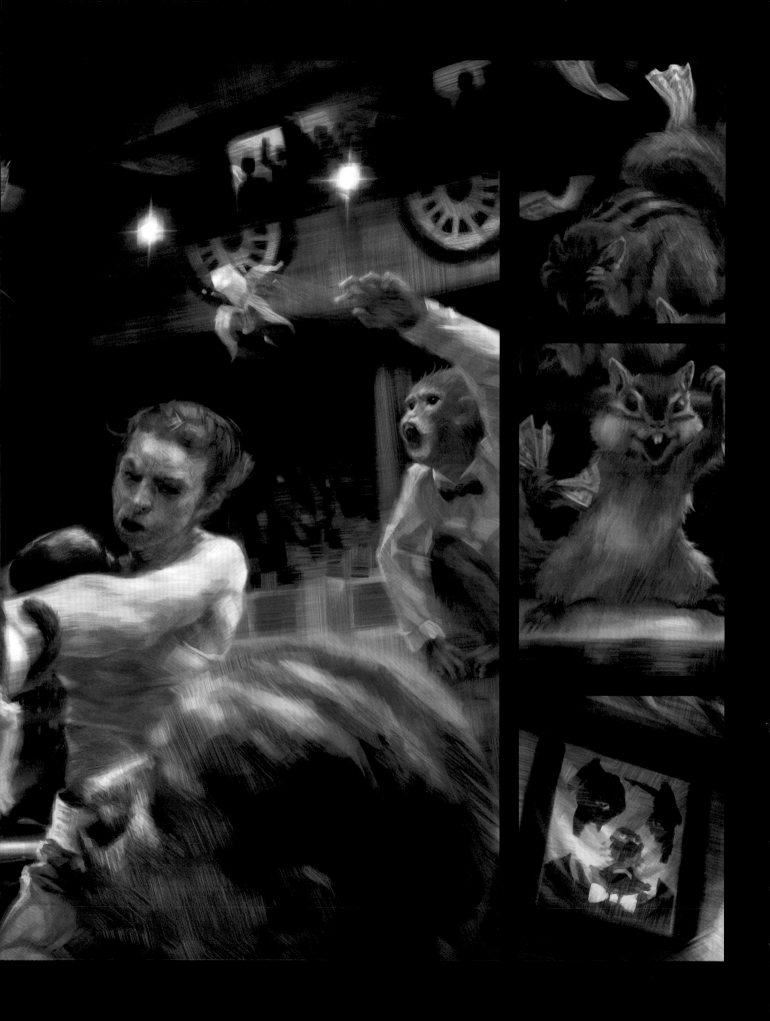

Strange Behaviour: Fighting Arena
Photoshop
Yang Yuchi, TAIWAN

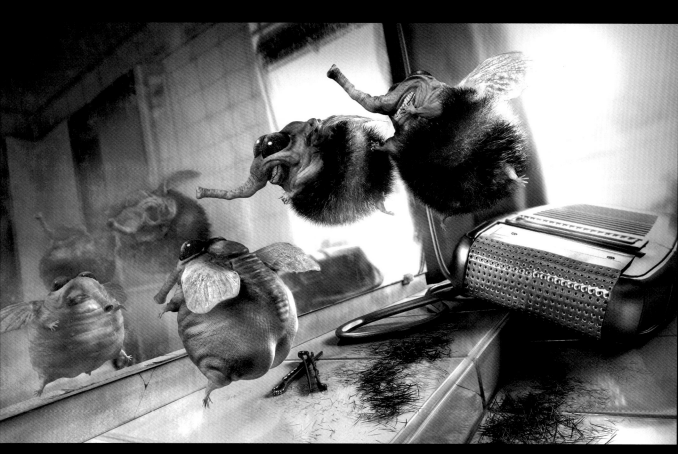

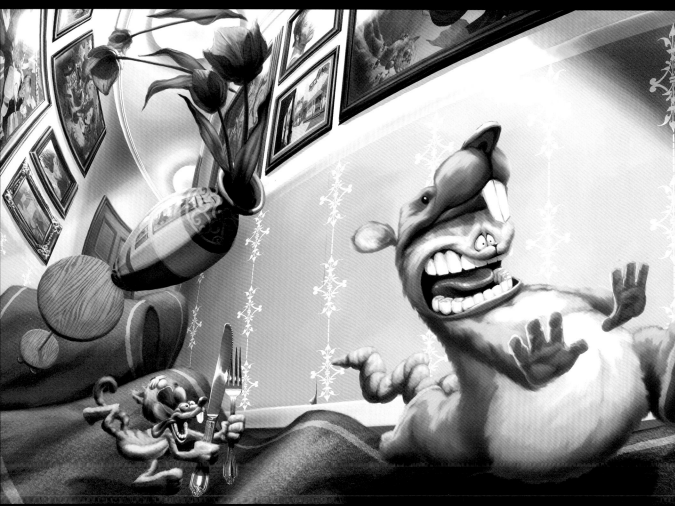

The Shaved Bumblebee
3ds Max, Photoshop,

The Daily Chase
Photoshop

Super Snail
CINEMA 4D, Photoshop

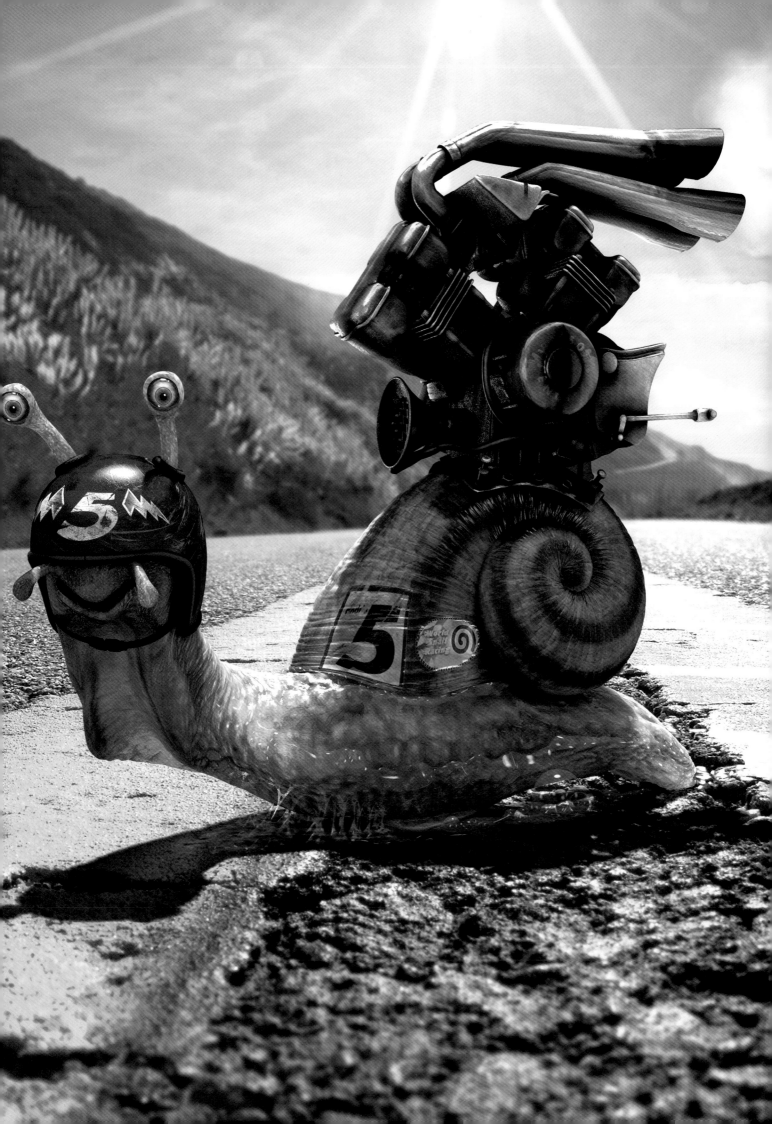

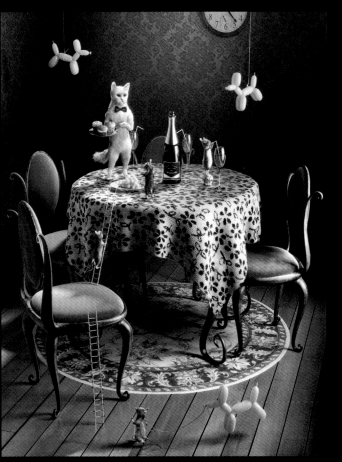

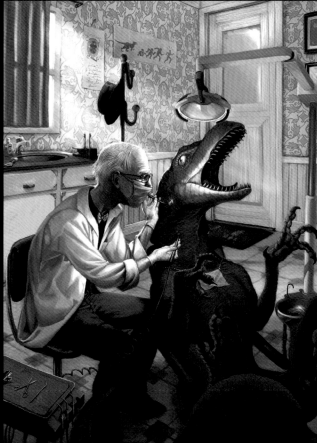

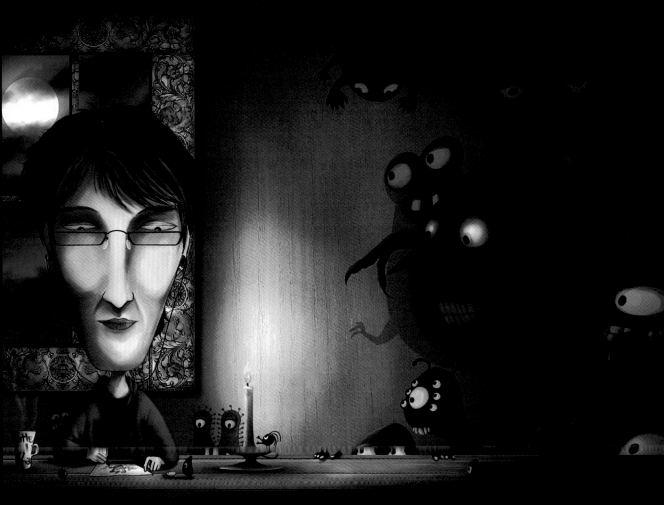

May Day with mice
Softimage|XSI, Photoshop, ZBrush
Pauli Pehkonen, FINLAND
[top]

D artist
Photoshop
Peter Ang, PHILIPPINES
[above]

Velociraptor at the Dentist
Photoshop
Hugo Araujo, BRAZIL
[top]

Sophisticated English ostrich
Photoshop
Yazan Khalifeh, JORDAN
[right]

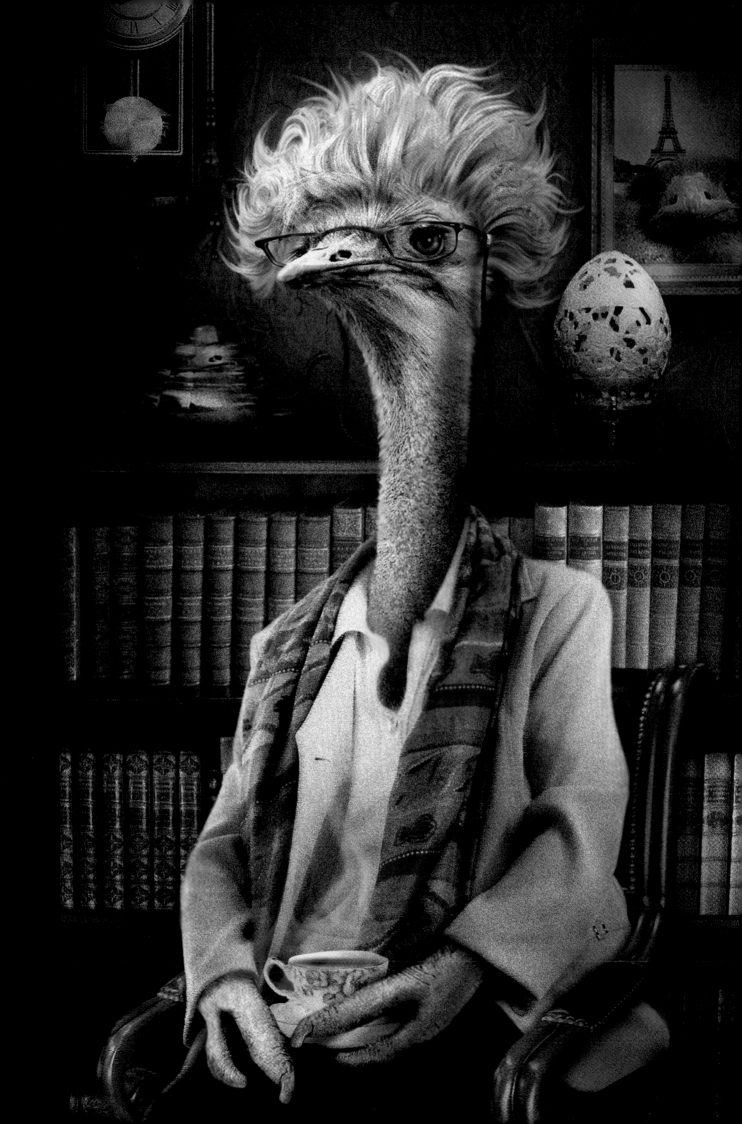

Dependency
3ds Max, mental ray, Photoshop
Andre Kutscherauer, GERMANY
[top]

Born to race
Photoshop
Bence Kresz, HUNGARY
[above]

553-487542
NYPD 03-17-1933

40

30

20

Kong, a happy ending?
ZBrush, Painter, CINEMA 4D
Vivian Garvey, FRANCE

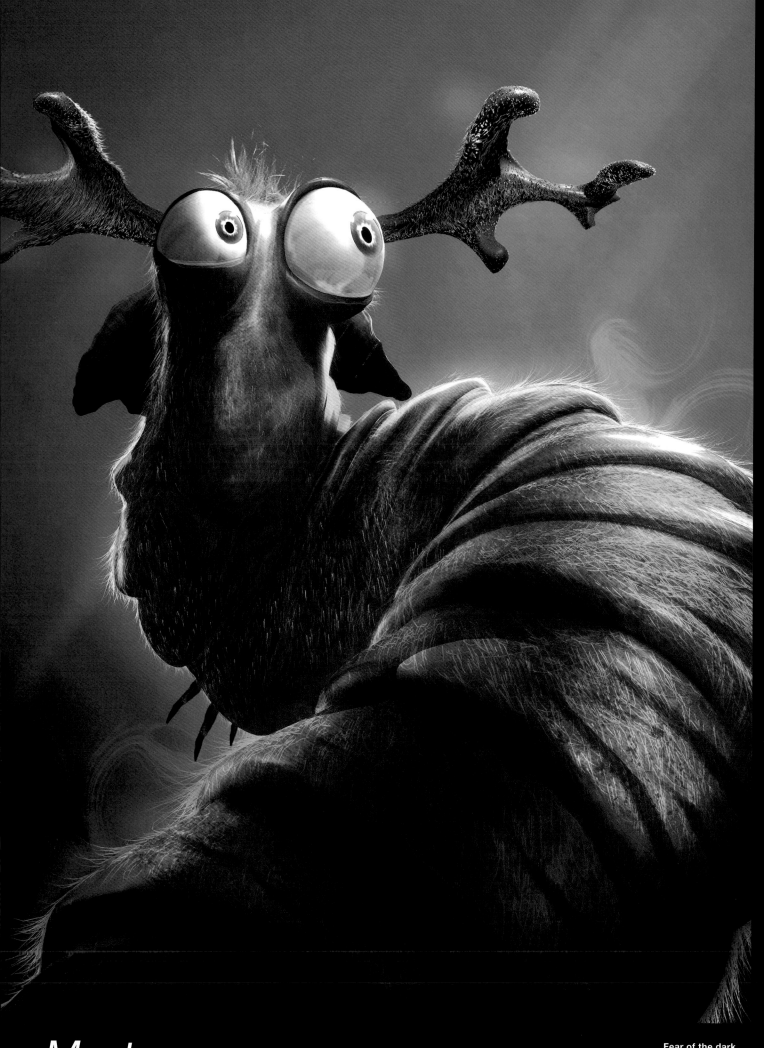

Master
Whimsical

Fear of the dark
3ds Max, Photoshop
Patrick Beaulieu,
CANADA

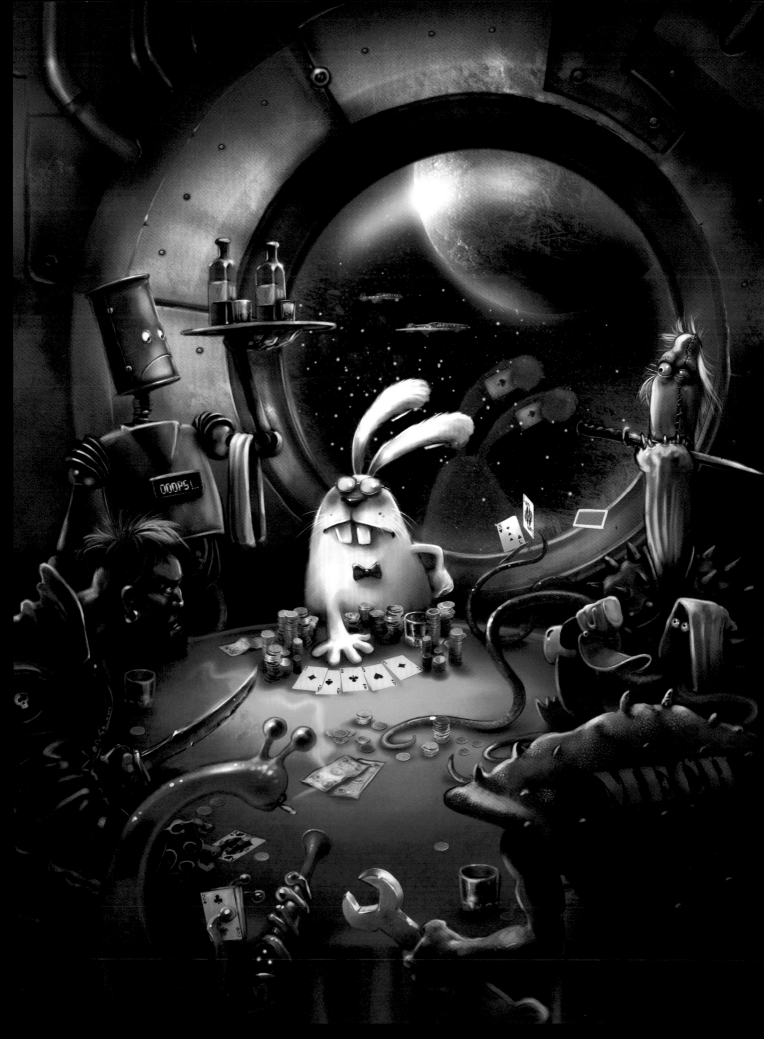

Not another winning hand
Painter, Photoshop
Ramón Acedo,
SPAIN

Excellence

Whimsical

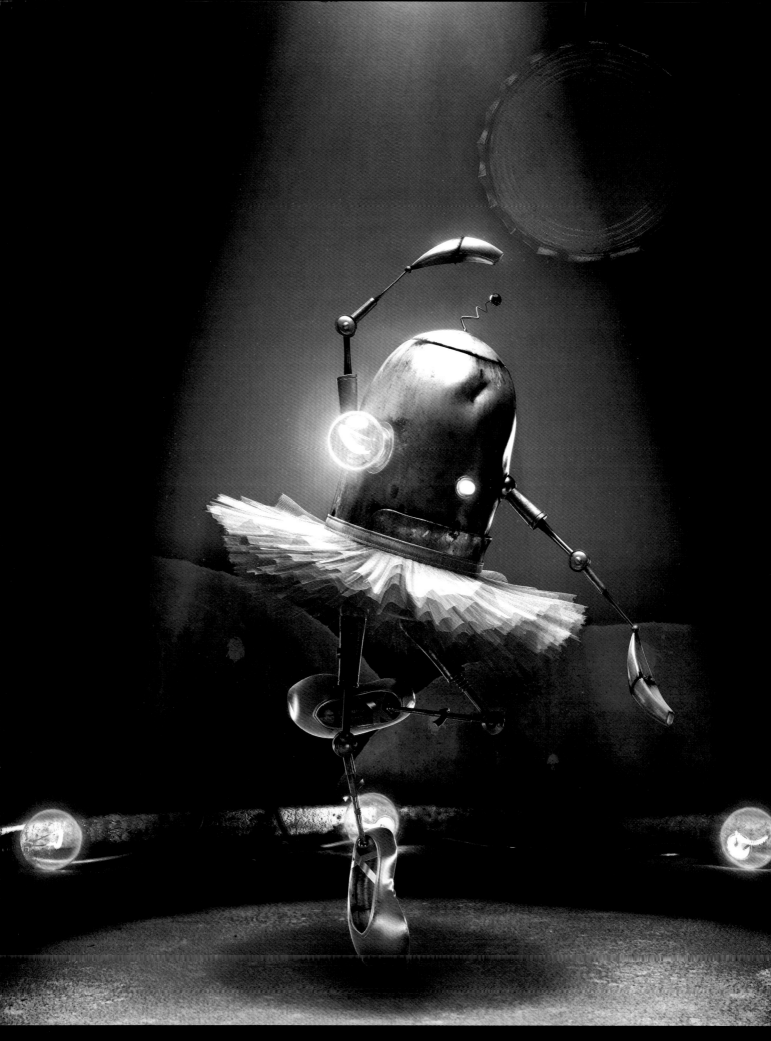

Excellence
Whimsical

Ballet-bot
3ds Max, Photoshop, V-Ray
Alex Jefferies, Digital Progression,
GREAT BRITAIN

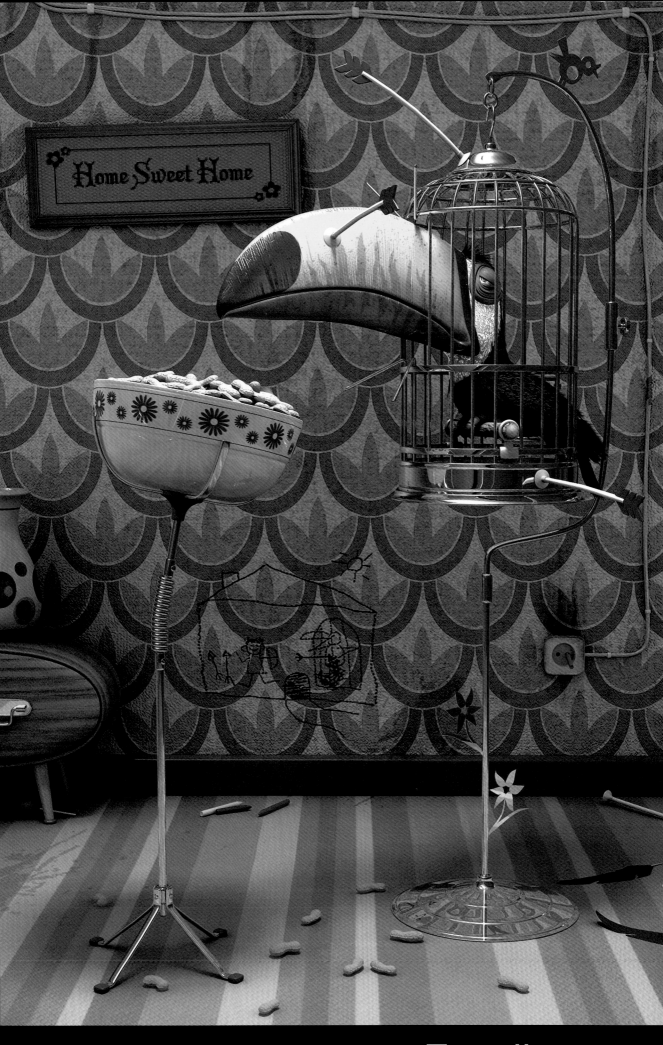

Home Sweet Home
Maya, mental ray, Photoshop
Iker Cortazar, SPAIN

Excellence

Whimsical

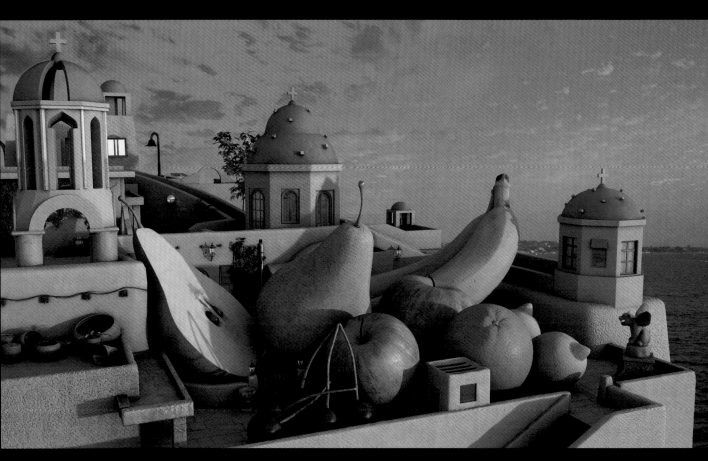

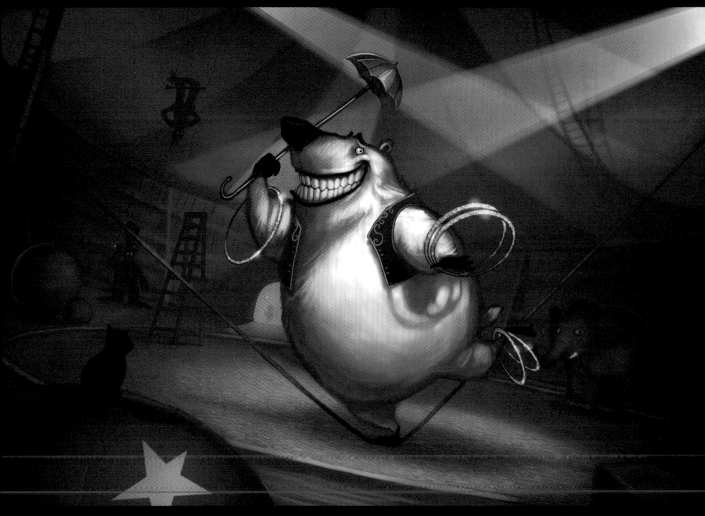

Fruits on Vacation **Polar Circus Bear** **Run Rabbit**

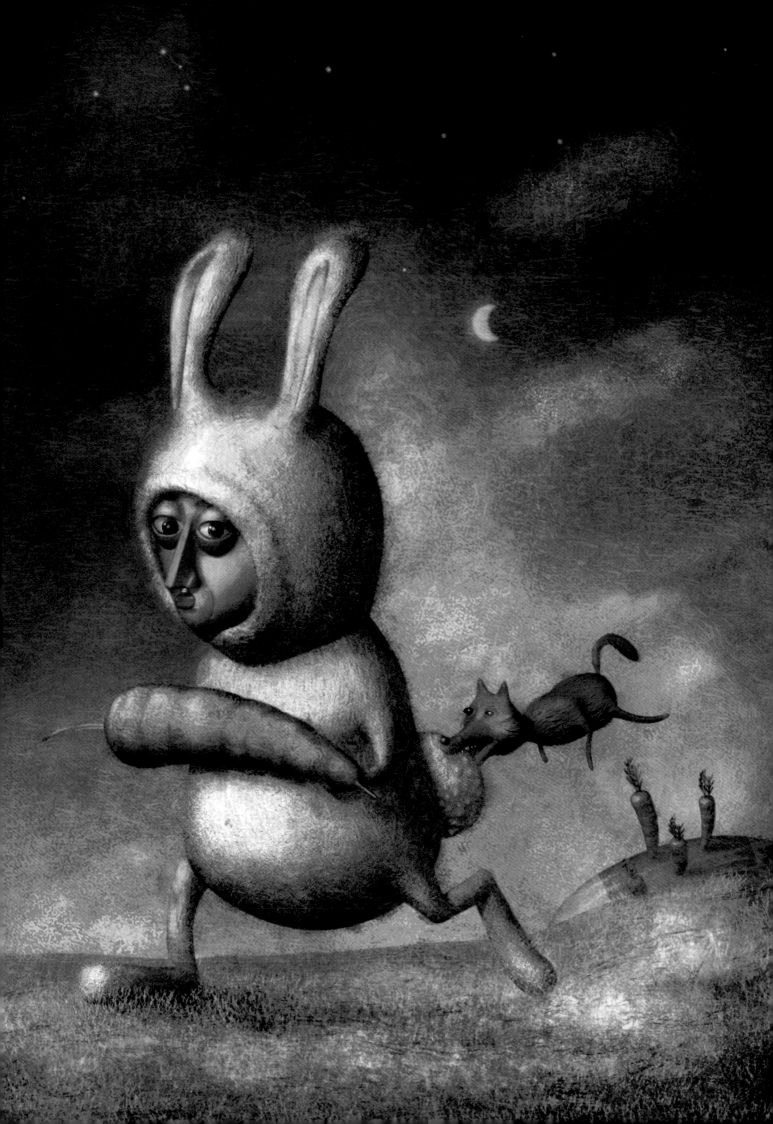

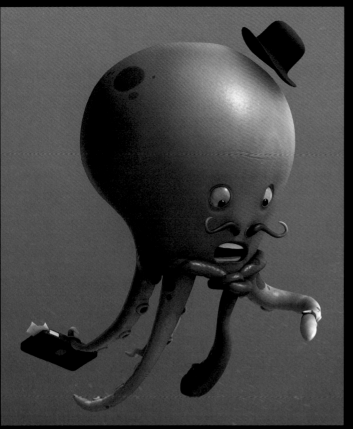

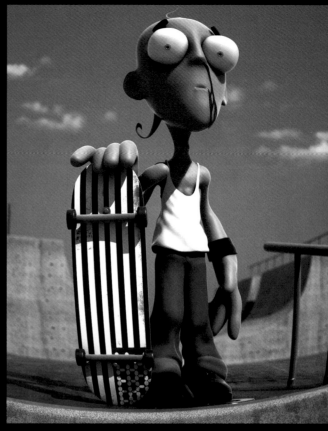

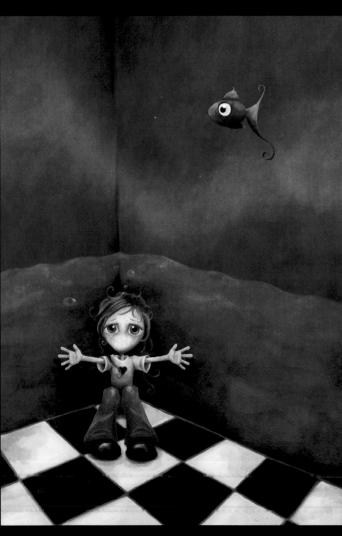

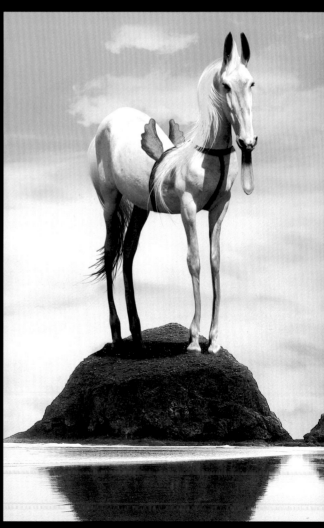

Mr Octopus is late for work
Softimage|XSI, Photoshop
Vincent Guibert, FRANCE
[top]

Like a Fish out of Water
Photoshop
Nykolai Aleksander, GREAT BRITAIN
[above]

Vincent
3ds Max, ZBrush, Photoshop, V-Ray
Olivier Ammirati, FRANCE
[top]

Licking my lonely island
Photoshop
Japi Honoo, ITALY
[above]

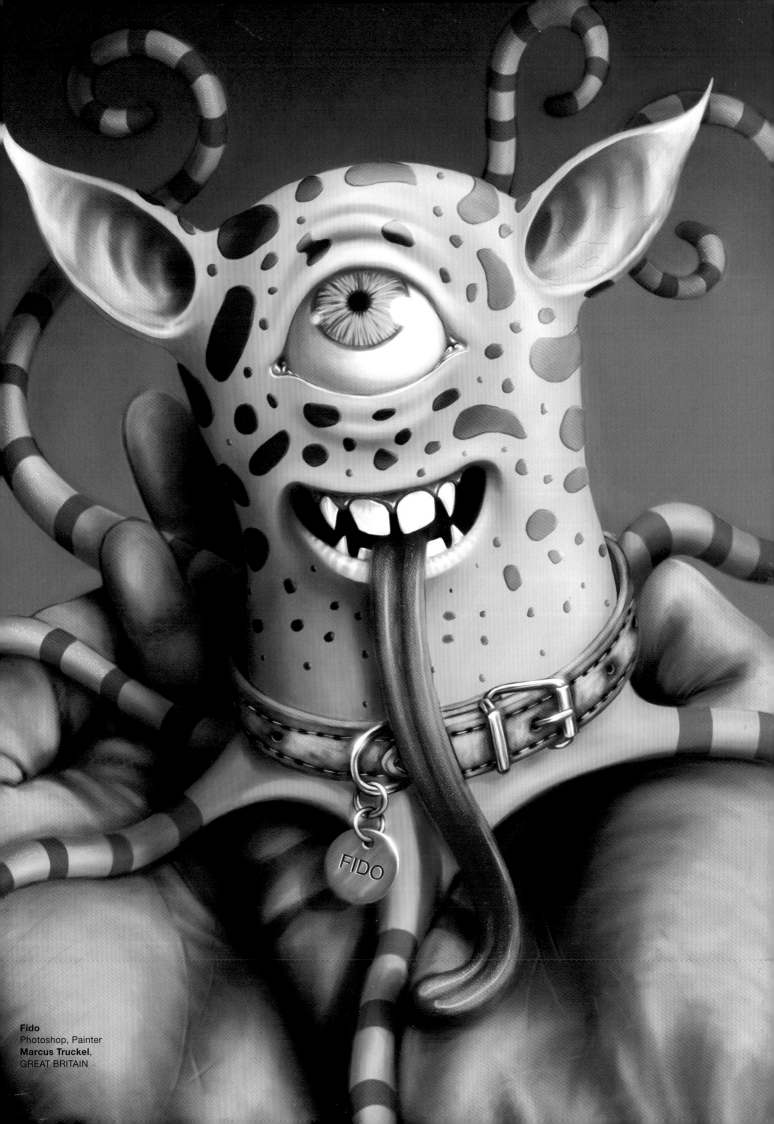

Fido
Photoshop, Painter
Marcus Truckel,
GREAT BRITAIN

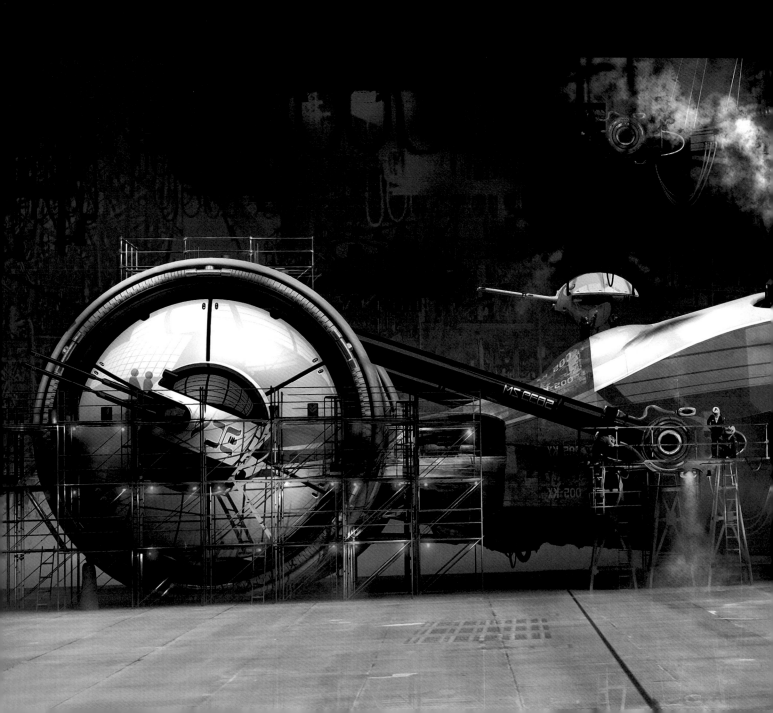

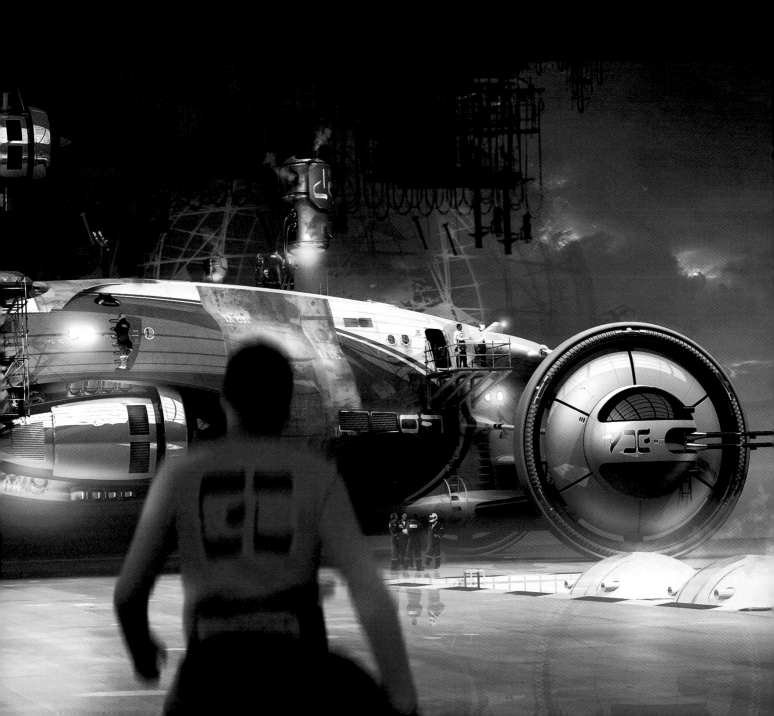

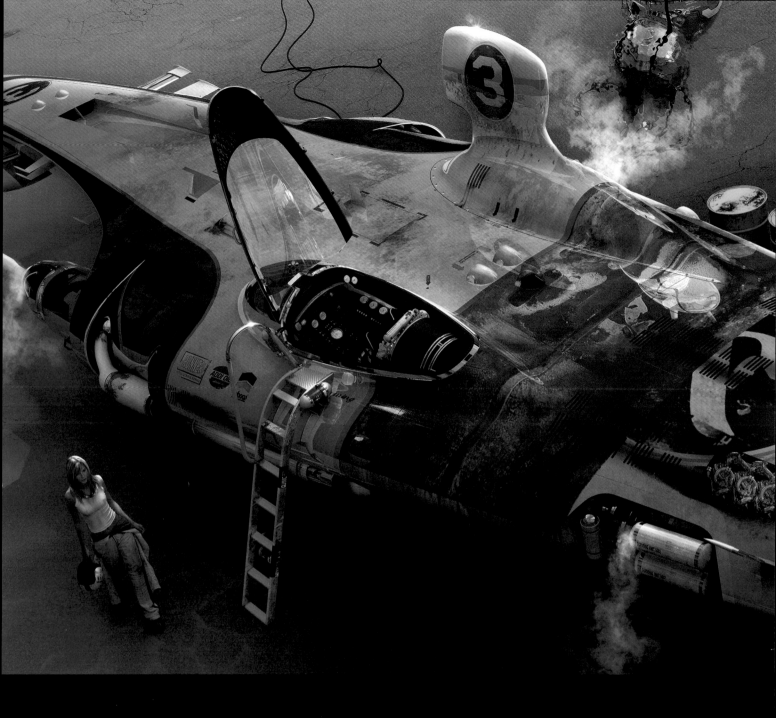

Excellence
Transport

Cosmic Motors: Sexy Magrela (pit scene)
StudioTools, Maya, mental ray, Photoshop
Daniel Simon, Daniel Simon Studio,
GERMANY

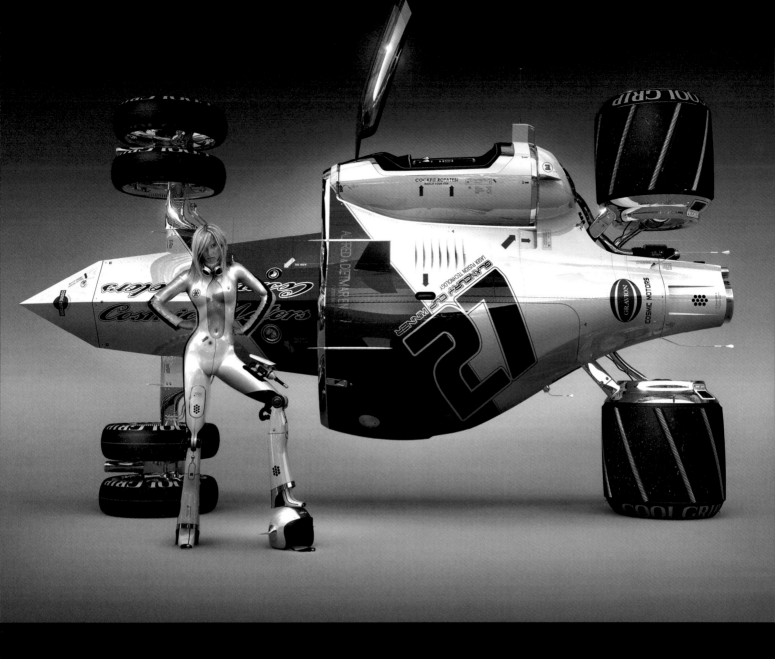

Cosmic Motors: Gravion
StudioTools, Maya, mental ray, Photoshop
Daniel Simon, Daniel Simon Studio,
GERMANY

Excellence

Transport

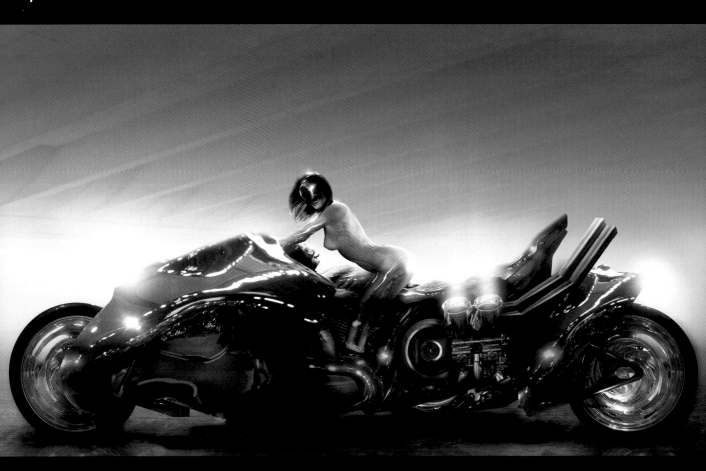

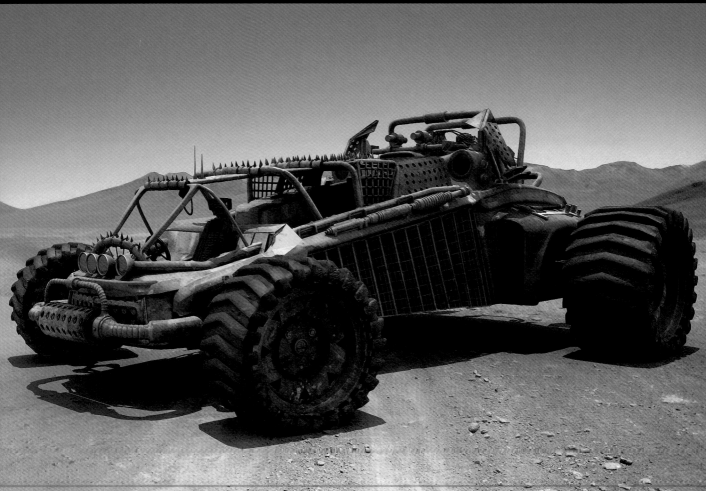

Joy Rider Desert runner Cosmic Motors: Icetrain (ceremony)

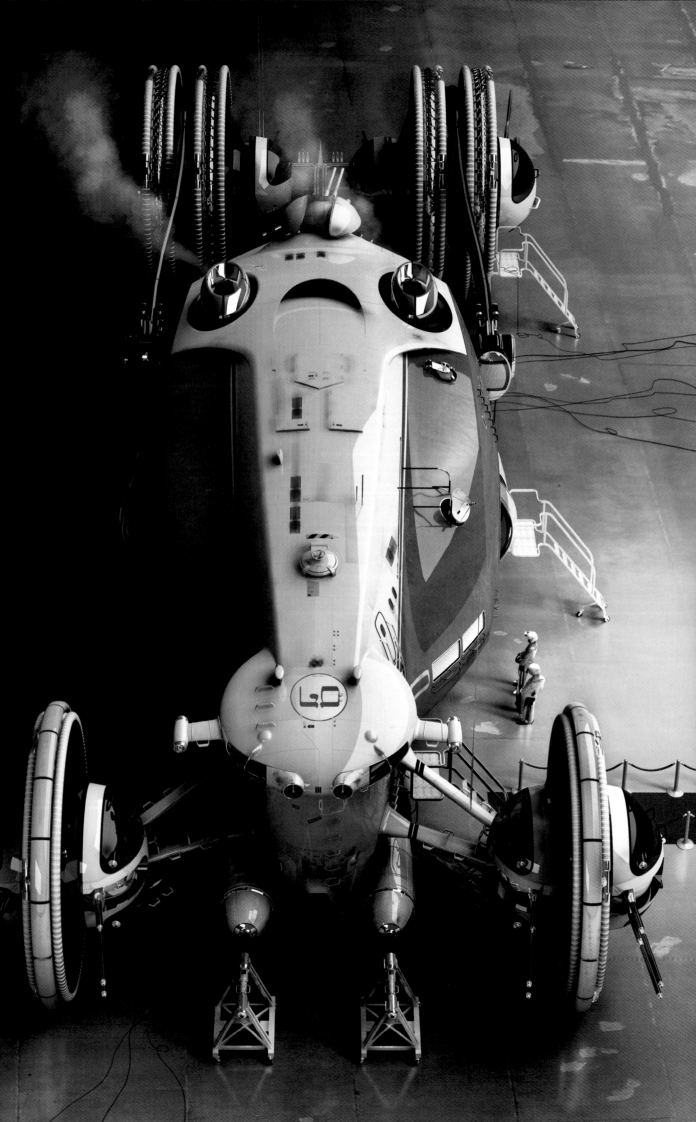

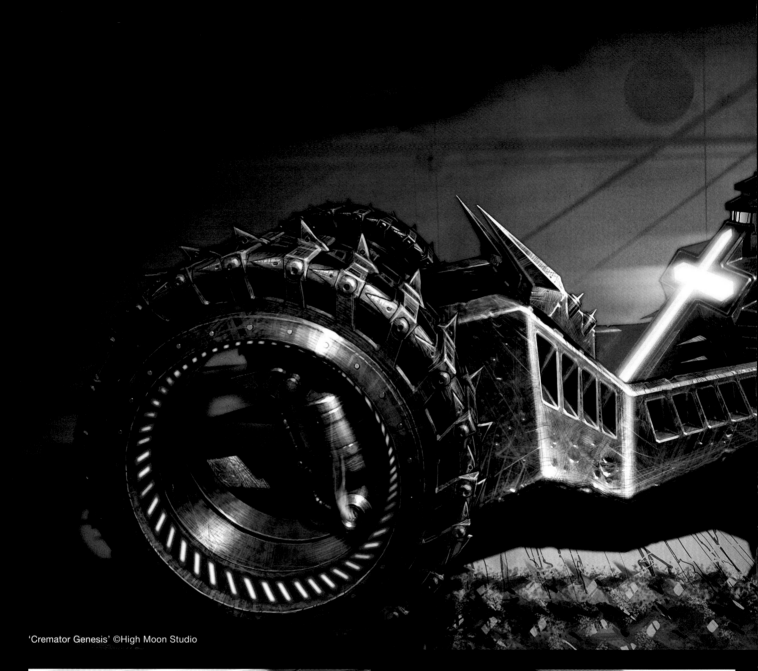

'Cremator Genesis' ©High Moon Studio

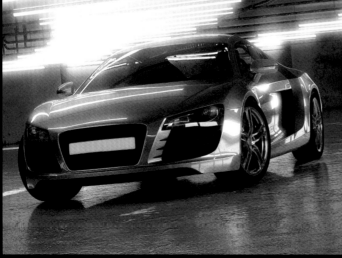

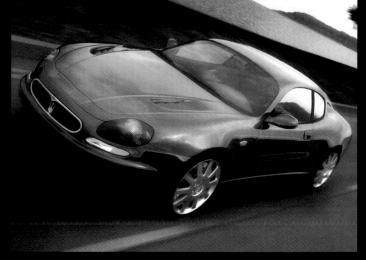

Cremator Genesis: Hellion
Photoshop
Farzad Varahramyan,
High Moon Studios, USA
[top]

Audi R8
3ds Max, V-Ray, Photoshop
Burzin Engineer,
Elemental Crafts, USA
[above]

Maserati Road Shot
3ds Max, mental ray
Robert Stava, Arup 3D Media Group,
USA
[above]

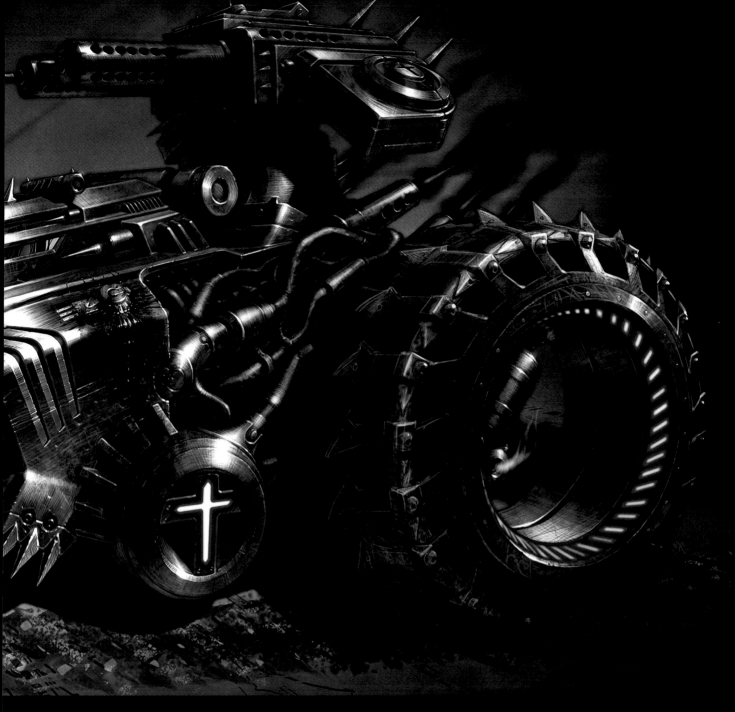

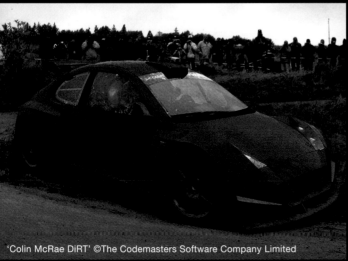

'Colin McRae DiRT' ©The Codemasters Software Company Limited

Colin McRae DiRT: R4 Prototype
3ds Max, Photoshop
Client: Codemasters
Richard Thomas, GREAT BRITAIN
[above]

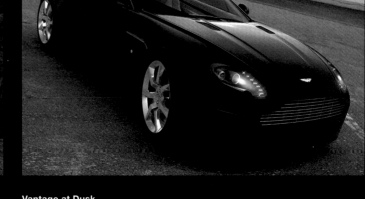

Vantage at Dusk
3ds Max, V-Ray, Photoshop
Ian Brink, thebrinc,
SOUTH AFRICA
[above]

INDEX

EXPOSÉ 6 Limited Edition

The EXPOSÉ 6 Limited Edition features an extra section on the Master Award Winners. These pages can be found in the index with the following reference: *[Limited Edition, i-xv]*

INDEX

EXPOSÉ 6 Limited Edition
The EXPOSÉ 6 Limited Edition features an extra section on the Master Award Winners.
These pages can be found in the index with the following reference: [Limited Edition, i-xv]

SOFTWARE INDEX

Products credited by popular name in this book are listed alphabetically here by company.

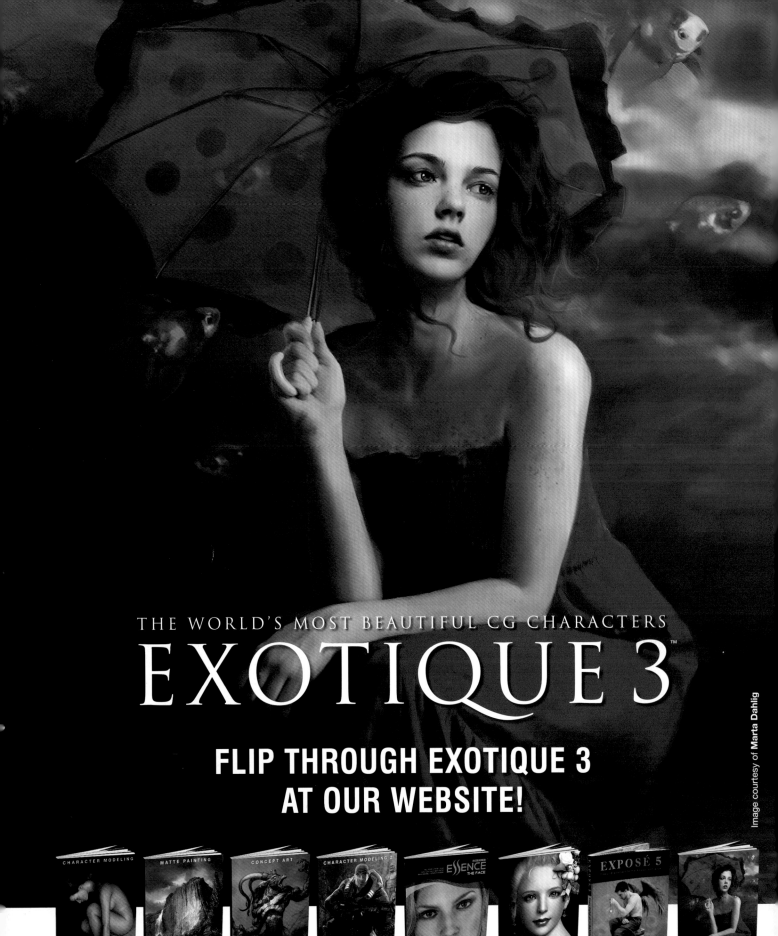

THE WORLD'S MOST BEAUTIFUL CG CHARACTERS

EXOTIQUE 3™

FLIP THROUGH EXOTIQUE 3
AT OUR WEBSITE!

Image courtesy of **Marta Dahlig**